Black & White Cinema

Black & White Cinema

A Short History

WHEELER WINSTON DIXON

Rutgers University Press

New Brunswick, New Jersey

Library of Congress Cataloging-in-Publication Data
Dixon, Wheeler W., 1950–
Black and white cinema: a short history / Wheeler Winston Dixon.
pages cm
Includes bibliographical references and index.
ISBN 978–0–8135–7242–0 (hardcover : alk. paper) — ISBN 978–0–8135–7241–3 (pbk. :
alk. paper) — ISBN 978–0–8135–7243–7 (e-book (epub)) — ISBN 978–0–8135–7244–4
(e-book (web pdf))
1. Black and white films—History and criticism. 2. Cinematography—History—20th
century. 3. Motion pictures—History—20th century. I. Title.
PN1995.9.B575D59 2015
791.43'6—dc23 2014049332

Visit our website: http://rutgerspress.rutgers.edu

Manufactured in the United States of America

For Gwendolyn, as always

Many moviegoers and video viewers say they do not "like" black and white films. In my opinion, they are cutting themselves off from much of the mystery and beauty of the movies. Black and white is an artistic choice, a medium that has strengths and traditions, especially in its use of light and shadow. Moviegoers of course have the right to dislike B&W, but it is not something they should be proud of. It reveals them, frankly, as cinematically illiterate.

—Roger Ebert

The angel said, "I like black-and-white films more than color because they're more artificial. You have to work harder to overcome your disbelief. It's sort of like prayer."

—Jonathan Carroll, *The Ghost in Love*

Contents

Illustrations

All images courtesy Jerry Ohlinger Archives

Acknowledgments

The author wishes to thank Richard Graham, Love Library, University of Nebraska, for his assistance in unearthing many of the original source materials for this volume; his enthusiasm and unfailing kindness were a source of continual inspiration throughout the writing of this text. Thanks also to Leslie Mitchner of Rutgers University Press for commissioning this volume, to Eric Schramm and Alison Hack for their expert copyediting, to Dana Miller for a typically excellent typing job, and Jennifer Holan for her meticulous indexing.

Sections of the first and last chapters of this text first appeared in *Film International* (Daniel Lindvall, editor); the material on *Shanghai Express* first appeared in *Senses of Cinema* (Rolando Caputo, editor); and the section on the films of Andy Warhol first appeared in *Classic Images* (Bob King, editor); my thanks to all for permission to use this material here. This text also contains brief sections of *A Short History of Film* by Wheeler Winston Dixon and Gwendolyn Audrey Foster, reprinted by kind permission of Rutgers University Press. The photographs in this volume are from the Jerry Ohlinger Archive; on project after project, Jerry and Dollie manage to come up with materials that have seemingly eluded everyone else.

Most of all, though, I wish to thank Gwendolyn Audrey Foster, who has been my life partner and closest collaborator for more than three decades, and whose patience and support during the writing of this book were of inestimable value. During the final editing of the book, her help was absolutely essential, and I thank her sincerely for all her efforts on my behalf. I couldn't have done it without you!

Black & White Cinema

Prologue

• •

Black-and-white movies have almost completely disappeared from the current cinematic landscape. There are occasional projects shot in black and white, but with cinema rapidly becoming an all-digital medium, and black-and-white film stock almost impossible to purchase, color has taken over completely, either glossy and popped-out or desaturated for a more dramatic effect, but always using some palette of color. Furthermore, while there have been numerous books on the use of color in the cinema, there has been no book-length study on the black-and-white film, and yet black-and-white cinema dominated the industry internationally for nearly seven decades, until the late 1960s.

Certainly, numerous cameramen and directors have weighed in on the use of black-and-white cinematography in their works, most notably John Alton in *Painting with Light*, but in each case, these works were created when black and white was still a commercially viable medium. Most of the texts I have encountered, with the exception of Alton's book, and to a lesser extent Edward Dmytryk's *Cinema: Concept and Practice*, written after the director had long since retired, treat black-and-white filmmaking as a part of everyday life, the main production medium for most movies, which at the time it certainly was.

In these necessarily practical books, it's about f-stops, filters, and cookies, but very little about the aesthetics of the medium. Indeed, when Alton published his landmark study, he was famously excoriated by his

colleagues as being a pretentious self-promoter; what cameramen did was work, nothing more, and any notions of artistic ambition were inherently suspect. During Alton's heyday, color was dealt with as a special case, which it was, but now, in the all-color, all-digital world of images we currently inhabit, black and white has become the anomaly.

Shooting in black and white is inherently a transformative act. As the filmmaker and opera director Jonathan Miller—whose beautiful film adaptation of *Alice in Wonderland* (1966) was elegantly photographed in black and white by the gifted Dick Bush—once observed in conversation with me, the very act of making a black-and-white film transmutes the original source material, for life, as we know, takes place in color. Therefore, there is an intrinsic level of stylization and reinterpretation of reality when one makes a black-and-white film, leading to an entirely different mode of cinematography. It's a different world altogether, one that is rapidly slipping away from us into the mists of the past.

Black and white was the original medium of the cinema from the invention of paper roll film and then cellulose nitrate film, and yet the industry and viewing audiences always yearned for color. This was first accomplished through the use of both hand-tinting the images frame by frame, as well as running entire lengths of film through baths of colored dye. By the 1920s two-strip Technicolor was well established with such films as Chester M. Franklin's *The Toll of the Sea* (1922, d.p. J. A. Ball). In 1935, the first three-strip Technicolor feature film, Rouben Mamoulian's *Becky Sharp*, photographed by Ray Rennahan, caused an industry sensation.

Soon Technicolor, as a company, had a lock on color cinematography in Hollywood, leading to a trend that had its first peak in 1939, when Victor Fleming's *Gone with the Wind* (with uncredited directorial contributions from George Cukor and Sam Wood, among others; photographed by Ernest Haller and an uncredited Lee Garmes), Fleming's *The Wizard of Oz* (with uncredited directorial input from Cukor, Mervyn LeRoy, Norman Taurog, and King Vidor; photographed by Harold Rosson), and a few other A-level films were produced in the new process. Black and white, however, remained the standard form of film production, simply because Technicolor cost so much more than black and white, and color films were thus considered *events* while black-and-white films were the norm.

From the 1900s to 1960, cinematographers such as James Wong Howe, Gregg Toland, Freddie Francis, Stanley Cortez, Nicholas Musuraca, Rob-

ert Krasker, John Alton, Boris Kaufman, Gunnar Fischer, John L. Russell, Sven Nykvist, Karl Freund, Fritz Arno Wagner, John Seitz, Robert Burks, and many others created an alluring and phantasmal world out of nothing more than light and shadow, transforming the real world into a cinematic *trompe-l'œil* that was so seductive and all-encompassing that it became an entirely new and hermetically sealed universe. Certain films lent themselves to black and white more than others; film noir, for example, is both a style and a genre, and, from its early days in such films as Boris Ingster's *Stranger on the Third Floor* (1940, d.p. Nicholas Musuraca), depended on large patches of darkness splashed with a single light source from the left or right of the screen. As noir director Edward Dmytryk and cinematographer John Alton both noted, this sort of high-key lighting was both effective and economical in creating the bleak, unforgiving world of the film noir.

Along with this, the archival statistics for black-and-white silent films are particularly shocking. A recent report by David Pierce tells a grim tale of just how much the black-and-white film has been neglected. Though most film historians and archivists have known for a long time that the news isn't good, we now know how bad it really is. As the report's introduction by James Billington notes,

> Only 14% of the feature films produced in the United States during the period 1912–1929 survive in the format in which they were originally produced, i.e., as complete works on 35mm film. Another 11% survive in full-length foreign versions or on film formats of lesser image quality such as 16mm and other smaller gauge formats. The Library of Congress can now authoritatively report that the loss of American silent-era feature films constitutes an alarming and irretrievable loss to our nation's cultural record. Even if we could preserve all the silent-era films known to exist today in the U.S. and in foreign film archives—something not yet accomplished—it is certain that we and future generations have already lost 75% of the creative record from the era that brought American movies to the pinnacle of world cinematic achievement in the twentieth century. (vii–viii)

This is the result of a number of factors: the death of the silent film as a commercial art form and the resultant neglect of film negatives by the Hollywood studios; nitrate film decomposition, which plagues all films

made prior to 1950; but mostly, it's a ringing indictment of the fact that we don't value our cinematic heritage as much as we should, and now, *it's gone forever.* We can't get it back, no matter what we do. Unless some long forgotten print or dupe negative turns up in a vault somewhere, these films have been consigned by neglect and indifference to perpetual oblivion, and even if such materials do turn up, they will probably be in very poor shape.

A few years ago, in 2008, twenty-five minutes of lost scenes from Fritz Lang's 1927 film *Metropolis* (d.p. Karl Freund, Günther Rittau, and Walter Ruttmann) surfaced in the Buenos Aires Museo del Cine, in 16 mm dupe negative format, footage that had been cut shortly after the film's initial premiere in Berlin. However, the footage was so scratched and damaged that even after extremely aggressive digital restoration, it was still of such inferior quality that it could only serve as an *aide-mémoire* for the images in their original form. The resultant "complete" version was thus so intensely compromised that it was of archival value only, and bore only the most distant relationship to the film's initial creation.

But it's better than nothing, and for 75 percent of the silent era, that's exactly what we get: nothing. For George Fitzmaurice's *The Dark Angel* (1925, d.p. George Barnes), named by the *New York Times* as one of the ten best films of the year, *nothing.* For Herbert Brenon's adaptation of *The Great Gatsby* (1926, d.p. Leo Tover), we have only tantalizing glimpses from the film's trailer and a few stills, but nothing else. For Tod Browning's *London after Midnight* (1927, d.p. Merritt B. Gerstad), we again have a few stills, but the last surviving print was destroyed in a fire in the MGM vaults in 1967. And the list goes on and on.

The old saying "nitrate won't wait" means that the decomposition of nitrate film negatives and prints is inevitable. Movies created in this medium must be transferred to either safety film or some sort of digital master or they will cease to exist. Film is a deeply fragile medium, and making a film is, as the 1940s producer Val Lewton observed, echoing John Keats's famous epitaph, like "writing on water." If just one copy of a book survives, no matter how badly damaged it is, if the text is decipherable, it can be reset in new type and reprinted, and thus live anew for succeeding generations, with no damage at all—the words have been reclaimed from the ashes. Not so with film. Once it's gone, it's gone forever; it's the death of every film that no longer survives that we mourn here, something for which there is no remedy.

For those films that no longer exist, all we can do is memorialize them, and try to keep what artifacts we can from their production to remind us that once upon a time, literally thousands of people labored on thousands of films in a variety of capacities, to bring their vision to life on the screen. But since they are gone, we should also look toward the future, and aggressively seek to save every film, silent or sound, foreign or domestic, commercial or experimental that we possibly can. What's more, silent films are only part of the picture. As Martin Scorsese's Film Foundation notes, half of all American films from before 1950 are gone forever. That means that viewers of a certain age have seen films that no longer exist—because of nitrate decay, or vault fires, or poor storage, or simple neglect. And most of those films, of course, were black and white.

What has vanished? Black and white offers a seductive world of fabrics and flesh tones rendered in sinuous images of shaded power, a world in which everything exists in gradations of black, gray, and white, constituting an entirely different way of looking at the movies. Watching a black-and-white film, we are lured into a world of romance, treachery, deceit, and fantasy, encompassing the work of literally hundreds of thousands of artists and technicians throughout the world.

Just as 35 mm prints are now being routinely junked by studios that don't want them around as an alternative to Digital Cinema Packages, so black-and-white films are now preserved only in archives and museums. When one considers that the world of black and white was once the *only* world of the cinema, it's astounding that it has been so thoroughly abandoned, an art form as ancient as stone lithography. Although I necessarily focus on films that have survived, what follows in this text is a history of an era not merely gone, but almost entirely lost and impossible to recapture.

1

Origins

● ●

In their first incarnation, the movies were magic. The public had no idea how they worked, and as with any magic show, audiences were happier to be kept in the dark rather than learning the secrets of their construction. The first viewers of the Lumière films, for example, were amazed by the sight of a train rushing toward them (*L'Arrivée d'un train en gare de La Ciotat*, 1895), a sight they had hitherto seen only in real life, which now appeared as a phantasmal image on the cinema screen. A gardener being watered with his own hose as a prank (*L'Arroseur arrosé*, 1895), workers leaving the Lumière factory (*La Sortie d'Usines Lumière*, 1895), a snow-ball fight against a backdrop of Utrillo trees (*Bataille de boules de neige*, 1896)—it was all too new, and for the first time removed from actual existence. The audience had no opportunity to interact with the images they viewed; they remained spectators only, spellbound in the dark. Painting and photography had brought viewers the illusion of pictorial verisimilitude, but without movement. Now, the pictures on the screen danced and shimmered, pulsating with artificial existence, somehow taking the audience out of their own corporeal reality and transporting them into a phantom zone of a "realistic" presentation of events taken from life. And thus was the spell of the movies born.

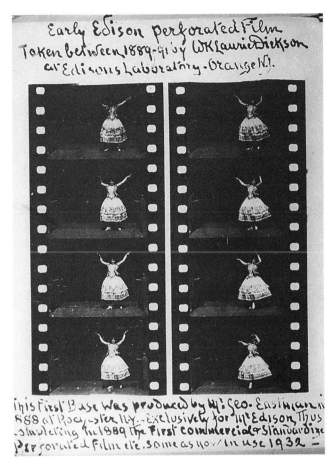

An early Edison filmstrip, photographed by William Kennedy
Laurie Dickson

When the ultra-realist painter Paul Delaroche saw one of the first Daguerreotypes in 1839, he famously exclaimed, "From today, painting is dead," but of course that wasn't, and isn't, the case. The impressionists, the surrealists, and others who saw reality and interpreted rather than recorded it, even in idealized fashion, immediately and intuitively sensed the limitations of the photographic image; they sought to move beyond it, to destroy it, to transform it into something else.

In contrast, the first films remained slavishly representative of their subjects; even the fantasy films of Georges Méliès, for example, sought to replicate the real within the realm of fantasy. So as Nancy Mowll Mathews notes, one can see in the American Mutoscope films of life in

early New York, such as *Madison Square, New York* (1903) or *Panorama of the Flatiron Building* (1902), traces of the work of the realist painter Joseph Oppenheimer, as reflected in his canvas *Madison Square* (1900), clearly a source of inspiration and pictorial guidance for early filmmakers ("City in Motion" 119).

Cinema pioneer William Kennedy Laurie (aka W.K.L.) Dickson, who began his career working for Thomas Edison and was one of the many inventors of the motion picture camera, eventually split off from Edison to join the American Mutoscope Company. American Mutoscope's *Delivering Newspapers* (1899) bears a striking resemblance to George Bellows's charcoal drawing *Election Night, Times Square* (completed between 1906 and 1909), with its monochromatic rush of action and streaks of bustling humanity; and Mutoscope's *At the Foot of the Flatiron* (1903) is closely related to Everett Shinn's pastel and watercolor drawing *Sixth Avenue Shoppers* (Mathews, "City in Motion" 120, 121). An even more direct example of pictorial representationalism can be found in American Mutoscope's *Spirit of '76* (1905), which duplicates almost exactly the composition, framing, and lighting of Archibald Willard's painting of the same name from 1891, attempting not only to capitalize on the fame of the painting, but also to "bring it to life" (Mathews, "Art and Film" 154).

And, of course, soon films themselves were examining the exhibition process itself, as with Edwin S. Porter's famous short film *Uncle Josh at the Moving Picture Show* (1902), which he both photographed and directed. A country rube tries vainly to interact with the "performers" on the screen; unable to separate illusion from reality, he ducks when a train approaches and later tries to intervene when a young woman's virtue is threatened, only to discover that all he has managed to do is tear down the theater screen, exposing the projectionist and the cinematographic apparatus behind it—apparently, an early case of motion picture rear projection. As Antonia Lant notes of John Sloan's depiction of early cinemagoers in his painting *Movies, Five Cents* (1907), "Film gatherings . . . combined new, peculiar, and contradictory elements. Key among these were assembling in the darkness, sexual and class mixing, mesmerization through lit motion, and a palpable sense of privacy within the mass. . . . As has often been remarked subsequently, film going offered spectators the apparently incompatible combination of public display and private reverie" (162). And indeed, this was clearly the case. One could not only get lost in the crowd, one could also get "lost" in the images, which is one

of the primary aims of the spectatorial experience in nearly every case; to take the viewer out of her- or himself, to remove corporeal consciousness and replace it with an identification with an illusory other, whether that image is moving or static, projected on a screen or displayed on an iPad, representational or abstract. Whether or not the pictorial artist or filmmaker intends it—and often, more didactic artists in either discipline will claim this is manifestly *not* their intent—every imagistic construction *implies* a viewer, just as it implies, or acknowledges, the existence, past or present, of its creator.

In such films as Georges Méliès's *A Trip to the Moon* (1902, d.p. Lucien Tainguy), special effects exploded off the screen in waves of wonder: fantastic rocket ships, rabid moon devils, constellations that became alive with chorus girls, a moon that took a direct hit in the face when the spaceship landed, a suspenseful confrontation with the hostile aliens, and a miraculous escape. In Segundo de Chomón and Ferdinand Zecca's *The Red Spectre* (1907, d.p. unknown), hand-tinted in lurid shades of red, a demon appears in a cavern and creates one illusion after another, entirely without narrative, in a naked attempt to dazzle the audience into silence and submission during its brief nine-minute running time.

Alice Guy, the marginalized foremother of the cinema, began her career by directing and photographing the charming fantasy *La Fée aux choux* (1896), and then went on to direct no fewer than 409 films in Europe and then America, including *L'Utilité des rayons X* (1898), a very early example of fantasy/science fiction; the thirty-three-minute religious spectacle *La Vie du Christ* (1906, d.p. Anatole Thiberville), which featured extensive use of special effects, a large cast, and lavish sets; and a 1913 adaptation of Edgar Allan Poe's *The Pit and the Pendulum*, which terrified audiences with its Gothic brutality. As Gwendolyn Audrey Foster notes,

> Like many other silent filmmakers of the era, Guy readily mixes staged studio settings with natural location shooting, a practice which continues to the present day. However, the extreme stylization of Guy's vision in *La vie du Christ* effectively creates an alternative universe, in which the protagonists of the film seem enshrined by each of the carefully framed compositions. Indeed, Guy's film is almost a moving painting, in which the prescient naturalism of the performers seems at times strikingly removed from the constructed settings which dominate most of the production. ("Performativity and Gender" 8)

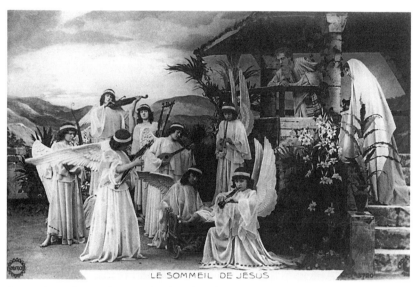

A scene from Alice Guy's *La Vie du Christ* (1906), photographed by Anatole Thiberville

As to Guy's compositional technique, Foster remarks:

> Although the camera moves little and adheres to the style of proscenium
> arch directing (popularized in the early twentieth century), the development
> of multiplaned spaces populated by hundreds of onlookers and participants
> is impressive. The sets highlight the use of forced perspectives, reminiscent
> of illuminated Medieval manuscripts. Actions often take place at the borders
> of the frame to further the sense of extradiegetic space. The shot composi-
> tions are often unusually complex and involve staged designs that center
> around columns, arches, and multiple-level platforms with extraordinarily
> complex designs. ("Performativity and Gender" 11)

These, of course, are but a few examples—audiences had also seen
Edwin S. Porter's and George S. Fleming's thrilling "true life" adventure
Life of an American Fireman (1903, d.p. Porter) and *The Great Train Rob-
bery* (1903, d.p. Porter and Blair Smith), both filled with violent action,
films that through their pervasive influence almost singlehandedly cre-
ated a series of genre conventions: the mother and her child saved from
the flames in *Fireman*; the train robbers tracked to doom by an unrelent-
ing posse for their crimes. It was all there on the screen—murders, dar-
ing escapes, phantasmagoric transformations, magic, suspense, spectacle,

everything to take the viewer out of themselves and transport them into another world.

Black-and-white cinema was especially seductive. It reveled in its artificiality and artifice, even if the primary considerations for most black-and-white films were economic rather than artistic. But as that changed, many filmmakers resisted color, just as Charles Chaplin and Yasujirô Ozu initially resisted sound—black-and-white films had a special magic that the specific insistence of color films could never replicate. As Mark Winokur and Bruce Holsinger note,

> In the 1930s and 1940s cost was not the only factor determining which film stock a film project would employ. Hollywood Technicolor tended to be used to make everything pretty, so that the most serious dramas often tended to be black and white: *Citizen Kane* (1941), *The Little Foxes* (1941), the entire genre of film noir, and so on. . . . Black and white is never just that: It is also all the gradations of gray in between. And silver. And beiges. . . . White has, if anything, even more variations, and gray is practically infinite. Black and white is the color of glamour cinematography. The most glamorous icons of the screen, those actors who only require last names— Garbo, Bogart, Bacall, Gable, Dietrich—are most famously photographed in black and white. ("Movies and Film: The Aesthetics of Black and White and Color")

Thus, almost from its inception, the cinema has been torn between the supposedly direct representationalism of color and the transformative power of black and white, switching back and forth as mood and/or circumstance dictated, creating a world of continual contestation. Alice Guy's hand-colored films, for example, are an attempt not only to break the boundaries of black and white, but also to create an entirely new, hybrid medium—the image in constant pictorial flux. And while the world that these films inhabit is a result of many factors, in the final result it is the director of cinematography who translates this world into images on the screen. Too often, however, their contributions go unnoticed, sometimes out of ignorance, and sometimes—as we'll see—because the director may claim all the credit, as if no other artists were responsible for a film's visual presentation. Though few claimed to be or were acknowledged as such, the cinematographers discussed in this volume were all artists, instinctively knowing where light should come from naturally,

how it should fall on an actor's face, how to light for comedy, tragedy, or romance.

These cameramen—and they were all men, in a male-dominated profession that openly discriminated against women, relegating them to the editing room or script supervision positions—created the fundamental grammar of the cinema. (It was not until the 1960s that women, such as Brianne Murphy, would start moving behind the camera within the film industry, but that was during the beginning of the all-color era. In the classical black-and-white period of motion picture history, it's a sad fact that cinematography was a profession completely dominated by men.)

As Daniel Bruns astutely notes, the world of black-and-white cinematography has its own special rules:

> For the best results when lighting for black and white . . . [one should] create dramatic shadows and highlights while still keeping a full range of midtones. This is often best achieved with a strong backlight and keylight. That's because without color to lead viewers' eyes in the shot, the only areas that a viewer's eyes are going to be drawn to will be areas of sharp contrast. . . . The grays are especially important for capturing the proper tone in skin and the gradual depth of objects in your scene. That's why overcast days are some of the best times to shoot landscapes in black and white. . . . The real trick is to make sure that the image not only includes a healthy gray level, but pure blacks and pure whites as well. Otherwise, your image will simply look washed out. ("Shooting in Black and White")

But these are just general rules; the image in black and white is always waiting to be "discovered," as it does not exist in real life. As Günther Rittau, one of the cinematographers on Fritz Lang's two-part epic *Die Nibelungen* (1924), noted,

> All who are engaged in this task are apprentices of the new "camera-art"— for there is no master. We appeal to the eye by a transient sequence of optical impressions, as the musician appeals to the ear by an acoustic sequence of sounds. The lens is our etching needle. We turn backwards and sweep along the avenues of time; we observe humanity in all its moods—and discover a new physiognomy. We turn slowly, and the flowers bloom. We turn quickly, and there is revealed to us the secret of the bird's flight. We let the camera swing through space, and observe its dynamics. We create giants and dwarfs,

legendary forests, dragons, and knights errant. We lead man over the whole earth and point out to him the grandeur of Nature; and we conduct him through the secret, tiny places of the microscope. ("Camera Art")

Or as cinematographer Philip Rosen, later a director, wrote in 1922,

A scene may be photographed in such a manner that it has little or no effect on the audience. On the other hand, the same scene, properly filmed, may conjure in the audience practically any mood that the director wishes to effect. . . . To the director, as well as the cinematographer, photography should be what the artist's colors and materials are to him. . . . Every sequence should have its own writing, that is, every sequence should be designed photographically, according to the impression which is designed to be conveyed. The simplest examples of designing for effect are the uses of light for "happiness" and shade for "sorrow." (qtd. in Keating 24–25)

Throughout the industry, pioneering cinematographers were figuring out new ways to push the possibilities of the medium, using "cookies" to cast shadow patterns on the sets and the actors, neutral density filters to create a day-for-night effect, and exploring various new film stocks and post-production techniques to make the images suit the subject matter of each individual film. And as the profession began to become regularized, a group of cameramen founded the American Society of Cinematographers (ASC) on January 8, 1919, among them Philip Rosen, Homer Scott, William C. Foster, L. D. Clawson, Charles Rosher, Victor Milner, Joseph August, Arthur Edeson, Fred LeRoy Granville, Devereaux Jennings, Robert S. Newhard, and L. Guy Wilky (Birchard).

Rosen would soon advance to the director's chair, working for the most part on program pictures. In fact, he was more prolific as a director than as a cinematographer, with only thirty features to his credit as a director of photography (DP) and some 140 films as a director, starting with *The Beachcomber* in 1915 (d.p. Gus Peterson) and ending with a series of atmospheric thrillers such as *The Mystery of Marie Roget* (1942, d.p. Elwood Bredell) and *The Secret of St. Ives* (1949, d.p. Henry Freulich), along with several films in the long-running Charlie Chan series in between. Rosen was an early example of a cinematographer who knew how to efficiently and effectively "cover" a scene with speed and precision and yet deliver either moody, densely shadowed work on his thrillers or

more brilliant, sharp images in his comedy work. Rosen also helped to form the Director's Guild in 1936, and could consistently be relied upon as a person who was sensitive to both the artistic and commercial requirements of the medium (Birchard).

Other forming members of the ASC were less well known. Homer Scott shot his first feature film, John Francis Dillon's *The Key to Yesterday*, in 1914, and followed with a 1916 version of *Davy Crockett* starring Dustin Farnum, a famous western star of the period. He was the director of cinematography on numerous Mack Sennett feature comedies from 1921 to 1923, including F. Richard Jones's *The Extra Girl* (1923), *Suzanna* (1923), and *Molly O'* (1921), all starring Mabel Normand, and served as the president of the ASC from 1925 to 1926. After that, his career was more sporadic; he moved to Warner Bros. to serve as second cameraman on William A. Seiter's *Little Church Around the Corner* (1923), and rumors persist that he began work on Ernst Lubitsch's *The Marriage Circle* (1924) before being replaced by Charles Van Enger and Henry Sharp, but other than that, little is certain (Birchard). He died in 1956, a forgotten figure in the industry, but a master of black-and-white comedy lighting, whose thirty-five feature films are a testament to his resilience and speed on the set.

The aforementioned Van Enger, whose career stretched all the way from Clarence Brown and Maurice Tourneur's *The Great Redeemer* (1920) to the television series *Lassie* in 1962 and *My Mother the Car* in 1966, was yet another cinematographic pioneer, with more than 170 credits to his name. His work also included Ernst Lubitsch's 1925 version of *Lady Windermere's Fan*, several entries in Universal's Sherlock Holmes series, and Charles T. Barton's *Abbott and Costello Meet Frankenstein* (1948). One of his signature films, however, was Rupert Julian's 1925 version of *Phantom of the Opera*. Julian, not a director of any great distinction, relied heavily on Van Enger to get the film completed, as the latter would tell historian Richard Koszarski: "The director would tell me . . . 'I don't like the lighting.' And I said, 'Well, that's the lighting you are going to get, brother.' . . . [Photographically, Julian] would tell me what he wanted—if he wanted a long shot I would line up the long shot, and that was it. If he wanted a close-up—I listened to him and gave him what he wanted, but I gave it to him the way that I wanted" (281–283).

Interestingly, in addition to the film's deeply saturated black-and-white images, there is also the use of two-strip Technicolor, the first color

process created by the company, during the masked ball sequence, in which the Phantom appears as the figure of Death. At least one critic has described this as creating a "melodramatic and strident" effect (Johnson 14), but given that one of the major tenets of commercial motion picture production, especially in Hollywood, is that of sensation, the sequence is perfectly designed and executed within the context of the overall film; it also gestures toward the future of the cinema and the introduction of three-strip Technicolor in feature films on a full-scale basis in Rouben Mamoulian's *Becky Sharp* (1935).

William C. Foster and L. D. Clawson both worked as cinematographers for Lois Weber, who in the early 1900s was one of the most prolific and highly paid directors in the business, shooting an amazing twenty-seven films in 1914 alone. By 1916, Weber was Universal's foremost director, but she made the mistake of leaving the company in 1917 to form her own thinly capitalized production outfit, Lois Weber Productions, and by the late 1920s she was bankrupt and out of the industry. During her career, however, Foster and Clawson ably created the naturalism she sought in the photography of her films, using available light and imbuing her players with a realistic aura that perfectly suited her grim social realist vision (Birchard).

Another key film of the silent era, King Vidor's *The Crowd* (1928), is one of the most technically sophisticated films of the period, and comes directly out of Vidor's experience on his war film *The Big Parade* (1925), which he wanted to replicate in a peacetime setting. As Gregory W. Bush recounts,

> Vidor wondered about other "interesting environments which are dramatic for the average man." He then hit upon the idea of creating a film that transferred wartime into peacetime encounters, adding that "objectively life is like a battle. . . ." *The Crowd* was one of the most technically advanced and thematically bold American films of the decade. Ultimately, Vidor's image of man in mass society, while realistic in contrast to most of the films of the 1920s, manifests a narrowly drawn and cynical psychological portrait derivative of earlier crowd associations. (227)

As photographed by Henry Sharp (who also shot such disparate films as Leo McCarey's *Duck Soup* [1933] and Fritz Lang's *Ministry of Fear* [1944]), *The Crowd* is perhaps one of the most visually "plastic" films ever

made, using, as with Abel Gance's *Napoleon* (1927), nearly every visual device in the cameraman's arsenal to depict the life of an ordinary man and woman as they cope with the depersonalization and forced anonymity of everyday life.

Today, we work in cubicles; in *The Crowd*, the workplace is a series of hundreds of desks in one huge room, where John Sims (James Murray) toils in obscurity, just another cog in the machine. With its drab naturalism and purposefully dehumanizing frame compositions—a famous overhead crane shot of a sea of desks, for example, would much later be referenced in Billy Wilder's equally bleak view of corporate life in *The Apartment* (1960), photographed in drab black and white by the gifted Joseph LaShelle—the concluding sequence of *The Crowd*, in which the camera pulls relentlessly back and up from the protagonists in the midst of a laughing theater audience until they are lost in a sea of humanity, is one of the most compelling and ultimately terrifying images of metropolitan isolation ever filmed—a credit to both Vidor's vision as director and Sharp's skill as cinematographer.

Charles Rosher had an extremely long and distinguished career beginning as a still photographer, shooting "actualities" in the style of the Lumière Brothers on a trip to the United States to exhibit his photographs at the Eastman School of Photography. Accustomed to working with natural lighting, the preferred method of illumination for most early films, Rosher went west with producer/director David Horsley in 1911, in large part to take advantage of the sunny California climate, which offered more shooting days of vibrant sunshine than one could find on the East Coast. Starting with Tom Ricketts's short film *The Indian Raiders* in 1912, Rosher was soon shooting feature films at a torrid pace, such as 1917's *A Mormon Maid*, starring rising star Mae Murray and future director Frank Borzage; the film itself was being helmed by another Hollywood veteran, whose career would stretch from 1913 to 1957, Robert Z. Leonard. But Rosher's greatest initial success came as the DP on a series of Mary Pickford vehicles, which he lit with such star quality, particularly in Pickford's close-ups, that she used him on all her subsequent films from *How Could You, Jean?* (1918), directed by William Desmond Taylor, through *My Best Girl* (1927), directed by Sam Taylor.

Accustomed to the freedom of movement that silent camerawork allowed, however, Rosher was unwilling to follow Pickford into sound films beginning with Taylor's *Coquette* (1929). Pickford insisted on using

a locked-down camera in what were known as "iceboxes" or "phone booths"—soundproof booths that muffled the sound of the camera's whirring motor. This system of photography, employed on numerous feature films in the early days of sound-on-disc shooting, essentially immobilized the camera and transformed it into a mere recording device, something that Rosher could not countenance. In fact, Rosher's long association with Pickford was due in no small measure to his care in lighting Pickford within the shot, essentially employing one strategy for photographing each scene as a whole and yet another for lighting Pickford within it. As Katherine Lipke reported, "This created a depth not accomplished in any other picture. . . . His method of lighting her . . . makes her personality fairly radiate beauty" (*Los Angeles Times*, January 21, 1925).

Rosher was nevertheless well positioned to move on from Pickford's production company due to his Oscar-winning work on F. W. Murnau's *Sunrise* (1927), an award he shared with Karl Struss, who shot the film with him. Rosher soon found employment at Metro-Goldwyn Mayer on such projects as Nick Grinde's *This Modern Age* (1931), a Joan Crawford vehicle in which his long partnership with Pickford proved exceptionally useful in building up the luminescence of Crawford's early stardom as a romantic ingénue. He then moved on to the acerbic showbiz drama *What Price Hollywood?* (1932), directed by George Cukor, an early forerunner to *A Star Is Born* (with William Wellman's version in 1937 and George Cukor's knowing remake in 1954), before being loaned out to Selznick International for John Cromwell's *Little Lord Fauntleroy* in 1936. In all these films, Rosher's style is wedded to the material being presented; *What Price Hollywood?* is shot in very hard-edged style, with brilliant, deeply saturated blacks and whites that MGM would soon forsake for their figurative "museum style" lighting—bright, evenly lit, with most of the illumination coming from the lighting grid above the set, and very few "practical" sources (lights actually on the set and in the frame).

Rosher's career continued apace, with an additional Academy Award for Clarence Brown's *The Yearling* (1947), which he shared with fellow DPs Leonard Smith and Arthur E. Arling, who worked with him on the film, though *The Yearling* was shot in color, and additional Oscar nominations for Gregory La Cava's *The Affairs of Cellini* (1934), William Dieterle's *Kismet* (1944), George Sidney and Busby Berkeley's *Annie Get Your Gun* (1950), and George Sidney's elaborate remake of the musical *Showboat* (1951). Rosher retired after his work on the similarly glossy *Jupiter's*

Darling (1955), directed by George Sidney; he had long ago eschewed his earlier, more direct approach for the Technicolor glossiness of the studio, though it seems significant that his Oscar for *The Yearling* was an exception to his later style.

Shot on location for the most part in Hawthorne, Florida, with additional photography in Ocala, Florida, Big Bear Lake, and Lake Arrowhead in the San Bernardino National Forest in California, as well as some studio material, *The Yearling*'s muted, naturalistic color style harkened back to the more subtle gradations of the black-and-white era. It was certainly not the usual candy-colored, slick style that Technicolor endorsed. Technicolor owned all the equipment necessary to produce their films, including the cameras, and when a studio made a Technicolor film, the head cameraman was part of the package, as was Natalie Kalmus, the omnipresent "Technicolor consultant." Her job was to insist that the colors in every composition pop off the screen, creating an unnatural, hyperglossy look well suited, perhaps, for fantasies such as Victor Fleming's *The Wizard of Oz* (1939) but out of place in a film with a much more intimate, real-life setting.

Victor Milner was one of the most intriguing stylists of the black-and-white era, a pioneer whose career stretches back to the 1913 featurette *Hiawatha*—for which no directorial credit is known to exist—through John Sturges's suspense thriller *Jeopardy* (1953). Just a few of his 139 credits as cinematographer demonstrate that he was able to switch from one visual approach to another with speed and facility. One of his most exquisite films, and one of the supreme romantic comedies of all time, is Ernst Lubitsch's *Trouble in Paradise* (1932), photographed in a dreamily romantic style with rich soft focus. Milner was decidedly outspoken regarding what he termed the "abuse" of tracking shots, which often disrupted lighting strategies that had been carefully worked out well in advance, but he praised Lubitsch for his thoughtful use of dolly shots in his films:

> Lubitsch, for example, regards camera movement as something to be used as precisely as punctuation. When he moves the camera, he invariably does it at a time when it is necessary to bring the audience closer to some important bit of business—some word, act, or expression which high-lights a whole scene or sequence. And he makes sure that the technique of the shot is so flawless that the movement is virtually imperceptible to the audience— natural, inevitable, and wholly subservient to the story-action. (Hall 47)

This, of course, was further problematized by the unwieldy nature of early sound cameras, which, although they had improved greatly since their "phone booth" introduction in the late 1920s, still posed a real handicap for lighting and designing a scene. As Milner wrote in a 1932 article, "Riddle Me This," the "weight and bulk [of the 'blimped' camera then in use] definitely slow down the production of pictures: one cannot move quickly from one set-up to another, nor can one take full advantage of many of the possibilities of the cinema, for these huge, bulky blimps are not easily adapted to the making of many effective angle and moving shots. In this connection, it is really amazing how well we have managed under this handicap" (12).

For director Preston Sturges, Milner photographed the sardonic and cynical comedies *The Lady Eve* (1941) and *The Palm Beach Story* (1942) in an appropriately clean style, with sharply defined blacks and whites and relatively even illumination. He also worked for Robert Florey on the romantic drama *Till We Meet Again* (1936), bringing a brooding, moody approach to the melodramatic material. But then Milner would turn right around and create a world of menacing shadows for a series of noirs, such as Lewis Milestone's *The Strange Love of Martha Ivers* (1946) and William Dieterle's *Dark City* (1950). Though he was nominated for an Academy Award for Best Cinematography nine times, he won only once, for Cecil B. DeMille's historical spectacle *Cleopatra* (1934), ironically a film on which DeMille executed total control on every aspect of the production, giving little latitude to his DP for any creative input. Milner, in fact, shot several features for DeMille, including *The Crusades* (1935) and the absolutely pedestrian *North West Mounted Police* (1940), demonstrating his almost chameleon-like ability to create a variety of lighting strategies to fit the mood and atmosphere of almost any film.

Joseph August, an equally adept professional who packed 155 credits into his tragically short career—he died of a heart attack on the set of William Dieterle's phantasmal black-and-white romance *Portrait of Jennie* in 1948 at the age of just fifty-seven—began his career working with another pioneer, Ray C. Smallwood, a director and cinematographer who would ultimately find his true calling as a photographic effects technician, specializing in background transparencies used in rear projection for studio work. As August recalled, Smallwood was a stern taskmaster who significantly refused to use a light meter when working on the set, preferring to let his eyes alone guide him in deciding what exposure

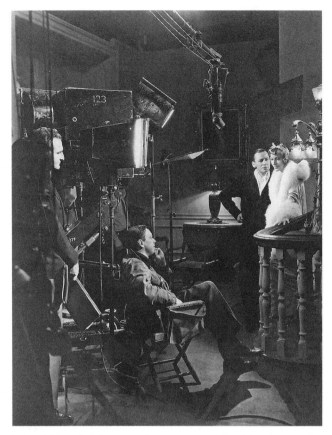

Victor Milner, far left, next to the camera, on Robert Florey's romantic drama *Till We Meet Again* (1936)

aperture to use for each scene. As August told an interviewer toward the end of his life, "There was a device . . . known as an illumination system . . . designed to obtain for the cameraman something parallel to what a [light] meter would do today. I was told with considerable detail and even more emphasis just what fate would befall me if he ever found me fussing with one of those gadgets" (Birchard).

August's early work was very rough-and-tumble filmmaking, shot with available lighting under deeply primitive circumstances. In short, August learned on the job, creating his own style as he progressed through the ranks in such films as Howard Hawks's classic screwball comedy *Twentieth Century* (1934). And yet, as he told Birchard, "Many things have changed during the rise and development of the picture-making

industry, but the basis of lighting seems to be about the same as it was in the beginning."

In 1947, in the midst of photographing *Portrait of Jennie*, August took time out to reminisce about his early days in the industry and, as always, he presented his approach to cinematography as practical and workmanlike.

Today I have the title of Director of Cinematography and a camera crew of four assistants. In the old days, I used to crank the camera myself. I can remember shooting William S. Hart in action on a horse by riding alongside him on another horse with my camera propped up in my lap. For one silent picture, I was perched high up on the edge of a ship's mast grinding away at the camera and rocking it for the right effect. A tug boat was shooting water up at me for a storm scene and I almost fell off when a stream of water caught me unawares. My assistant grabbed me just in time. I always had a man standing by to cover me during the early pictures I shot since I had to keep my eyes glued to the camera no matter what was going on around me. (Goodman X3)

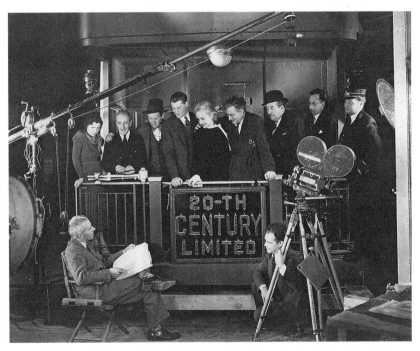

Howard Hawks and the cast of *Twentieth Century* (1934) in a posed publicity shot, with cinematographer Joseph August kneeling next to the camera

Arthur Edeson was a similarly versatile cameraman, and he too started as a still photographer before breaking into the movie business at the Eclair Studios in Fort Lee, New Jersey, in 1911. He spent his spare time shooting portraits of the other actors in the Eclair troupe, which brought Edeson to the attention of cinematographer John Van den Broeck, and when one of the regular Eclair DPs fell ill, Van den Broeck tapped Edeson as a last-minute replacement. This posed a distinct challenge for Edeson, who had developed a more painterly nuanced style in his still portrait work, and was reluctant to abandon it in favor of the utilitarian lighting techniques widely employed in the industry at the time. Not surprisingly, Edeson's more sophisticated approach brought forth considerable resistance. As he noted,

> In those times, flat lighting was the rule of the day. However, I began to introduce some of the lighting ideas I had learned in my portrait work—a suggestion of modeling here, an artistically placed shadow there—and soon my efforts tended to show a softer, portrait-like quality on the motion-picture screen. This was so completely out of line with what was considered good cinematography in those days that I had to use my best salesmanship to convince everyone it was good camerawork. (Birchard)

Yet Edeson's work was not solely defined by this "portraiture" style. The more romantic approach was well suited to Henry King's maternal melodrama *Stella Dallas* (1925), but Edeson quickly demonstrated that he was also capable of darker, more deeply shadowed and menacing lighting in such films as Roland West's suspense mystery *The Bat* (1926). Edeson easily adapted to the exigencies of early sound exterior shooting for Irving Cummings's spare, sun-drenched western *In Old Arizona* (1928), and then shot Lewis Milestone's darkly ambitious antiwar film *All Quiet on the Western Front* (1930, co-photographed with Karl Freund) in an almost documentary style, re-creating the horror of combat conditions in World War I with unflinching realism. For the latter film Edeson used a partially soundproofed camera that he himself designed. As he recalled in a 1968 interview,

> I had taken [my 35 mm] camera over to Gus, the mechanic at Mitchell's, and he put a micarta gear in the rear of the camera. He took some of the metal parts out and that made the camera 50 percent quieter than other

cameras. And I also had a big padded bag we called a 'barney' that I put over the camera to quiet it down more. . . . You couldn't have made a picture like *All Quiet on the Western Front* using those sound houses [photographic "booths" that encased both the camera and the operator, making them soundproof]. . . . You couldn't get good photography. You couldn't light. Now [*All Quiet*] was at least 50 percent exterior war stuff so my camera could easily handle it. We also shot the battle stuff silent. . . . Sometimes on the interior scenes when the camera moved in close I placed a big piece of plate glass between it and the actors so there were no big problems with camera noise. (Mitchell 38)

The film also allowed Edeson to show off his stylistic versatility. As George J. Mitchell astutely notes, Edeson treated

the passage of day-to-night and [back-to-day] with a subtle but realistic lighting style. At night, flashes of gunfire light up the shell hole. In the morning Edeson's camera catches [a] dead Frenchman's face in an unforgettable close-up. His dead eyes are open and stare into nothing. A whiff of smoke from the battlefield drifts into the frame. . . . Paul and Albert [William Bakewell] are both wounded and taken to a hospital behind the lines staffed by Catholic nuns. Edeson uses a higher lighting key for these scenes. Albert's shattered leg is amputated, unknown to him. When he comes out of the anesthetic, he complains of pain in his toes and suddenly remembers the complaint was the same he had heard made by another comrade in the same situation. Edeson's camera adroitly captures the pathetic moment when Albert tilts a small hand mirror in such a way that he sees with horror his leg is gone.

 For Paul's convalescent homecoming, Edeson has lit the scene in a high key. Bright sunlight streams through the front door as Paul enters his parents' home. His sister runs to embrace him. 'Paul's home,' she tells the mother, who is bedridden. As Paul realizes that he can no longer fit into life on the home front, the mood of the lighting becomes more subdued. (Mitchell 41)

Jumping from studio to studio, Edeson was always in demand, and his most influential work was still to come, notably James Whale's *Franken-stein* (1931) at Universal. The film is significant for its German Expressionistic stylings, but here Edeson also embraced the artistic tenets of

tenebrism, which uses extremely deep shadows throughout the frame and offers sharp contrast between illuminated areas and the darkness surrounding them. The style is often employed in conjunction with a chiaroscuro approach to lighting, composition, and framing, which keeps much of the image area immersed in darkness and typically employs a single source of light to illuminate the scene—two techniques that would become immensely popular in the era of film noir in the 1940s. Edeson continued at Universal with Whale's *The Invisible Man* (1933), a special effects tour-de-force, with superb matte work by the gifted John P. Fulton, but he seemed equally at home at Warner Bros. shooting Lloyd Bacon's aerial war drama *Devil Dogs of the Air* (1935), which once again marked a decided shift in his approach, offering stripped-down images devoid of any trace of romanticism.

Edeson reached a new career peak with his noirish work on John Huston's first feature film *The Maltese Falcon* (1941) and then Michael Curtiz's iconic wartime romance *Casablanca* (1942). For *Casablanca*, perhaps Curtiz's supreme accomplishment as a director, Edeson created a world of parched, sunlit exteriors (many actually shot in the studio), coupled with polished, glittering interior lighting in the set for Rick's cafe and deep shadows for Rick and Ilsa's nighttime romantic interludes, all of which create a fully-rounded fantasy world of romance, intrigue, and adventure that remains a classic to this day. As George Turner writes of Edeson's work in the film,

> He had a knack for making his players look bigger or smaller than life. In the films *Frankenstein*, *The Invisible Man* and *The Maltese Falcon*, his camera peers up at Boris Karloff, Claude Rains and Sydney Greenstreet, respectively, to enhance their size. In *Casablanca*, Peter Lorre gets the opposite treatment as he wriggles through a crowd like a worm crawling out of an apple. Edeson also made Humphrey Bogart (who wasn't tall) seem bigger than Ingrid Bergman (who was) and just as tall as his rival, [Paul] Henreid. With deft lighting and the careful use of camera angles, he added menace to [Conrad] Veidt's sculptured features, and helped Claude Rains sustain his characterization of a dapper, skirt-chasing little rogue. ("*Casablanca*" 112)

Looking over Edeson's legacy, it's hard to reconcile his work on *Frankenstein* just ten years earlier with his cinematography on *Casablanca*, so different are their approaches to the material; it's also astounding to note

that at the height of his career, Edeson would agree to shoot a "big band" one-reel short, Jean Negulesco's *Glen Gray and the Casa Loma Orchestra* (1942), a project that took exactly one day to complete.

In addition to all these accomplishments, Edeson was a pioneer in the use of 70 mm film and widescreen cinematography, comparable to the effect that one achieves through the use of an anamorphic lens and conventional 35 mm film in the CinemaScope widescreen process. Shooting Raoul Walsh's epic western *The Big Trail* in 1930, starring a very young and raw John Wayne, Edeson actually photographed two versions; one in conventional 35 mm, and another in 70 mm widescreen, dubbed "Grandeur photography," to obtain a wall-to-wall effect that was employed in only a few other films of the era. Edeson wrote about his work on the film in detail from both an artistic and a technical viewpoint:

> The chief requirements for lenses for wide-film cinematography are, first and foremost, extremely wide covering power; and secondly (and of quite as great importance), extremely great depth of focus. Due to the more natural shape of the Grandeur frame, there is a certain pseudo-stereoscopic effect produced: but this effect is lost unless there is a very considerable depth of focus in the image. The 70 millimeter picture is very nearly the same proportion as the natural field of our vision, which, I suppose, is responsible for this pseudo-stereoscopy. But, clearly, to take full advantage of this, we must use lenses [that] will give us a degree of depth at least somewhat approximating that of our eyes. Therefore, it is vital that Grandeur lenses be selected with a view toward getting this effect, so that the crispest, deepest pictures may be had. . . .
>
> The director, however, must in a Grandeur picture pay considerably more attention to his background action than is usually the case, for, even in close-ups, the depth of focus demanded by Grandeur makes the background an important part of the picture. (Edeson, "Wide Film Cinematography" 8, 9, 21)

Clearly, Edeson was correct in his prediction that CinemaScopic formats, and other widescreen formats such as Panavision, would eventually become a major part of the cinema industry—he was just two decades too early. Twentieth Century–Fox finally introduced anamorphic CinemaScope (as they dubbed it) in 1953, using a process patented by the French inventor Henri Chrétien in 1926. "Grandeur" photography, as Edeson

calls it, used the width of the entire 70 mm frame for a widescreen image, rather than squeezing it onto a 35 mm negative as CinemaScope did; in fact, using 70 mm film for a widescreen image is technically far superior to Chrétien's process.

However, the use of 70 mm film during shooting also necessitated the use of 70 mm projection equipment in theaters, and in the depths of the Depression few exhibitors were willing to install the necessary equipment, in view of both the prohibitive cost and also the fact that only a few films were being made using the process. Thus, only the standard 35 mm version of *The Big Trail* received wide distribution; the 70 mm version was screened in only a few major cities, such as New York and Los Angeles, and ultimately failed at the box office. Not coincidentally, the penetrating gaze of Edeson's 70 mm camera also brought out relative neophyte John Wayne's inexperience in front of the camera; the actor would be forced to labor in B-westerns for the rest of the decade, until his old mentor, John Ford, rescued him from poverty row by offering him the lead in his soon-to-be classic *Stagecoach* (1939), photographed by yet another pioneer of the medium, Bert Glennon. Edeson rounded out his career with one of Negulesco's first feature films, the John Garfield noir *Nobody Lives Forever* (1946), and Arthur Pierson's swashbuckler adventure *The Fighting O'Flynn* (1948).

Thus, as cinematographers, only Rosher, Milner, August, and Edeson of the founding ASC members enjoyed careers that extended well into the sound era; the rest, Fred LeRoy Granville, Devereaux Jennings, Robert S. Newhard, and L. Guy Wilky, all enjoyed some measure of success, but nothing approaching the innovative distinction of their more accomplished peers. Granville left the United States to work in England in 1920 and never returned, dying there in 1932; working with cinematographer Bert Haines, Jennings created the naturalistic images for Buster Keaton and Clyde Bruckman's Civil War farce *The General* (1926) as well as Charles Reisner and Keaton's riverboat comedy *Steamboat Bill Jr.* (1928), but the success of both films is more dependent on Keaton's skill as a slapstick comedian than any pictorial aspects inherent in either project; Newhard's chief claim to fame is his work as the DP of Wallace Worsley's 1923 version of *The Hunchback of Notre Dame*, starring Lon Chaney Sr.; while Wilky was blacklisted by major studios for his efforts as a labor organizer for the International Photographers Union and thus relegated to second-unit work after 1928, ending his career as an assistant

at Columbia in the 1950s (Birchard). Not one can be considered a major stylist. But in their pioneering work with the ASC, as well as their collective impact on the discipline of cinematography in its formative years, all these technicians made a lasting contribution.

The degree of input these cinematographers had on the films they worked on varied widely. Buster Keaton, of course, was the consummate auteur, controlling every aspect of his classic silent films in the mid- to late 1920s with an almost fanatical degree of perfectionism. He tended to concentrate more on the often dangerous gags he performed (such as when a house collapses around him in *Steamboat Bill Jr.*, leaving only the space of a small window as an "escape hatch") than on lighting, which was generally even and bright during the exterior daylight sequences—most often using natural light and reflectors—and suitably subdued at night, whether indoors or outside. Yet if Keaton's approach to lighting his films could arguably be described as utilitarian, he knew exactly what to do in any given scene to obtain the designed effect. Describing a dream sequence in his film *Sherlock Jr.* (1924, d.p. Byron Houck and Elgin Lessley) to Christopher Bishop, in which Keaton seems to leave the audience in a movie theater to join the characters "on the screen," Keaton explained:

> We built what looked like a motion picture screen and actually built a stage into that frame but lit it in such a way that it looked like a motion picture being projected on a screen. But it was real actors and the lighting effect gave us the illusion, so I could go out of semi-darkness into that well-lit screen right from the front row of the theater right into the picture. Then when it came to the scene changing on me when I got up there, that was a case of timing and on every one of those things we would measure the distance to the fraction of an inch from the camera to where I was standing, also with a surveying outfit to get the exact height and angle so that there wouldn't be a fraction of an inch missing on me, and then we changed the setting to what we wanted it to be and I got back into that same spot and it overlapped the action to get the effect of the scene changing. (17, 18)

With such close supervision by Keaton, his DPs became more or less an extension of his vision, rather than being given more freedom as they might have with another director.

In Europe, cameramen were applying a different set of aesthetic principles to their work in the cinema. Yet many of these cinematographers adopted Hollywood's utilitarian methodology later in their careers, especially after they left Europe—as many did, particularly from Germany in the 1930s, to escape the Nazi onslaught—and began working in America. In this regard, the career of the distinguished German cinematographer Karl Freund is a particularly instructive case study.

Born in 1890 in what was then Bohemia in the Austro-Hungarian Empire, Freund broke into the business in Berlin in 1905, working as a projectionist. His first credit as a cinematographer was on Urban Gad's forty-minute Asta Nielsen vehicle *Gipsy Blood* (*Heißes Blut*, 1911), on which he worked with two assistants, Gad and Guido Seeber (the film is now considered lost). Freund then continued with a string of shorts and featurettes for Gad and later Robert Wiene, who would soon soar to fame with his 1920 horror classic *The Cabinet of Dr. Caligari*, which Freund did not photograph; the honors on that film went to DP Willy Hameister.

By 1920, Freund had graduated from smaller projects to big-budget feature films, such as Reinhold Schünzel's *Catherine the Great* (1920) and Carl Boese and Paul Wegener's *The Golem* (1920), in which Wegener also starred as a mythical creature, sculpted from clay, who is brought to life by a rabbi in sixteenth-century Prague to protect the Jews of the city from religious persecution. By 1924 he was working with the great Danish director Carl Theodor Dreyer on *Michael*, in which Freund also appeared as an actor in the role of an art gallery owner, and with F. W. Murnau on the tragic drama—until the intentionally preposterous happy ending—*The Last Laugh* (1924), becoming in the process one of the most influential cinematographers of the silent German cinema.

But his magnum opus was yet to come: Fritz Lang's epic *Metropolis* (1927), a science-fiction film so spectacular and grandiose in its execution that it became a worldwide sensation upon its initial release. Through the subsequent decades it has informed nearly every dystopian science-fiction film, from Ridley Scott's *Blade Runner* (1982) to Marco Brambilla's *Demolition Man* (1993) and, more recently, Alfonso Cuarón's *Children of Men* (2006) and *The Hunger Games* franchise, along with countless other projects. With its overarching narrative of a society in which the privileged few lead lives of luxury while the masses toil in the depths below to support the wealthy's lavish lifestyle, *Metropolis* foretold the coming

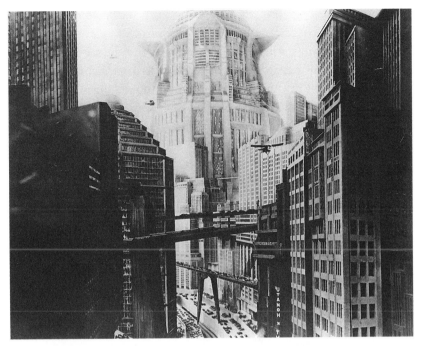

A futuristic cityscape from Fritz Lang's 1927 film *Metropolis*, photographed by Karl Freund, Günther Rittau, and Walter Ruttmann

economic inequality that engulfs us today, in which 1 percent of the population controls 99 percent of the world's wealth, and the rest must be content with the few remaining scraps tossed their way by the ruling elite. The production design of the film was massive in scale, employing literally thousands of extras, state-of-the-art special effects, and a vision of the future that was both bleak and utterly convincing.

Yet Freund was not blind to the rise of Hitler and his followers, or to the fact that technical facilities in Hollywood were vastly superior to those available in Germany. He thus resolved to immigrate to America in 1929 and soon found himself assisting Arthur Edeson in an uncredited capacity as associate director of cinematography on *All Quiet on the Western Front*, which, as noted, depicted the entire Great War as a useless and cynical exercise in territorial expansion. For obvious reasons, especially when the film won the Academy Award for Best Picture in 1930, *All Quiet* was not well received in Freund's homeland, and Freund realized that he was now essentially a permanent Hollywood exile.

Assigned to shoot Tod Browning's 1931 version of *Dracula,* Freund quickly recognized that the director's difficulty with early sound techniques was becoming a problem on the film. Freund thus played a large part in the overall design and execution of the film, handling most of the visuals, while Browning concentrated on toning down Bela Lugosi's performance in the title role, which was much too theatrical for the intimacy of the camera (Lugosi had played the role on Broadway in 1927 for 261 performances, and then went on tour with the production). Having directed films in Germany just before his departure, Freund now leveraged his camerawork on *Dracula* into a directorial assignment on *The Mummy* (1932), perhaps the most dreamlike and hypnotic film in the early Universal horror canon.

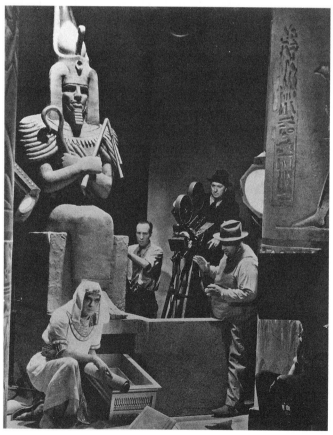

Karl Freund, hands raised, right, directing *The Mummy* (1932), with cameraman Charles Stumar lining up a shot with star Boris Karloff

Karl Freund's eccentric horror film *Mad Love* (1935), photographed by Gregg Toland and Chester Lyons, with Peter Lorre, the film's star, on the right

Photographed by Charles Stumar, another pioneer of the cinema who shot more than 100 films before his untimely death in 1935, with Freund closely supervising the proceedings, *The Mummy* features horror icon Boris Karloff in one of his most compelling roles, as the "undead" mummy Imhotep who returns to life to claim his "bride," reincarnated as the mysterious Helen Grosvenor (Zita Johann). The film was enormously successful and inspired a torrent of indifferent sequels, but Freund soon found that his gift for moody, deeply shadowed, macabre lighting was his strongest asset as a cinematographer, and that his own sensibility as an artist was less well suited to his subsequent directorial projects, such as the musical comedy *Gift of Gab* (1934). He finished out his career as director with a more suitable project, the willfully perverse *Mad Love* (1935) for MGM, in which insane surgeon Doctor Gogol (Peter Lorre) grafts the hands of a knife-throwing murderer on to pianist Stephen Orlac (Colin Clive) after the pianist's hands are smashed in a railway accident. In the meantime, Doctor Gogol has become obsessed with Orlac's wife, Yvonne (Frances Drake).

Filming began on May 6, 1935, with Chester A. Lyons as DP, but Freund soon recognized Lyons's relative mediocrity behind the camera and insisted upon the services of Gregg Toland (who would later shoot *Citizen Kane*) for the final eight days of production (Mank 130). Tellingly, according to Frances Drake, the film's female lead, "Freund wanted to be the cinematographer at the same time [as being the director]. . . . You never knew who was directing" (Mank 140). *Mad Love* is a deeply eccentric, visually stunning film, which nevertheless failed at the box office. Freund and Toland's visual style was decidedly at odds with MGM's studio look of blandly anonymous, flat, white lighting, to say nothing of the film's outré subject matter. Recognizing that he was more interested in designing and capturing images than in helming entire films, Freund decided from then on to concentrate solely on work as a cinematographer.

However, in doing so, Freund acquiesced almost entirely to the regularized overhead grid lighting that was MGM's distinctive visual trademark, and his subsequent films for the company are on the whole visually undistinguished. Sidney Franklin and Victor Fleming's *The Good Earth* (1937) is a conventionally epic MGM literary adaptation for which Freund nevertheless won an Academy Award for Best Cinematography in 1938; *Green Hell* (1940) is arguably James Whale's least interesting film; Victor Fleming's *A Guy Named Joe* (1943, co-photographed with George J. Folsey) is a predictably jingoistic wartime fantasy drama; and of these later films, only John Huston's *Key Largo* (1948), for which Freund was on loan to Warner Bros., has the punch and verve of his best work. But an even more pronounced change in Freund's style was just around the corner.

By 1950, essentially retired from the business, Freund was lured away from his orange groves to design the first three-camera sitcom system of photography, which essentially remains in use to this day, for the still beloved television series *I Love Lucy* in 1951, which used three cameras running simultaneously—one in the middle to cover a wide shot of the action, and two other cameras, one on the left and the other on the right, to pick up close-ups of the performers during a scene (Arnaz 206–207).

Using 35 mm Mitchell cameras with 1,000-foot magazines running ten minutes each, Freund devised the flattest, most even lighting of his career—entirely devoid of nuance or emphasis—to enable stars Lucille Ball and Desi Arnaz to shoot 148 episodes of the series in front of a live

audience, in three seven-minute acts, like a play, so that all the coverage the editor needed was accomplished in one take—as the cameras rolled nonstop through each seven-minute segment, supplying the master shot and the close-ups all in one pass. Now, of course, this is done on digital video, but the coverage model remains the same; get all the materials in one shooting session.

This three-camera system, of course, represents the absolute nadir of creative cinematography—an odd twist in the career of such a prime exponent of Expressionistic lighting in his early work in Germany. Freund took it on as a technical challenge, and was richly rewarded for his efforts by Arnaz, who at this point in his career was so powerful that he bought out the failing RKO Radio Studios with one phone call, and turned the facility into the physical plant for his own company, the TV giant Desilu (Arnaz 294). Three-camera sitcom lighting was frankly an assembly-line procedure, nothing more, designed to record the performances of the actors as quickly and efficiently as possible, and, not incidentally, to take advantage of the live studio audience to create an instantaneous "laugh track," which would, of course, be enhanced in post-production.

It's more than a little ironic, then, that Freund won his second Academy Award, in 1955, "for the design and development of a direct reading brightness meter," which had been instrumental in creating the utilitarian bright, white world of *I Love Lucy*, and its companion series, *Our Miss Brooks*, for which Freund served as DP on 126 episodes using the same three-camera system. In 1956, Freund retired from the studio system that had so totally subsumed him; he died at the age of seventy-nine in 1969.

Another classic horror film of the 1930s came not from Universal, by then regarded as Hollywood's horror factory, but from Paramount, better known for its Mae West vehicles, Marx Brothers films, and Josef von Sternberg's delirious exoticism. Erle C. Kenton's *Island of Lost Souls* (1932, d.p. Karl Struss), a resolutely pre-Code film (that is, before the Motion Picture Production Code was strictly enforced, starting in 1934, though it had technically been in place since 1922), told the tale of the demented Dr. Moreau (Charles Laughton), who creates synthetic "manimals" from the various animals who roam his island kingdom. Kenton, an aggressive stylist, was for most of his career destined to work in generally undistinguished program pictures, but he is perhaps best known for the dreamy, almost hallucinatory images he created with Struss for *Island of Lost Souls*.

Much of the film, indeed, is suffused with a gauzy, soft-focus effect, but his work on the film remains an outlier in his career. It is perhaps no accident that among Kenton's last assignments as a director were *House of Frankenstein* (1944) and *House of Dracula* (1945), both photographed by yet another gifted cinematographer, George Robinson, who started in the silent era with William Duncan's *Where Men Are Men* (1921) and racked up more than 180 credits before his retirement in 1957. Kenton, working with Struss, Robinson, and others, had a distinct advantage over many of his directorial colleagues; as Struss noted, Kenton understood how to compose an effective image from his early days as a still photographer.

Billy Bitzer, one of the first and greatest of all cameramen, knew this implicitly, even if he approached his labor with D. W. Griffith as an essentially workaday affair. The artistry that arose out of the images he photographed came from the light falling on the scene in front of him, the framing that accentuated certain portions of the image and excluded others, and, perhaps most importantly, the skill to make the end product look so effortless that no one viewing the film could conceive of the care that went into each new camera setup. Above all, Bitzer strove for a sort of faux naturalism, often accentuated in post-production by color tinting, which sought to emulate the actual circumstances of the situation, even going so far as to shoot at night using magnesium flares for Griffith's epic *Intolerance: Love's Struggle Throughout the Ages* (1916).

Bitzer was born in 1872 in Roxbury, Massachusetts, as Johann Gottlob Wilhelm Bitzer. He began his long career as an assistant to W.K.L. Dickson, working for the American Mutoscope Company, later known as Biograph Pictures. He became a full-fledged cameraman as early as 1903, when he switched from shooting "actualities" to narrative films, and assisted Griffith on the director's first film, *The Adventures of Dollie* (1908), which was actually shot by Arthur Marvin. Marvin, born in 1859, is another unjustly forgotten cinema pioneer, who shot an astounding 445 short films between 1897 and 1911, the year of his death; for Griffith, he not only shot *Dollie* but also *The Lonely Villa* in 1909, another key film in the director's career. Bitzer absorbed everything he could from Marvin and then moved into the first cameraman slot with such films as Griffith's *A Corner in Wheat* (1909) and *In Old California* (1910), and subsequently kept up a torrid pace of production. Although there is now legitimate dispute on the matter, since Alice Guy, head of production at Gaumont from 1896 to 1906, incorporated many of the stylistic

and technical advances Bitzer is routinely credited for in her more than 400 films, Bitzer is considered by many to have created the fade-out, soft-focus photography, and other basics of film grammar.

Certainly, Bitzer's work ethic was prodigious, with more than 1,200 credits to his name. He began his career as a DP with a documentary film, *William McKinley at Canton, Ohio* (1897), and shot nearly 500 films for other directors before his work with Griffith, for which he is best remembered. With the appallingly racist epic *The Birth of a Nation* (1915), Bitzer pulled out all the stops, consciously modeling his work in the film on the real-life Civil War photographs of Mathew Brady. As Richard Griffith and Arthur Mayer note, Bitzer obtained "the Brady prints from a librarian, who parted with her precious collection for a box of chocolates. The orthochromatic film of those days aided the illusion of nineteenth-century photography" (32). Astonishingly, the entire film was photographed with a single hand-cranked camera, and Griffith seemed oblivious to injury to both cast and crew during the battlefield sequences of the film. As Bitzer later recalled,

> There were times when I wished that Mr. Griffith didn't depend on me so much, especially in battle scenes. The fireworks men shooting smoke bombs over the camera—most of them exploding outside camera range—and D. W. shouting, "Lower, lower, can't you shoot those damn bombs lower?" "We'll hit the cameraman if we do," answered the fireworks brigade, and bang! one of them whizzed past my ear. The next one may have gone between my legs for all I knew. But the bombs were coming into the camera field so it was okay. As I write this, looking at my hand, it still shows the blue powder specks from the battlefield of *The Birth of a Nation*. (Griffith and Mayer 33)

Bitzer's most ambitious film—and Griffith's as well, for that matter—was undoubtedly the 197-minute epic *Intolerance*, which was partially funded by Bitzer's life savings. Griffith designed *Intolerance* as an answer to his critics who, even then, recognized *Birth*'s racism, but the film's length, extravagance, and complex plot structure alienated audiences, who stayed away in droves. In an attempt to recoup a portion of his financial losses, in 1919 Griffith took two sections of the film, one dealing with the decline and collapse of ancient Babylon (which not incidentally had the most spectacular sets in the original work), the other a contemporary

Billy Bitzer at the camera, left; D. W. Griffith, right, during the shooting of
Way Down East (1920)

American story, and released them as separate pictures, *The Fall of Baby-lon* and *The Mother and the Law*, respectively. But Griffith's career was in decline. Bitzer's last films with Griffith were *Way Down East* (1920); *America* (1924), a Revolutionary War drama that failed to capture the public's imagination; *Drums of Love* (1928), a historical romance that also failed to catch fire; and *Lady of the Pavements* (1929), a part-talkie that survives only in a silent version.

Work became harder to come by, and it wasn't until 1933 that Bitzer got another assignment, but this time on the distinctly down-market *Hotel Variety*, directed by Raymond Cannon. A cheap production in every respect, running a scant sixty-five minutes, *Hotel Variety* would be Bitzer's last DP credit, and his only fully synchronized sound film. His

associate DP on the film, who had also worked with Bitzer on some of his final projects for Griffith, was Marcel Le Picard, whose career began in 1915 with the silent film *The Outlaw's Revenge* and then stretched through the 1940s and 1950s as the cinematographer for more than 190 horror, western, and comedy films. Many of these were produced by Monogram Pictures—a reliable purveyor of quotidian black-and-white cinema, as evidenced by such projects as William Beaudine's *Voodoo Man* (1944), an atmospheric horror film starring Bela Lugosi, John Carradine, and George Zucco, which Le Picard photographed.

But for Bitzer, *Hotel Variety* was the end of the trail. Shortly before his death, Bitzer was working at the Museum of Modern Art in New York, in the newly inaugurated film department under curator Iris Barry, supervising the maintenance of the museum's collection. He died in 1944, ten years after his last work as a cinematographer; his autobiography was published posthumously in 1973, and in 2003 he was voted one of the ten most influential cameramen of all time by the members of the International Cinematographers Guild.

If Bitzer's work is overshadowed by Griffith's celebrity, it's instructive to remember that Bitzer's cinematography on more than 1,000 films is an accomplishment in its own right. More specifically, his conscientious application of the concepts of backlighting, early deep-focus cinematography (long before Gregg Toland became celebrated for his deep-focus work in Orson Welles's *Citizen Kane* [1941]), and an almost painterly photographic style formed the foundation of Hollywood black-and-white cinematography—and when Griffith moved west early in his career, Bitzer's work as DP on Griffith's *In Old California* (1910), in what was then called "Hollywoodland," marked him as perhaps the first truly Hollywood studio cameraman.

Bitzer was effectively passing the torch to a younger generation; on his last two films for Griffith, *Drums of Love* (1928) and *Lady of the Pavements* (1929), he was assisted by Karl Struss, whose work with Charles Rosher on F. W. Murnau's *Sunrise: A Song of Two Humans* (1927) won Rosher and Struss an Academy Award for Best Cinematography in 1929. Struss and Rosher would both become major figures behind the camera, though for his part Struss was cheerfully pragmatic about his entry into the film industry. As he told Kenneth Turan, "Anyone who could turn a crank was a cameraman. [In the early days,] you tried to take the whole burden of production off the director so he could concentrate on the

acting." This suited Struss just fine, and on *Sunrise,* he and Rosher were given the freedom to create an entire tactile world for the film's characters to inhabit. *Sunrise*'s tragic narrative is of a man, never named, played by George O'Brien, and his wife, also unnamed, played by Janet Gaynor — the actors are listed in the film's credits simply as "The Man" and "His Wife" — who are deeply in love until the man is seduced by the "vamp-ish" Woman from the City (Margaret Livingston), who urges the man to drown his wife so they can be together.

The man tries to do this during an outing on a boat, but at the last moment realizes that he can't go through with it, that he truly loves her. But too late: his wife realizes his murderous intent and flees for her life, while the man pursues her through the city and pleads for forgive-ness. Finally reconciled, the couple takes another boat ride together, but a storm comes up, the boat capsizes, and it appears that the wife has drowned. Stunned, the man returns home, only to find The Woman from the City waiting for him, convinced that her plan has succeeded. Furious with himself for agreeing to her scheme, the man begins to strangle her, only to be interrupted by a maid calling to him from the distance that his wife has survived. As the film ends, the man and wife are reunited and exchange a passionate kiss. The Woman from the City departs in her car-riage, as the sun rises in the distance.

I offer this brief summary of the film to frame remarks by the Cuban-born cinematographer Néstor Almendros (1930–1992), a master of the craft who photographed Terrence Malick's *Days of Heaven* (1978), for which he won the Academy Award for Best Cinematography; Alan J. Pakula's *Sophie's Choice* (1982); Eric Rohmer's *Pauline at the Beach* (1983); and François Truffaut's *Confidentially Yours* (1983), among many other films. In a lecture delivered in 1984, Almendros had these observations on Rosher and Struss's exquisite camerawork:

> The reason I chose [*Sunrise*] to discuss, aside from the obvious one that I like it very much, is that it received the first Academy Award given for cinema-tography. The Academy of Motion Picture Arts and Sciences awards were created in 1927, and ... *Sunrise* won a special award that has never again been given, for "artistic quality of production." ... As strange as it may sound, awards for cinematography did not exist at that time and, stranger yet, they barely exist today. Cannes, Berlin, Venice and all the other major film festi-vals of the world have no awards for cinematography. They do have awards

for supporting actors and supporting actresses, for writers and directors, and for a lot of other things, but the cinematographer's work is often disregarded.

Murnau belonged to the school of German Expressionism, perhaps most evident in his direction of the classic vampire film *Nosferatu* (1922), photographed by Fritz Arno Wagner and an uncredited Günther Krampf. The camera angles, the lighting, the sets and the costumes were meant to convey the psychological complexities of the characters. . . . The compositions give an interesting impression of three dimensions. This was achieved by having objects or people in the foreground and action in the background, as in the scene where the city woman is watching the searchers coming back from the rescue attempt. In the interiors, there are lamps in one part of the frame or, in some instances, statues in the foreground. The foreground objects are cut off by the frame on one side, leaving the rest of the foreground open for the main action, enhancing the impression of depth and perspective. (Almendros 95–96)

Almendros's observations are right on target; this is a film which has an almost three-dimensional feel, in part because of the intensity of the

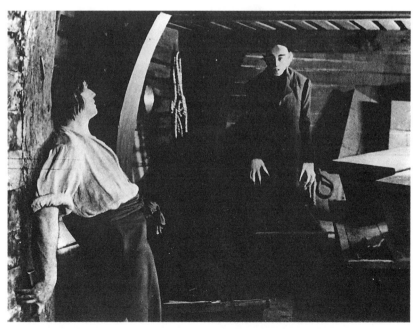

A scene from F. W. Murnau's classic vampire film *Nosferatu* (1922), photographed by Fritz Arno Wagner and an uncredited Günther Krampf

actors' performances, but also because of the magisterial camerawork of Struss and Rosher, who make the narrative seem authentic, immediate, and emotionally accessible to the audience.

As the cinema moved into regularized feature films on an international basis, various "schools" of cinematography began to appear around the globe, marked by radically different stylistic approaches to lighting, set design, and editorial structure, all existing within the world of black-and-white cinema as an alternative universe, separate from and yet inextricably tied to the real world. But another question was beginning to arise: just how much of this "other world" could be attributed to the director, and how much to the director of cinematography? Some directors worked exclusively with the actors, while others would design elaborate camera movements, and still others engage in a genuine collaboration. Who was really the author of the image on the screen—the director, the cinematographer, or both? As it turned out, this varied in each and every individual case, and the relationship between the actors, the director, and the cinematographer was often a matter of constant negotiation, unless, as is sometimes the case, the director and cinematographer were in rapport.

Consider the example of Arthur C. Miller, whose remarkable career stretched from the short film *A Heroine of '76* (1911), directed by Lois Weber, to Louis J. Gasnier and Donald Mackenzie's pioneering motion picture serial *The Perils of Pauline* (1914), starring Pearl White, and then into a long series of silent features such as Weber's *The Angel of Broadway* (1927). Eventually he landed at Twentieth Century–Fox as the DP on the Shirley Temple vehicles *Bright Eyes* (dir. David Butler, 1934), *Wee Willie Winkie* (dir. John Ford, 1937), *Heidi* (dir. Allan Dwan, 1937), and *Rebecca of Sunnybrook Farm* (dir. Allan Dwan, 1938), becoming Temple's signature cameraman. In contrast to the soft, often romantic style of much of Bitzer's work, Miller preferred a hard-edged, sharply detailed style, with rich blacks and whites and deep shadows. He found his greatest collaborator in director John Ford, for whom Miller shot the Welsh coalmining drama *How Green Was My Valley* in 1941, the first of three films for which Miller won an Academy Award for Best Black and White Cinematography, the others being Henry King's *The Song of Bernadette* (1943) and John Cromwell's *Anna and the King of Siam* (1946).

Miller also enjoyed a fruitful relationship with director George Fitzmaurice; they made a total of thirty-three films together, starting

with Fitzmaurice's silent *New York* (1916) and concluding with two films in 1925, *A Thief in Paradise* and *His Supreme Moment*. Like Ford, Fitzmaurice encouraged Miller to experiment with his lighting and develop his own realistic style, and he gave the cinematographer considerable latitude; when Cecil B. DeMille later used Miller, however, DeMille's rigidity of style created a much more evenly lighted, bland effect in such films as *The Clinging Vine* (1926) and *Eve's Leaves* (1926), which left Miller deeply dissatisfied.

Like many of his black-and-white compatriots who started in the silent era, in which the image was all and the sound track (except for an orchestral scene at best, or a piano banging away in the background) was nonexistent, Miller continued to insist on the primacy of the image in his work, with high-key lighting and brilliant surfaces. His final films, including Edmund Goulding's *The Razor's Edge* (1946) and Elia Kazan's *Gentleman's Agreement* (1947), climaxing with his work on Joseph Losey's disturbing film noir *The Prowler* (1951), are a fitting legacy for a man who was one of the first to insist on a utilitarian style of cinematography, which eschewed artifice for honest simplicity. As Miller said of his work, "The basic principle I have had in making pictures was to make them look like real life, and then emphasize the visuals slightly." This, of course, suited him well when working with John Ford, whom Miller called "the director I liked working with better than anybody in the industry. You'd only talk, I think you might say, fifty words to him in a day; you had a communication with him so great you could sense what he wanted" ("Arthur C. Miller"). For Miller, the unadorned integrity of the image was his ultimate goal, as it was with Ford.

Working with DeMille, Miller realized that not every assignment would result in a wholly successful effect and that few directors were as gifted as Fitzmaurice and Ford, who allowed him the artistic latitude to paint with light. As he said, "I always gave a director my best, even if he was a truck driver" ("Arthur C. Miller"), and sometimes, as when he worked with such directors as William "One Shot" Beaudine, there was little time for artistry; it was just a matter of getting it in the can. But on those occasions when Miller and his director were able to work in harmony, the results could be truly astonishing.

In the waning days of the silent era, several dramatic changes in lighting technique occurred, driven in part by the evolving technology of the

period, and also, oddly enough, by the coming of sound. As Deborah Allison notes,

> It became common to use a combination of several lights to create a pleasing aesthetic that flattered the appearance of the actors and the sets as well as serving the film's narrative requirements. One of the best known lighting setups is the so-called three-point system, which was used primarily for figure lighting. The brightest of the three lights was the "key" light, which was directed toward the actor's face from the front-side. If this light were used on its own it would leave one side of the face in virtual darkness and cause the actor's nose to cast a large, unflattering shadow. To prevent this from happening, a second softer light known as the "filler" light was directed at the other side of the face. This light was normally positioned close to the camera, on the opposite side from the key light. It helped to balance the composition, reducing the dark shadows cast by the key light while preserving the facial sculpting. A third "backlight" was positioned behind the actor in order to create a halo of light around the hair. This served to separate the actor from the background and also helped to emphasize the fairness of blonde hair, which did not otherwise show up well on the monochromatic film stock that was used until the late 1920s.
>
> A third type of light that came to be used in conjunction with the arc and mercury vapor lights was the incandescent light, which used a glowing metal filament, much like most modern domestic lighting. . . . It was not until the introduction of panchromatic film stock in 1926 that it came into common use, when it was found that the color temperature of incandescents, or 'inkies,' was better matched to this stock than was that of the arc lights. . . . A further decisive factor in the wide adoption of incandescent lights was the temporary abandonment of arc lighting with the coming of sound. Filmmakers discovered that the humming noise emitted by arc lights was picked up by recording equipment. Only in the early 1930s, after a way was found to silence them, were arcs reintroduced as a supplement to the incandescents that had taken their place as standard studio equipment.

This, of course, was not the only practical adjustment to synchronized sound filmmaking that both cinematographers and directors faced during the transition from silent films to "talkies." Directors could no longer give instructions to the performers during shooting, as they had been accustomed to doing; instead, they had to remain absolutely silent

throughout the scene, as dubbing and/or post-synchronization in the early days of sound were almost impossible. Many films made during this period, such as *Sunrise* and *All Quiet on the Western Front*, were begun as silent films and then hastily overhauled for release as "talking pictures"; in the case of *Sunrise*, a musical and sound effects track was added to the film for final release, and *All Quiet* was partially reshot to accommodate the advent of the new technology.

When it came, the shift happened almost overnight, although experimentation along these lines had been going on for some time. Lee de Forest and others had been experimenting with sound-on-film, and others used sound-on-disc methods of sync-sound filming from the early 1920s onward; earlier attempts going as far back as Alice Guy's wax cylinder Chronophone film shorts in 1898 demonstrate that the cinema had long struggled to find an effective system to record spoken dialogue. When the decisive shift finally came with Alan Crosland's part-talking *The Jazz Singer*, photographed by Hal Mohr in 1927, silent films became obsolete overnight. Existing projects either had to be reshot, be released with musical accompaniment and sound effects, or use sync-sound scenes as "inserts" to meet audience expectations.

Alfred Hitchcock, for example, started his film *Blackmail* (1929), photographed by Jack Cox, as a silent production, but retooled the film for sound in a most unusual fashion. Since his leading lady in the film, Anny Ondra, could not speak English—not a problem with a silent film, but now a seemingly insurmountable obstacle—Hitchcock shot Ondra's scenes with an English-speaking actress out of camera range providing the spoken words, while Ondra lip-synched the dialogue onscreen without making a sound. This had to be done during the actual shooting, of course, since post-synchronization was then impossible, and techniques such as this proved both cumbersome and impractical in the long run, putting an end to the career of many popular silent film actors, such as Emil Jannings, Pola Negri, and most controversially, John Gilbert.

Directors also felt the effects of the transition from silent to sound. The director Erich von Stroheim was one of the great tragic figures of cinema history, and his film *Greed* (1924) is undoubtedly one of the most important films in American cinema. Based on Frank Norris's novel *McTeague*, and credited as being "personally directed by Erich von Stroheim," the film was photographed by Ben Reynolds and William H. Daniels over nine months in San Francisco, Oakland, and Death Valley, California,

finally emerging in a forty-two-reel cut completed by von Stroheim and Frank Hull. Much of *Greed* was shot using natural light; for the film's many sequences in a San Francisco boarding house, von Stroheim famously tore the walls off one side of the building so he could film using sunlight alone, balanced by reflectors (Griffith and Mayer 214).

The forty-two-reel version, however, was rejected by the film's producers, despite several preemptory publicity screenings by the director. Von Stroheim and Hull obliged with a twenty-four-reel version and then pronounced the film finished. Again, the film's production company, MGM, in the person of Irving Thalberg—the film had been initiated by the Goldwyn company, but by the time editing was completed Goldwyn had been absorbed into the newly formed Metro-Goldwyn-Mayer (Koszarski, "Reconstructing *Greed*" 13)—rejected this shorter version, and so von Stroheim turned to his friend, director Rex Ingram, who, working with editor Grant Whytock, cut the film down to eighteen reels and declared he could cut no more without ruining the film. But even this was not enough to appease Thalberg, who demanded that the film be cut to ten reels. The final ten-reel version was completed by June Mathis and Joseph Farnham, and the outtakes and trims were then summarily destroyed, in one of the most sacrilegious episodes in motion picture history. The resulting version was released to negative reviews.

Thus, all that survives today of *Greed* is the severely truncated version, although historian and archivist Rick Schmidlin supervised a 239-minute "reconstruction" of the film in 1999, using 589 on-the-set stills ("Reconstructing *Greed*" 14) and other materials to fill in the gaps left by the final editing. But even from what remains, we can discern the hand of a master of naturalistic lighting and direction, whose efforts at realism created a cinematic style that is unmatched to this day. In his use of depth and chiaroscuro black-and-white cinematography, enhanced at certain points by strategic color tinting, von Stroheim created a deeply personal and unique work.

Von Stroheim at least had the satisfaction of having shown the complete version to a number of Hollywood insiders, one of whom, the newspaper columnist Harry Carr, wrote that "I saw a wonderful picture the other day—that no one else will ever see. It is the unslaughtered version of Erich von Stroheim's *Greed*. It is a magnificent piece of work, but it was forty-five [*sic*] reels long. . . . For stark, terrible realism and marvelous artistry, it is the greatest picture I have ever seen" ("Reconstructing

A complex setup from Edmund Goulding's *Grand Hotel* (1932), photographed by William Daniels

Greed" 12–13). Von Stroheim, Daniels, and Reynolds would have to be content with that—a masterwork that was, at the last minute, intentionally destroyed by its backers.

Daniels is perhaps best remembered as director of photography for several films starring the demanding Greta Garbo, including Clarence Brown's *Flesh and the Devil* (1926), Brown's *Anna Christie* (1930), Edmund Goulding's *Grand Hotel* (1932), Rouben Mamoulian's *Queen Christina* (1933), and Ernst Lubitsch's *Ninotchka* (1939). But Daniels had a wide range of styles at his command as a cinematographer, and could effectively adapt to nearly every cinematic genre. He would later photograph such classics as Lubitsch's romantic comedy *The Shop Around the Corner* (1940), Jules Dassin's neorealist *The Naked City* (1948), Henry Koster's whimsical *Harvey* (1950), and Anthony Mann's violent western *Winchester '73* (1950), to name just a few of his many projects.

Of Daniels's pioneering work, Jim Bishop wrote, "In the old silent days, Daniels had been the best of them all. His camerawork was so close to art that producers and directors and cameramen used to sit in private projection rooms, not to judge a picture, but to see what new tricks of

Cinematographer William Daniels behind the camera on Rouben Mamoulian's (seated, with glasses, on camera dolly) *Queen Christina* (1933)

lighting and effects Daniels had achieved. The industry acknowledged that Daniels' work was so fine that other cameramen were never censured for shamelessly stealing it" ("William H. Daniels").

Yet another extraordinarily important cinematographer of the silent era was Eduard Tisse, who was born in what is now Latvia in 1897 and served as director Sergei Eisenstein's cinematographer on such films as *Strike* (1924), *Battleship Potemkin* (1925), *October: Ten Days That Shook the World* (1928), *¡Que viva México!* (1932; co-photographed with Gabriel Figueroa), *Alexander Nevsky* (1938), and *Ivan the Terrible Pts. I and II* (1944–46). Starting out as a newsreel cameraman in the early days of the cinema, Tisse gained international prominence for his work with Eisenstein, using his naturalistic, available-light strategy of cinematography for the first films by the director, further enhanced by Eisenstein's brilliant use of rapid-fire editing to create an absolutely kinetic effect.

Tisse's "coverage" of the scenes in these early films is filled with intense detail; wide shots alternate with extreme close-ups, facial reactions are filmed from a variety of angles for maximum impact, and the entire film

is obviously carefully planned, much more so than a typical Hollywood or Western European film of the era. It's clear that Eisenstein's youthful, vigorous cinema was successful as both Soviet propaganda and a personal statement; screened through the world to great acclaim, Tisse and Eisenstein's work on these films was highly influential on more adventurous cinematographers, such as Gregg Toland.

By *October,* however, Tisse was developing a much more theatrical style of lighting, using deep shadows and flickering lighting to heighten the drama of the film. In his later films, Eisenstein moved away from this use of location shooting for a far more pronounced studio look, as in *Alexander Nevsky*, which uses interior settings for much of the film, particularly the memorable "battle on the ice" sequence, and which is composed of much longer shots, using deep focus and varying planes of action rather than montage to create the finished film.

This more leisurely style reaches its apotheosis in the two parts of *Ivan the Terrible,* in which images are held for minutes at a time, and editing seems almost an afterthought, something like the later films of director Carl Th. Dreyer, renowned for his equally intense editorial strategies on his film *The Passion of Joan of Arc.* The final sequences of *Ivan the Terrible Part II* are also interesting in that they represent the only time that

The famous Odessa steps sequence from Sergei Eisenstein's *Battleship Potemkin* (1925), photographed by Eduard Tisse

Eisenstein and Tisse had the opportunity to work together in color, using the experimental Bi-Color process, which, like early two-strip Technicolor, used only two colors to create the film's entire palette, red and blue. Though shot in 1945–46, *Ivan the Terrible Part II* was not completed and released in the Soviet Union until 1958, a decade after Eisenstein's death at age fifty, and three years before Tisse's death at the age of sixty-four. There can be no doubt that their collaboration represented their greatest achievements; indeed, one can hardly imagine the work of one without the other.

There was another factor to consider, and that was the language barrier, both for foreign films in America, and English-language films abroad. Some films, such as Karl Hartl's *F. P. 1 Does Not Answer* (1933), were produced in multiple-language versions for international release; Laurel and Hardy shot some of their early two-reel sound shorts in English, French, and Spanish versions, speaking their lines phonetically; and Tod Browning's *Dracula* was reshot at night, in Spanish, during the filming of the English-language version, on the same sets with a different cast of actors by director George Melford, who didn't speak a word of Spanish, with Enrique Tovar Ávalos as the dialogue director.

In the conclusion of this chapter, let's consider two penultimate masterpieces of the silent cinema, released just as the shift to sound was taking place; Carl Th. Dreyer's *The Passion of Joan of Arc* (1928) and Abel Gance's *Napoleon* (1927).

Joan of Arc stands as one of the supreme achievements of the silent era, immaculately photographed by the great Rudolph Maté on Expressionistic sets, and graced by the superb performance of Maria Falconetti as Joan. Maté photographs each shot with a radiant clarity, often using a halo "iris" effect during Joan's close-ups, to accentuate her isolation and persecution during the trial. Often, Maté frames Joan slightly from above, looking down at her with a mixture of reverence and sadness, which also serves to suggest her powerlessness during her interrogation by the judges; when the film moves outside during Joan's carnivalesque execution (Dreyer and Maté take care to show that Joan's demise is being presented as a public spectacle, complete with jugglers, contortionists, and acrobats on the sidelines, all hoping to attract a portion of the massed crowd's attention), the camerawork takes advantage of bright sunlight to present Joan's death in the starkest terms. And yet, echoing concerns that exist to this day, *The Passion of Joan of Arc* received only limited release

in major cities, due not only to its deeply emotional subject matter (and the fact that the Catholic Church objected to the depiction of the judges within the film as merciless inquisitors), but also because, in 1928, the film was simultaneously an instant classic and an instant relic; a dying art—the silent film—had produced a masterpiece.

Many of the same problems faced Abel Gance's *Napoleon*, which employed no fewer than four cinematographers, Léonce-Henri Barel, James Kruger, Joseph-Louis Mundwilber, and Nikolai Toporkoff, to bring the film's overwhelming spectacle to the screen. Gance famously filmed the climax of *Napoleon* in what he dubbed Polyvision, a three-screen process akin to Cinerama in the 1950s, using three cameras simultaneously to photograph sequences to give not only the illusion of depth, but also so that the screen could be split at will into three distinct sections, thus allowing Gance to switch from panoramic vistas to intense close-ups.

Gance and his cinematographers used nearly every aspect of the silent cinema's visual vocabulary in creating the film; superimpositions, crane shots, handheld camerawork in the battle sequences, and an impressive array of lighting strategies, from darkly atmospheric scenes to dazzlingly illuminated panoramic wide shots. The three-camera, three-projector aspect of *Napoleon* naturally occasioned the most discussion when the film was first released.

In the final days of the silent cinema, we can see that both cinematographers and more imaginative directors were embracing new forms of pictorial representation, in which the image is the primary factor in conveying both emotional content and narrative information to the audience. With the coming of sound, the camera would at first be severely restricted, but soon innovative cinematographers, impatient with the newly enforced immobility of the camera, would seek to move beyond the "phone booth" style of cinematography and create an entirely new visual language for film.

2

The 1930s

• • • • • • • • • • • • • • • • • • • •

Escapism and Reality

The 1930s marked the first complete decade of synchronized sound film production on a worldwide basis, but it also was an era of economic upheaval: the 1929 stock market crash brought an end to the explosive financial speculation of the 1920s, and stocks purchased "on margin" lost most of their value almost overnight in late October of that year. This plunged the United States and the rest of the industrialized world into a period of severe economic depression, which ultimately would only be conquered by the feverish efforts of President Franklin Delano Roosevelt's New Deal and its numerous ancillary programs, such as the National Recovery Administration and the Works Progress Administration, which put millions of people back to work, and the tremendous manufacturing boom caused by wartime industry in the early 1940s at the onset of World War II.

So severe were the effects of the Great Depression that the stock market would not recover its lost ground until 1954, or roughly a quarter-century after the 1929 crash. Only a few extremely wealthy persons were untouched by the Depression's effects, and for the vast majority of the world's population the fever dream of the Roaring Twenties was over.

Now, audiences flocked to theaters to see the new talkies for as little as a nickel a seat, and whole families literally lived in twenty-four-hour "grind houses" simply to keep warm during the winter, as food and housing became more and more difficult to obtain. In such an atmosphere, the advent of sound motion pictures was almost a godsend; it gave desperate, frustrated, and disillusioned people someplace to go and forget their troubles for a few hours as they watched the shimmering images on the silver screen.

The entertainment industry was one of the few areas of commerce that was relatively unaffected by the Depression; sound had been firmly established and the studio system itself was solidly in place, churning out thousands of films a year from the various production companies—MGM, Paramount, Warner Bros., Universal, Twentieth Century–Fox (created in 1935 by the merger of Twentieth Century and Fox Films, with Darryl F. Zanuck at its head), as well as numerous smaller concerns, such as Tiffany, Pinnacle, Mascot, and Educational Pictures. There was now a voracious appetite for filmed entertainment—it was cheap and readily available, and it offered escape from a real world of broken dreams and continued economic hardship.

Thus, in the early 1930s, as the "dream factories" continued to create a torrent of films for mass consumption, several distinct genres of commercial filmmaking emerged, which matched the public's new world outlook. The most popular films of the 1930s offered either outright fantasy, as in the musicals of director Busby Berkeley, or stark realism, as in the gangster cycle of films initiated by William Wellman's *Public Enemy* and Mervyn LeRoy's *Little Caesar* (both 1931) and Howard Hawks's *Scarface* (1932). In addition, a group of films, mostly from Warner Bros., dealt directly with the social inequities of the period, such as LeRoy's *I Am a Fugitive from a Chain Gang* (1932), an uncompromising look at the brutality and corruption of the prison system in America's Deep South. There was also a series of harshly acerbic films that addressed the fraud and deception that led up to the Depression itself, such as Wellman's *Heroes for Sale* (1933), about the plight of World War I servicemen who now found the ground cut out from under them, and Wellman's *Wild Boys on the Road* (1933), detailing how economic privation forced families to split up, as parents could no longer afford to support their children with even the barest essentials. Thus, in broad strokes, the cinema of the 1930s offered either a momentary respite from the cares of daily life in musicals or comedies, or

films that spoke directly to their audience's fears and concerns related to the greatest economic downturn of the twentieth century.

One of the most visually expressive and exoticist directors of the 1930s was Josef von Sternberg, whose films *Morocco* (1930), *An American Tragedy* (1931), and the sumptuous *Shanghai Express* (1932), to name just a few, are tapestries of light and shadow, evoking a sense of mystery and wonder that was brought out by the work of Lee Garmes. Garmes, a versatile and talented cinematographer who moved smoothly from romance to realism as his assignments required (photographing, for example, Hawks's classic *Scarface*), was one of the most influential Hollywood DPs of the early 1930s, and he knew it; he was also an expert self-publicist who had a genuine interest in classical painting and could apply this knowledge to film. As he told Charles Higham and Joel Greenberg in a 1967 interview,

> I've always used [Rembrandt's] technique of north light—of having my main source of light on a set always coming from the north. He used to have a big window in his studio ceiling or at the end of the room, which always caught that particular light. And of course I've followed Rembrandt in my fondness for low key. If you look at his paintings you'll see an awful lot of blacks. No strong highlights. You'll see faces and you'll see hands and portions of clothing he specifically wants you to notice, but he'll leave other details to your imagination.... Dietrich took the north light very well. Although for some shots I changed the style, making one side of the face bright and the other side dark. I experimented with her face; at one stage she looked too much like Garbo, and you couldn't have two Garbos on the screen, so I changed her again.... I can honestly say the Dietrich face was my creation. (Higham and Greenberg 193)

Garmes remembers his work on *Scarface* primarily because of the complexity of the first shot in the film. As he told Higham, "I wanted the picture full of bare light bulbs.... I hung these low, and through my use of the north-light effect the images were full of shadows, of my particular kind of shadows" (*Hollywood* 43).

Shanghai Express is one of von Sternberg's most effective entertainments. It's a riotous exercise in excess in every area; the visuals are overpowering and sumptuous; the costumes ornate and extravagant; the sets a riot of textures, light, and space; and all of it captured in the most delectable black-and-white cinematography one can find anywhere, more than

enough to convince even the most superficial viewer that when black and white ceased to be a commercially viable production medium, the world lost a true art form that color film can never hope to replace. There are some films that can exist only in black and white, and *Shanghai Express* is one of them: a world in which the unreal is real, the intangible tantalizingly within our reach, and where luxury and violence are inextricably linked in a narrative that is both preposterous and ineluctably genuine. There's a nominal plot, of course; a group of passengers are traveling through revolutionary-era China from Peking to Shanghai, thrown together by chance and circumstance in a train that may or may not make it to its designated destination.

Shanghai Express isn't even remotely believable, and that's precisely the point. The film is part of von Sternberg's world—not the real world—created for our visual and sensual delectation. We're just visiting for the duration of the film, and we're never allowed to escape from the insularity and hermetic compactness of his cinematic vision; this is a dream, and we're part of it. In this fourth of seven collaborations between von Sternberg and Dietrich, Jules Furthman's script, from a story by Harry Hervey, is the very least of the film's priorities. Although it clocks in at a relatively economical eighty minutes, the film seems languorous, eternal, a fever from which no one will ever awake, stitched together with the most extended lap dissolves I've ever seen in a commercial film, running as long as 256 frames and even longer, as one scene drifts into another in a haze of flesh tones, gauzes, and heavily filtered chiaroscuro photography. And, as always, von Sternberg took his time in shooting the film, allowing absolutely no front office interference; the film was in production from August to November 1931, an extremely luxurious shooting schedule.

Shanghai Express justifiably won Garmes an Academy Award for his work as director of cinematography, and Garmes's uncredited assistant, James Wong Howe, soon to become a major cinematographer in his own right, also fits in perfectly in constructing the visual design of the project. *Shanghai Express* seems to exist entirely in zones of light that transfix the protagonists, who become instantly read iconographs (luxury, desire, Orientalism) within the universe they inhabit. The visuals of the film ultimately overpower the narrative, and simultaneously become part of it, as if both the characters and their world are inextricably intertwined with von Sternberg's sumptuous, deliriously lavish design for *Shanghai Express*. The film was also nominated for, but did not win, the Academy

Awards for Best Picture and Best Director. Surprisingly, Dietrich wasn't even nominated for Best Actress.

This is the visual terrain of *Shanghai Express*. It's a place that exists only in the mind of von Sternberg and the eye of the beholder; for the duration of the film we're all passengers, bound for an uncertain destination. Like all of von Sternberg's work, *Shanghai Express* is an entirely personal project over which the director—in the pre-Code era, before the Hays/Breen Office clamped down on precisely the sort of moral ambiguity that the film displays—had nearly complete control. Although whether it made money was almost immaterial to von Sternberg, the film was a huge hit with the public, grossing $3.7 million in its initial engagements in the United States alone (more than $55 million today adjusted for inflation). So here's a film that has it both ways: a completely personal vision that nevertheless struck a reverberating chord with a public desperate to escape the darkest days of the Depression for a world of fantasy and romance, exoticism and danger. All this was achieved through Garmes's black-and-white cinematography, perhaps the film's greatest artistic achievement. As he noted, "I think you have to work a lot harder as a cinematographer with black and white film than you do with color. In color you can be a lot lazier in your work and still come out pretty well. In black and white you've really got to work hard to get your separations, distances, and depths" (59).

Another groundbreaking film of the 1930s was W. S. Van Dyke's comedy/mystery *The Thin Man* (1934), shot in a reported twelve days by the gifted James Wong Howe, who used deep shadows and equally sharp, saturated images, setting the film apart from all the series' subsequent and indifferent sequels. Howe always favored a more realistic style of lighting in his films—or so he said—and although he would eventually acquiesce to requests for more conventionally "dramatic" lighting, he was clearly unhappy about it. As he told Charles Higham, "I have a basic approach that goes on from film to film: to make all the sources of light absolutely naturalistic. . . . In *The Thin Man*, the director wanted shadows because it was a mystery, too many shadows. Often I didn't see where a light was in a room to make a shadow, but he'd say, 'There's a blank space on the wall, let's fill it,' and I'd make him a shadow. I threw away naturalism on that picture, unfortunately" (Higham, *Hollywood* 75).

Nevertheless, in his deeply textured, carefully interlocking shadows in *The Thin Man*, Howe, while still working at top speed to keep up with

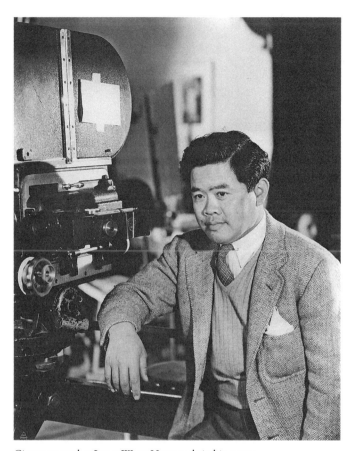

Cinematographer James Wong Howe early in his career

the director, crafted a world that was at once seductive and wholly syn-
thetic, interpreting rather than mimicking reality, whether he wished to
acknowledge it or not. As he admitted to Higham, "I wanted it stripped of
shadows, except for one effect when the thin man [inventor Clyde Wyn-
ant, played by Edward Ellis, or] the detective Nick Charles, walks and casts
a long, long thin shadow. All the shadows [Van Dyke] wanted would dis-
sipate the effect. We disagreed, and finally we compromised" (*Hollywood*
87). Otherwise, Howe noted, "most directors leave the lighting to you":

> On *Hud* [1963; director] Marty Ritt said to me, "That sky in Texas looks
> flat. Can we put clouds in?" I told him we could double-expose as many
> as he liked, and I ran him reels and reels of every kind of cloud, cirrus,

cumulus, everything. Then I said, "We'll be *decorating* if we use clouds. It's not real." . . .

In William K. Howard's *Transatlantic* [1931] I used deep focus and ceilinged sets ten years before *Kane*. They'd never heard of 24mm lenses at the studio—I went to downtown Los Angeles and bought them specially—and I had a terrible argument with the art director, Gordon Wiles. I said, "Make the passageways narrow. Put ceilings in." He said, "I can't, you won't be able to light them." I said, "Don't worry, I'll do it." And he did put the ceilings in and I made him change the engine-room as well, so there were more foreground pieces, more perspective. You got focus carried very far all through, although film being slower then we couldn't quite close our aperture far enough, there wasn't the exposure you have today. (Higham and Greenberg 195–196)

Howe was ultimately a traditionalist, unable to see beyond his own approach to cinematography, or to embrace newer styles of black-and-white lighting—lighting, in fact, that uses mostly natural light, but which he surprisingly dismissed out of hand. Asked what he thought of the work of New Wave cinematographers Henri Decaë and Raoul Coutard, two of the greatest DPs of French black-and-white cinema, Howe countered, "Their work has no continuity, it's catch-as-catch-can; they just go ahead arbitrarily and throw lights in. I don't think that's good. It's very difficult to achieve natural lighting. They don't seem to be aware of the difficulty. It's hardest of all, in this business, to be honest to the sources of light, to be totally real" (Higham and Greenberg 196). But as anyone who has seen, for example, Jean-Luc Godard's *Breathless* (1960), knows, Coutard staged entire sequences in the film using only natural light—including one bedroom scene using only an open window for illumination—so this criticism seems unfounded. Better to say, perhaps, that for all of his talk of "naturalism," Howe was a painter of light, depicting not how lighting actually occurs, but how it might be best used to dramatize a scene.

Busby Berkeley's musicals, for which he choreographed his signature, over-the-top dance numbers and designed the camerawork, offered audiences romance and escape, as in *Gold Diggers of 1933* (directed and with a storyline by Mervyn LeRoy) and *42nd Street* (also 1933, directed by Lloyd Bacon). Both films, however, mix a certain amount of realism in with the happily-ever-after. In *Gold Diggers of 1933*, for example, a musical number being rehearsed for a Broadway show is interrupted when bailiffs charge

into the theater to repossess the props and sets for nonpayment; the film ends with a paean to World War I veterans who can't find work in the Depression, suitably entitled "Remember My Forgotten Man," staged as a grimly elaborate musical pageant. And yet, the musical within the film ultimately rescues all the cast members from starvation. Brad Roberts (Dick Powell), the son of a millionaire, whose family doesn't approve of his show business ambitions, not only writes the score for the musical, but also puts up $15,000 to back it—an enormous sum at the time—and even takes over the leading juvenile role in the final production when the real star falls ill.

In *42nd Street*, director Julian Marsh (Warner Baxter) has been wiped out by the Depression and desperately tries to put together one last musical triumph despite his fading health, hoping to recoup his losses. Throughout the film, the entire production process of "putting on a show" is depicted as anything but glamorous; instead, it's an endless series of grinding rehearsals, backstage hardship (no one has enough to eat), and last-minute crises, particularly when temperamental leading lady Dorothy Brock (Bebe Daniels) injures her ankle just before the show's opening night. Young Peggy Sawyer (Ruby Keeler), an inexperienced but game chorus girl, is given the leading role at the last minute—"You're going out a youngster but you've *got* to come back a star!" Marsh tells her, just as he pushes her onstage for the first scene, and, of course, that's exactly what happens.

Both films were shot by Sol Polito, a Warner Bros. stalwart whose career once again stretches back to the days of the silent film, with such films as Maurice Tourneur's drama *A Butterfly on the Wheel* (1915). Born in Palermo, Sicily, in 1892, Polito came to the United States with his family in the late 1890s and broke into the business, as so many DPs of the era did, as a still photographer, camera assistant, and then a full-fledged director of cinematography on 1914's *Rip Van Winkle*, directed by Edwin Middleton.

Polito rapidly demonstrated that he was both a hard worker and able to keep up with the changing technology of the film industry. Between 1925 and 1928 he shot a series of B-westerns with star Harry Carey, such as James P. Hogan's *Burning Bridges* (1928), and soon found a permanent home at Warner Bros., quickly adapting to the new medium of sound films and creating a brilliant, pointed look that became his trade mark as a cinematographer. His output was both prodigious and varied: from

Mervyn LeRoy's tabloid newspaper drama *Five Star Final* (1931), starring Edward G. Robinson as the ultra-hardboiled editor of a big city scandal sheet; to Alfred E. Green's prescient political satire *The Dark Horse* (1932), in which an incompetent simpleton, Zachary Hicks (Guy Kibbee), is pushed into running for governor by unscrupulous campaign manager Hal Blake (Warren William); to the unflinching realism of LeRoy's *I Am a Fugitive from a Chain Gang*, Polito proved that he could tackle almost any assignment with style, assurance, dependability, and speed.

The elaborate *42nd Street*, for example, was shot in a mere twenty-eight days. These early films were rough-and-tumble affairs, photographed and directed with a utilitarian sense of workmanlike craftsmanship, and some of the most striking effects in these films were achieved through the simplest means possible. The end of *I Am a Fugitive*, for example, ends with wrongly convicted but eternally persecuted prison gang escapee James Allen (Paul Muni) disappearing into the darkness despite the desperate entreaties of his girlfriend, Helen (Helen Vinson), who asks, "How do you live?" to which Allen famously replies "I steal!" before being swallowed up by the night.

Polito went on to photograph the film version of Robert Sherwood's play *The Petrified Forest* (1936), directed by Archie Mayo, combining location work for the exterior sequences with extensive studio shooting for the interior of the café where most of the film's melodramatic action takes place. His next assignment was Michael Curtiz's epic *The Charge of the Light Brigade* (1936), but he then shifted to color cinematography on Curtiz's *The Adventures of Robin Hood* (1938), photographed by both Polito and Tony Gaudio, and co-directed by William Keighley. Gaudio was another Hollywood veteran whose career encompassed more than 140 features and short films, starting with 1909's *Princess Nicotine; or, the Smoke Fairy*, directed by cinema pioneer J. Stuart Blackton, continuing on with such films as William Keighley's wartime drama *The Fighting 69th* (1940), and ending with Lewis Milestone's *The Red Pony* in 1949. It was Gaudio who photographed Warner's first feature-length Technicolor film, *God's Country and the Woman* (1937), a lumberjack adventure film directed by Keighley, and also Keighley's black-and-white *The Prince and the Pauper* in the same year, starring Errol Flynn.

It was Flynn, of course, who would soon headline the aforementioned Technicolor spectacle *Adventures of Robin Hood*, an ambitious, $2 million gamble on the part of Warner Bros. Working with the ever-demanding

Curtiz, Sol Polito created a world of vibrant color, but he also drew on his monochrome experience to employ deep shadows in the more dramatic sections of the film, particularly the climactic dueling sequence between Robin (Flynn) and Sir Guy of Gisbourne (Basil Rathbone), further enhanced by the fact that Rathbone, an expert swordsman, worked with both Polito and Curtiz to bring out every possible ounce of kinetic energy in the scene. The film was an enormous success, much to Warner Bros.' relief, but Polito, far more comfortable in the world of black and white, soon turned his attention to other projects. Among them was the studio's adaptation of Jack London's *The Sea Wolf* (dir. Curtiz, 1941), the memorable Bette Davis melodrama *Now, Voyager* (dir. Irving Rapper, 1942), and the even more over-the-top Davis vehicle *A Stolen Life* (dir. Curtis Bernhardt, 1946), in which Davis appeared in a dual role as twin sisters Patricia and Kate Bosworth, with the aid of a good deal of split-screen camerawork and the assistance of cinematographer Ernest Haller, who shared credit with Polito.

Perhaps the most memorable of Polito's later films was Anatole Litvak's relentlessly suspenseful noir *Sorry, Wrong Number* (1948), in which invalid Leona Stevenson (Barbara Stanwyck) overhears a plot to murder her on her telephone and spends the rest of the film vainly trying to summon help. This utterly claustrophobic film, shot for the most part on one set, Leona's luxurious bedroom (though peppered with numerous flashbacks), represented a particular difficulty for Polito in maintaining viewer interest; it was based on a radio play starring Agnes Moorehead and written by Lucille Fletcher. Yet Polito embraced the challenge, and the film's final sequence—in which the shadow of Leona's killer, hired by her husband Henry (Burt Lancaster), slowly mounts the stairs to strangle her—is one of the most chilling scenes in all of film noir.

Oddly, none of Polito's three Academy Award nominations—for Howard Hawks's ultra-patriotic antipacifist tract *Sergeant York* (1941), shot almost entirely on soundstages with obvious backdrops and theatrical sets, and photographed in a flat, indifferent manner, atypical of Polito's work as a whole; the equally unremarkable color production *The Private Lives of Elizabeth and Essex* (dir. Michael Curtiz, 1939), which Polito shared with fellow DP W. Howard Greene; and Curtiz's wartime aviation drama *Captains of the Clouds* (1942), starring James Cagney and Dennis Morgan—were up to the standard of his best black-and-white work, and he never took home the award in any case. Polito remains

best known for his moody black-and-white work and for his adaptability to an entirely different way of composing a scene when Technicolor came along.

Another indigenous American cinema that flourished during the 1930s and 1940s is all too often ignored. African American cinema operated outside the Hollywood mainstream and shot feature films on the most meager of budgets, offering blacks an opportunity to see themselves on the screen in roles other than that of servants, comic buffoons, or Pullman porters. The foremost exponents of this marginalized cinema are Spencer Williams and Oscar Micheaux, two directors who created work of lasting worth and beauty when everything seemed to conspire against them. Micheaux, for example, had been making films since 1919, when he wrote, produced, and directed *The Homesteader*, based on his own novel, and even more importantly *Within Our Gates* (1920), Micheaux's response to D. W. Griffith's ultra-racist *Birth of a Nation*.

As Anna Siomopoulos notes, "*Within Our Gates* also counters *The Birth of a Nation* in the politics of its aesthetics, specifically in its very different use of parallel editing. Griffith's film uses crosscutting to present a very simple opposition between white virtue and black villainy; in contrast, Micheaux's film uses a complex editing pattern to present a larger social vision of many different, competing political positions within both white and African-American society" (111).

In this fashion, Micheaux continued on with *The Brute* (1920), *Symbol of the Unconquered* (1920), *The Gunsaulus Mystery* (1921), *The Dungeon* (1922), *The Virgin of Seminole* (1923), *Deceit* (1923), and *Body and Soul* (1925)—the latter perhaps his most famous silent film after *Within Our Gates*, featuring a young Paul Robeson in a dual role—all of which Micheaux produced, wrote, and directed. Unfortunately, the names of most of Micheaux's technical crew members, including his DPs, appear to have been lost to posterity on these early films. It isn't until the sound era and *The Exile* (1931) that we get any credits for cinematography on Micheaux's films, in this case two white men, Lester Lang and Walter Strenge.

Micheaux was authoritative on the set, refusing to let anyone interfere with his vision, willing to put up with slipshod equipment, inexperienced casts, and budgets as low as $5,000 for a feature film—an astounding figure by any standard, when absolute bottom-rung Hollywood films cost at least $25,000 for even a sixty-minute B-western. DP Lester Lang again

worked with Micheaux on the drama *Ten Minutes to Live* (1932), which Micheaux wrote, produced, directed, and acted in; as well as the musical *Swing!* (1938), *God's Stepchildren* (1938), *Lying Lips* (1939), and *The Notorious Elinor Lee* (1940) before Micheaux was forced by financial and personal circumstances to wait seven years to make his final film, *The Betrayal* (1947), photographed by Marvin Spoor.

While obviously compromised by their threadbare production circumstances, Micheaux's films, and those of Spencer Williams, William D. Foster, George Randol, and other black cineastes, radiate a confidence, an ebullience of spirit that is both infectious and welcoming, as if to say, "Here's another way to look at American society, if you wish to do so," and an effective antidote to the all-white world of MGM, Paramount, Universal, and the other major studios, and even the minors, such as Republic, PRC, and Monogram. Here was a vision of American life you could see nowhere else, screened for the most part in theaters that catered solely to an African American clientele, and deeply resonant in their crisp, unadorned cinematography as well as their undeniable cultural value.

In Europe, where the cinema had been allowed to develop more as an art form than a strictly narrative, commercial medium—witness such early black-and-white masterpieces as Jean Cocteau's *Blood of a Poet* (shot in 1930, but released in 1932, and photographed by the great Georges Périnal) and Luis Buñuel's violent yet romantic surrealist tract *The Age of Gold* (1930), photographed by Albert Duverger—both directors and cinematographers were intent on exploring the absolute limits of the black-and-white image as a phantasmal construct, divorced from real life, and containing an undeniable aura of surreal mystery. As director Jean Renoir noted in an interview with Jacques Rivette and François Truffaut,

> There's an element of surprise in black and white that you don't have in color. Black and white also gives the director and the cameraman an infinite number of possibilities for special effects. Suppose you have an actor who can't play a scene well. You have to admit he's a little weak in expressing certain emotions. So you use some unrealistic lighting, with exaggerated lights. On one side you have absolute blackness, and on the other you hide half of his face. He emerges from a kind of vague shadow, and suddenly he becomes very talented, and the scene can be very good. So I think that with color, you have to abandon these special effects; it's a matter of being more and more honest. That's all. (46)

Working with cinematographer Georges Asselin, Renoir crafted a naturalistic, deeply human visual style in such films as *Boudu Saved from Drowning* (1932), further enhanced by the then revolutionary use of a mobile sound-on-disc truck for sound recording, just as Arthur Edeson used a newsreel truck to shoot *In Old Arizona* in 1928, when studio executives told him he couldn't shoot sync-sound outdoors. Further, unlike his Hollywood counterparts, Renoir made profitable use of the crowds who gathered whenever he filmed outside, as in the scene in which the title character, Priape Boudu, the tramp (Michel Simon), is unceremoniously fished out of the Seine after a botched attempt at suicide.

One might call Asselin's work here almost documentary, but he was equally at home in the studio, as shown by the film's opening fantasy sequence, as well as his assured and intimate lighting on the set that constitutes the home of Édouard Lestingois (Charles Granval), the bookseller who rescues Boudu from a watery grave. Asselin brought much the same sense of poetic realism to his work on *La Maternelle* (1933), directed by Jean Benoît Lévy and Marie Epstein, which tells the story of a young woman, Rose (Madeleine Renaud), who works at an elementary school for the desperately poor in Montmartre, and forms a bond with an especially troubled young girl, Marie Coeuret (Paulette Elambert), leading to censure by the school's administration. As with *Boudu*, Asselin's style is at once direct and empathetic, using a mixture of natural illumination and studio lighting to achieve a nuanced, subtle look for both projects, which he carried over in his other work.

In France during the 1930s, cinematography was much more widely viewed as an art form rather than just a means of capturing images on a strip of celluloid to tell a story; the brilliant cameraman Georges Périnal is one outstanding example of a DP who left his own imprint on all the work he accomplished. For director René Clair, he photographed three masterpieces in a row: *Sous les toits de Paris* (1930), *Le Million* (1931), and, perhaps Clair's finest film, *À nous la liberté* (1932), which centers on two convict pals in a forbidding, automated prison, where everyone is forced to behave with robotic precision. One of them, Louis (Raymond Cordy), manages to escape, and works his way up the corporate ladder until he becomes the head of an enormous phonograph manufacturing conglomerate; the other, Émile (Henri Marchand), is eventually released, and winds up working in one of Louis's factories, where conditions are just as regimented as they were in prison. Charles Chaplin famously used

many of the same visual gags in his film *Modern Times* (1936), photographed by Ira Morgan and Roland "Rollie" Totheroh, so much so that Clair's production company, Tobis, sued Chaplin for plagiarism, though Clair refused to join the lawsuit, saying that he was artistically indebted to Chaplin, as were all filmmakers (McGeer 104).

For the multitalented artist Jean Cocteau, Périnal photographed his first feature film, *The Blood of a Poet* (shot in 1930, but released in 1932), and then during a long sojourn in England shot Alexander Korda's *The Private Life of Henry VIII* (1933), starring Charles Laughton as the oversize monarch; the Academy of Motion Picture Arts and Sciences was stunned when Laughton walked off with the Best Actor Oscar, and the film itself was nominated for Best Picture, though it didn't win. Périnal followed this picture by lensing William Cameron Menzies's prophetic science-fiction epic *Things to Come* (1935), with an original screenplay by H. G. Wells, which accurately depicted the coming conflict of World War II as well as numerous technological advances such as Skype, instant messaging, and space travel to the moon.

This was followed by Korda's *Rembrandt* (1936), also with Charles Laughton, which, needless to say, Périnal photographed as if the film comprised a series of paintings by the great artist, with pictorial compositions that precisely re-created Rembrandt's signature lighting strategies. During this highly productive period, Périnal also lensed Josef von Sternberg's aborted version of Robert Graves's *I, Claudius* (1937), again starring Laughton, but the film was fraught with difficulties and was shut down after one of the stars, Merle Oberon, was seriously injured in a road accident; Périnal's work on the film nevertheless survives in Bill Duncalf's documentary *The Epic That Never Was* (1966), in which the surviving participants in the film dissect the production's unfortunate collapse. Not coincidentally, all three films were in black and white.

Périnal's later work was uneven. His work on Carol Reed's adaptation of Graham Greene's story *The Fallen Idol* (1948), for which Greene wrote the screenplay, is immaculate; but he was hardly a likely choice to co-photograph, with José Luis Pérez de Rozas, the Spanish version of the distinctly low-budget, low-quality programmer *Babes in Bagdad* (dir. Jerónimo Minura, 1952), much less Paul Dickson's threadbare science-fiction film for the notoriously penurious producers the Danzigers, *Satellite in the Sky* (1956). Yet even in his final work, there are some real gems, such as Chaplin's bittersweet *A King in New York* (1957),

Otto Preminger's *Bonjour Tristesse* (1958), and the remarkably ambitious fairytale spectacle *tom thumb* (dir. George Pal, 1958). Overall, as historian Barry Salt astutely notes, Périnal's greatest accomplishments were in France and England in the 1930s, especially with his work on *Rembrandt* and *Henry VIII*:

> Périnal was able to create the apotheosis of the European style in a series of Korda productions that he lit in the late thirties. The way of the best European film lighting since about 1913 had been to light the set and actors as one unit, and to apply no separate light (or very little) to produce special modeling on the actors. Périnal managed to combine an elegantly simple disposition of the major shadows on the set with glossy treatment of the figures at the appropriate moments. This creation of simple large geometrical shapes in the solid black shadows cast on the background of shots means that Périnal's lighting is probably the only work in the late thirties that can be attributed to its author without prior sight of a film's credits. (24)

Jean Renoir, in the meantime, was moving to a more highly polished style, most notably the World War I drama *Grand Illusion* (1937), photographed by Christian Matras, and *Rules of the Game* (1939), his masterpiece about French society in collapse on the eve of World War II. For *Rules of the Game*, Renoir used no fewer than four cinematographers, Jean-Paul Alphen, Jean Bachelet, Jacques Lemare, and Renoir's own son, Alain Renoir, along with a young Henri Cartier-Bresson as one of his assistant directors. Together they created a glittering world of power and privilege ruled by the fabulously wealthy, foppish, yet deeply sympathetic Robert de la Cheyniest (Marcel Dalio) and his wife, Christine (Nora Gregor), the hosts of a weekend gathering for aviator André Jurieux (Roland Toutain), who has just crossed the Atlantic Ocean in a record-breaking flight.

The film is rife with subplots in a sort of "upstairs, downstairs" fashion in which the aristocracy, as represented by Robert, Christine, Robert's mistress, Geneviève (Mila Parély), and their free-loading houseguest Octave (played by Renoir himself), find themselves enmeshed in the domestic troubles of their servants—Christine's maid Lisette (Paulette Dubost), her brutish gamekeeper husband Edouard Schumacher (Gaston Modot), and the poacher Marceau (Julien Carette), along with a multitude of other guests, until the weekend comes to a halt with the

film's haunting conclusion—the death of André Jurieux as the result of a tragic case of mistaken identification and romantic jealousy.

Most of the film's action takes place on location, at the Château de La Ferté-Saint-Aubin in Loiret, for the exterior shots of Robert's sumptuous country residence, with interiors photographed at the Studio Pathé-Cinema in Joinville-le-Pont, Val-de-Marne. Renoir's use of the camera in the film is exceptional, gracefully tracking through this world of privilege and power with style and assurance, as the studio floors, polished to a high sheen, serve as the perfect stage for the tragi-comedy unfolding before us. The centerpiece of the film is an unforgiving, roughly five-minute sequence of the partygoers blasting pheasants and rabbits with their shotguns during a hunting expedition, engaging in ritual slaughter with casual indifference, made all the more real by the fact that it *is* real: no special effects or prosthetic "dummy" animals were used.

Just as the rabbits and pheasants fall before the guns of the weekenders, so too will French society collapse with the invasion of the Nazis in May 1940. Renoir saw this coming, and *Rules of the Game* remains one of the most penetrating social critiques ever created precisely because of this; Robert de la Cheyniest and his guests and servants are oblivious to the catastrophe that awaits them, and they will all pay a price for it. When the film was first released, it was met with a storm of disapproval from both the critics and the public. Though Renoir disingenuously disavowed any social critique, his true intent was obvious. Renoir was forced to cut the film due to the hostile public reception, and it was soon withdrawn from distribution; reconstituted in 1959 by Renoir, Jean Gaborit, and Jacques Marechal, *Rules of the Game* was declared a masterpiece, and is now routinely included in "ten best" lists of the greatest films ever made.

Hollywood, in contrast, was all about fantasy during the Great Depression, seeking to distract moviegoers from their quotidian reality. As Charles William Brooks aptly notes,

> The brightness and glamour of American films and their stars were consciously meant to counterpoint the drab material tone of American life in these years; with a few notable exceptions they were an expression of hope rather than a reflection of reality.
>
> It is not surprising that the one film genre spawned by the Depression was one which rejected consistency and consequences, the screwball comedy, so called because it was based on caprice and the possibility of sudden,

inexplicable changes in fate and fortune. What is probably the most famous Depression comedy, [Gregory La Cava's] *My Man Godfrey* [slickly photographed by studio veteran Ted Tetzlaff], denied the reality of the Depression; for Godfrey, the bum who becomes a butler but is in fact all the time a wealthy man, the Depression is a sham, and in the end he shows it to be a sham for everyone else in the film by bailing his employers out of impending bankruptcy and by turning the shanty town where he had lived into a posh night club employing its formerly out-of-work inhabitants. (264)

Yet fantasy can take many forms. For some, Universal's monsters were reassuring precisely because their threat *wasn't* real; seated in a theater with hundreds of other viewers gathered nearby for "safety," a spectator could enter into the world of vampires, werewolves, and dead bodies brought back to life with no real risk. The violence of the gangster films brought catharsis—audience members could fantasize "taking" what was rightfully theirs, what had been stolen from them by the banks, the speculators, and the plutocrats at the point of a gun. But perhaps the most enduring fantasy of the 1930s, and one that the public still seems to embrace with uncritical alacrity, is the populist vision of director Frank Capra, particularly in his 1930s films for Columbia, as photographed by his favorite cinematographer, Joseph Walker, who, in addition to working tirelessly for Capra, compiled a list of more than 140 credits as a director of cinematography before his retirement in 1952.

Capra, however, was rather peevishly dismissive of Walker's contributions to his films, telling interviewer Harry Hargrave in 1976 that he and Walker

did a lot of experimenting together with the use of lenses and with the use of masks and with the use of gauze, and things like that . . . but if you see the machinery, the story's going out the window. It is not a machinery-to-the-people medium. It's a people-to-people medium. The actors are telling the story. You can only involve the audience in the lives of the actors and characters that the actors are playing. You can't involve them in machinery. They don't give a darn about a sunset, or a fast moving camera, or a hand-held camera, or anything like that. These are ego-massaging, little, egocentric things that directors indulge in, and we indulge in for ourselves and for each other. But audiences are bored with that. (197)

Not surprisingly, for someone with such a traditional view of cinematography, Capra was an early proponent of multi-camera shooting, noting that despite the problems of lighting a scene for three cameras,

> it's worth the effort because then you've got that scene photographed from three different angles, and you just intercut those angles at will. You can go from one to another without fear of stopping the pace or the effects of the scene or anything else, because it is one scene being photographed from several angles. And if you have to stop in between and photograph all those angles separately, you're liable not to get the same intensity, the same character of the scene, the same kind of mood of the scene, the same feeling of the scene as when it's photographed all at the same time. And then you pick up close-ups from one of the other cameras at the same time that the master scene was being photographed. (199)

In short, the camera, for Capra, must always remain in service to the narrative, and refrain from any Brechtian "distancing" for an audience eager to identify with the protagonists on the screen. Even when he wasn't working with Walker, Capra left the nuts and bolts of lighting to his cameramen, sometimes with excellent effect as in his film *Meet John Doe* (1941), beautifully photographed by George Barnes. As many critics have noted, Capra's faux populism fell out of public favor by the late 1940s, although his film *It's a Wonderful Life* (1946), which Walker photographed for Capra's independent company Liberty Films, became a Christmas classic, endlessly re-run on television.

Walker, still under contract to Columbia, from which Capra had long since acrimoniously departed, had to be wrangled into photographing *It's a Wonderful Life* after Capra and the first DP on the film, Victor Milner, repeatedly clashed on the set. As veteran camera operator and later DP Joseph Biroc, who also worked on the film, recalled, "Vic was a perfectionist. . . . [Capra] was a perfectionist about the people and the dialogue, but not about lighting. He couldn't care less if it was a few feet this way or that way. Vic didn't like a lot of stuff that Capra was doing" (McBride 528).

Walker and Biroc finished the film, reshooting much of Milner's material, but as DP George Folsey later commented, when he worked with Capra on *State of the Union* (1948), "I never had one single bit of

A scene from Frank Capra's *Meet John Doe* (1941), with cinematography by George Barnes

conversation with Capra about the photography. I didn't have any prob-lem with him, except for the fact that he would never talk about it" (McBride 538). Perhaps Capra's films, then, are really more dependent on Joseph Walker than he cared to admit; far from having, as Capra put it, "no particular style" (Hargrave 197), Walker might rightly be considered the visual architect of Capra's most effective films.

Indeed, one might well argue that Walker helped Columbia Pictures immeasurably in the 1930s and 1940s by being instrumental in creating the studio's own distinctive visual identity. As Ethan Mordden percep-tively comments in his book *The Hollywood Studios*, "Most significant of all the studio staff was the combination of director and cameraman"

(13), which would rapidly serve to establish each studio's vision. MGM's slickness, even glossiness, was dependably the same from one film to the next, with equally nondisruptive editorial patterns to match, supervised by the studio's editorial head, Margaret Booth; Warner Bros.' style was hard-edged, sharp, impatient, torn from the day's headlines; Paramount pursued a dreamy, suffused look, dripping with glamour, even in their comedies with the Marx Brothers, such as Leo McCarey's *Duck Soup* (1933, d.p. Henry Sharp); and Universal's hallmark was its deeply shadowed horror films and blindingly bright Abbott and Costello comedies, as best exemplified by the work of master cinematographer Joseph Valentine.

In a 1939 interview, Valentine explained how a classic black-and-white image of the era was set up for the camera, using sets that were designed and executed entirely in just four pastel shades rather than in full color. *Three Smart Girls Grow Up* (dir. Henry Koster, 1939) was the first film shot at Universal to utilize Plus X negative black-and-white stock, which Valentine described as

> a system of painting sets with a standardized range of pastel shades. . . . This system consists of four standardized pastel tones: a violet-gray, a blue-green, a pink, and a tan. Each of these is in turn divided into four standardized shades, ranging from a No. 1 or light shade, which is virtually a pure color, to a No. 4 or dark shade. The darkened numbers are produced not by deepening the color but by graying it. In practical terms this means that we have a range of sixteen standard colors for use in painting our sets. . . . When the art director specifies such-and-such a color scheme for his set, he not only knows precisely how it will look, but from tests and production already available to him he knows how each shade will photograph. (Valentine 56)

Thus, the deeply saturated blacks and whites in a Universal film of the late 1930s and early 1940s are the result of a careful and entirely artificial color design, which exists only to be transformed into a crisp, monochrome image. Thus, when one thinks of Valentine's rich, vibrant images in such films as *Shadow of a Doubt* (dir. Alfred Hitchcock, 1943) and *Saboteur* (dir. Hitchcock, 1942), to name just two of many possible examples, one is remembering a series of settings, as well as costumes and facial makeup, designed specifically for transmutation into a black-and-white image, all of which would seem entirely bizarre if rendered in color. As Valentine

noted, "Sooner or later, natural color cinematography will *force* us to use color" (56; my emphasis), but in a firmly monochrome universe, "why should we not make use of the known facts of monochrome color rendition" in the films of the classical Hollywood era?

Valentine also had very definite—if not exactly accurate—ideas on the differences between Hollywood and European cinematography of the 1940s, as he told John Erskine in no uncertain terms in a 1941 interview, saying that Hollywood cinematographers were trying to get

> more of the three-dimensional effect [in their work]. We've always been trying to get away from a flat picture, like a painting on a canvas. French pictures made in the studio use more powerful lights than Hollywood does, but they diffuse the light by some kind of screen. The French like a little mistiness in a film, as in their personal photographs. The American picture maker needs less light because he'll use all he has. His audience wants the picture to be clear, even in the background. (Erskine 49)

One of the more interesting monochrome productions of the early sound era was F. W. Murnau and Robert Flaherty's *Tabu* (1931), which was shot on location in the South Pacific and photographed by cinematographer Floyd Crosby, who would ultimately win an Academy Award for his work on the film. Crosby was one of the most adept and adventurous cinematographers of the late silent and the early sound era, beginning with his entirely uncredited work as, in his own words, "an assistant" to cinematographer Clyde de Vinna—who won an Academy Award for his efforts—on W. S. Van Dyke and Robert Flaherty's *White Shadows in the South Seas* (1928) (Langer, "Tabu" 38).

Another major figure of the 1930s was Bert Glennon, whose career began with Donald Crisp's 1916 production of *Ramona* and ended in 1963 with his work in episodic television in *77 Sunset Strip* and other teleseries. By 1923, he was one of five cameramen on Cecil B. DeMille's first version of *The Ten Commandments*, along with J. Peverell Marley, Archie Stout, Fred Westerberg, and Ray Rennahan, who supervised the two-strip Technicolor sequences in the film. In the 1930s and 1940s, Rennahan would become Technicolor's most prolific in-house photographer.

By the late 1920s, Glennon was working for Josef von Sternberg on his classic gangster film *Underworld* (1927), as well as *The Last Command* (1928), the tragic tale of a former Imperial Russian officer from the

A scene from F. W. Murnau and Robert Flaherty's *Tabu* (1931), shot on location in the South Pacific, and photographed by cinematographer Floyd Crosby

czarist era who has been reduced by circumstances to the lowly position of a Hollywood extra, with a superb performance by Emil Jannings in the leading role. As sound films arrived, Glennon shot one of von Sternberg's most outrageous Dietrich vehicles, *Blonde Venus* (1932), in which the star dresses up in a gorilla suit for a musical number at one point, as well as von Sternberg's *The Scarlet Empress* (1934), and Gregory La Cava's equally peculiar fantasy *Gabriel Over the White House* (1933), in which U.S. president Judson Hammond (Walter Huston) becomes an agent of heavenly destiny in leading the country out of the Depression. In addition, Glennon and DP Henry Sharp photographed Norman Z. McLeod's bizarre live-action version of *Alice in Wonderland* (1933) with an all-star cast, including Gary Cooper as the White Knight, W. C. Fields as Humpty-Dumpty, Cary Grant as the Mock Turtle, and Edward Everett Horton as The Mad Hatter, to name just a few, featuring production design by William Cameron Menzies, who just six years later would supervise the entire physical look of Victor Fleming's *Gone with the Wind* (1939).

But with *The Prisoner of Shark Island* (1936), directed by John Ford, Glennon finally found a director with whom he was truly in sympathy. Ford's deeply economical style and his no-nonsense approach appealed to Glennon's equally straightforward style of cinematography, which he had been forced to suppress when filming the exoticist spectacles devised by von Sternberg for Paramount. Working for Ford and producer Darryl F. Zanuck at Twentieth Century–Fox in a much more realistic style, Glennon was able to directly embrace his material in the story of Dr. Samuel Mudd (Warner Baxter), who, after John Wilkes Booth's (Francis McDonald) assassination of President Lincoln, unwittingly treats the actor's broken leg and is then unjustly imprisoned under the supervision of the sadistic Sergeant Rankin (John Carradine).

In a 1968 interview, fellow director Burt Kennedy asked John Ford why he favored black-and-white cinematography, mentioning that he, too, had worked with Glennon and was very pleased with the results. As Ford told Kennedy, "Anybody can shoot color; you can get a guy out of the street and he can shoot a picture in color. But it takes a real artist to do a black and white picture" (Kennedy 135–136). This suited Glennon perfectly. As Arthur Knight observed regarding one of Glennon's most illustrious collaborations with Ford, *Stagecoach* (1939):

> *Stagecoach* was, for [Ford], his first trip to Monument Valley, and it was a case of love at first sight. Never before had its grandiose scenery been captured so crisply, so lovingly as it was by Bert Glennon's camera. But apart from these natural grandeurs, the camera was utilized in the best Ford tradition—functional, utilitarian, without frills. The camera is so still throughout most of the film that when it does move—a pan for the river crossing, the tilt and pan up to the Indians waiting on the bluff, the wild traveling shots during the Indian attack—the very fact of its movement enhances the excitement of these sequences. But the camera placement is also exciting in its stillness. . . . His lighting, while always stark and dramatic, is rarely artificial. (Knight 143)

As Knight points out, however, excessive use of rear-projection in some of the dialogue sequences detracts from the film, which otherwise is a marvel of realism, down to Yakima Canutt's superb stunt work, captured so ably by Glennon and his crew.

Stagecoach won two Academy Awards, Best Supporting Actor (Thomas Mitchell, as the alcoholic Doc Boone) and Best Music Score, and was nominated for an additional five Oscars: Best Picture, Best Director, Best Art Direction (Alexander Toluboff), Best Black and White Cinematography (Glennon), and Best Film Editing (Otho Lovering and Dorothy Spencer). Without some remarkable luck, however, it might have been impossible to enjoy *Stagecoach* today: the original negatives were somehow lost, but the film's star, John Wayne, had a 35 mm positive print in his possession, which, amazingly, he had never screened and so was in pristine condition. In 1970, Wayne allowed the print to be used to strike a new negative for the film, from which all subsequent restoration masters derive (Clooney 191).

The impact of *Stagecoach* was immediate and lasting, and, of course, it is immeasurably better in black and white than it would have been in color, with Glennon's stark desert imagery as the centerpiece of the film. (Proof of this fact, as if any is needed, was amply provided by Gordon Douglas's abysmal color remake of *Stagecoach* in 1966, photographed by William H. Clothier, which lacked any of the impact of the original film.) Glennon was nominated for a second Academy Award in the same year, for his work on the color production *Drums Along the Mohawk* (1939), also directed by Ford, which Glennon shared with Ray Rennahan. He would receive a third nomination for Michael Curtiz's Technicolor production *Dive Bomber* (1941, co-photographed with Winton C. Hoch), but Glennon never took home the statuette.

It's interesting to note that while *Drums Along the Mohawk* was an A-picture all the way, starring Henry Fonda, Claudette Colbert, and John Carradine and lavishly produced at Twentieth Century–Fox at great expense, the film is little remembered or esteemed today; rather, it's the economical western *Stagecoach*, noted for its style and simplicity, which resonates in one's memory—clear, clean, and direct.

Indeed, 1939 was a banner year for both Ford and Glennon, as they collaborated on a third film, Ford's *Young Mr. Lincoln*, starring Henry Fonda in the title role, on which Glennon was assisted by an uncredited Arthur C. Miller. Even more astonishing is the fact that Glennon photographed an additional two films with other directors during the same period. The first, on which he collaborated with DP Miller, was Clarence Brown's epic spectacle *The Rains Came* (1939), starring Tyrone Power and

Myrna Loy, featuring exceptional special effects when an enormous dam cracks due to excess rain, for which Fred Sersen and Edmund H. Hansen won an Academy Award. The other was Sidney Lanfield's highly fictionalized biography of songwriter Stephen Foster, *Swanee River* (1939), which Glennon shot entirely on his own, with Twentieth Century–Fox's busiest star of the era, Don Ameche, as Foster, and Al Jolson in a supporting role as Edwin P. Christy, the founder of the turn-of-the-century vaudeville act Christy's Minstrels.

Glennon would work with Ford again on two more westerns in 1950, *Wagon Master* and *Rio Grande*, both shot in black and white, and then go on to lens the downbeat noir *Crime Wave* (dir. André De Toth, 1954), photographed with appropriately menacing shadows, before teaming with De Toth to create the first major studio 3-D full-color film, *House of Wax* (1953), co-photographed with J. Peverell Marley and an uncredited Robert Burks, starring Vincent Price as the mad proprietor of a wax museum. Although Glennon subsequently continued to work in such teleseries as the early and extremely violent police procedural *M Squad*, starring Lee Marvin, as well as numerous western series, it is for his work with Ford that Glennon is best remembered, work done in austere, sculptural black and white.

George Folsey, another master of the black-and-white cinema, began working in 1915 as an assistant on James Durkin's short film *The Incorrigible Dukane*. His career stretched all the way to the linking sequences in Gene Kelly's 1976 musical compendium *That's Entertainment II*, racking up more than 160 credits along the way. Like many other artists of the era, he sought both inspiration and guidance from classical painting. He began haunting museums, wondering, in his words,

> how the hell could I get my film to look like the famous paintings of the old master artists I saw in the museums. My first experience came when I saw old master artists at the museums using light for all kinds of effects. From that time on I had it in my mind to photograph my subjects with that in mind. I was an ambitious kid, and wanted my scenes to look better than usual. I had trouble figuring this out and went on my own time to art school to learn more about photography. (Wanamaker 43)

Folsey worked first at the Biograph Studios at 175th Street in the Bronx before being transferred to First National's West Coast studios,

then returned to Paramount's Astoria Studios in New York, which were at the time a central part of the studio's sound production facilities. Since "talkies" demanded trained stage actors, capable of delivering dialogue in long takes to accommodate the inherent clumsiness of early sound technology, performers would often appear in productions on the Broadway stage at night while shooting at the Astoria Studios during the day (Wanamaker 44). Like many cinematographers of the early sound era, Folsey was faced with the problems of the new use of incandescent lighting on the set, as well as the notorious "soundproof booth" cinematography of the era. Director Rouben Mamoulian had more or less pushed Folsey to make the camera more mobile on the backstage drama *Applause* (1929), and now Folsey put Mamoulian's lessons to good use on his other Astoria productions.

It was during this period that Folsey developed a predilection for "bounce" lighting, in which light rebounds from a reflective surface into the scene rather than illuminating the performers and sets directly. As Marc Wanamaker notes,

> During [the early 1930s], Folsey's interest in "bounce light" developed. At MGM, the head of the laboratory, Jack Nickolaus, increased the speed of the developing machines, resulting in bringing out more contrast in the film. The finished product posed different problems, but Folsey, with his inventiveness, created new techniques in the field. He hung large silk sheets and diffusers in front of the lights, creating an effect of soft light. He had to increase the amperage in the lighting to compensate. The results were exceptionally good. Folsey had what he wanted. From the early thirties and into the 1940's, he was known for his bounce light inventiveness. (46)

In addition to helping pioneer the "bounce lighting" technique, Folsey was also one of the chief designers of MGM's ubiquitous "museum lighting," in which most of the illumination on the set comes from an even, overhead lighting grid, with a minimum of shadows, giving the film a somewhat bland, processed look. It might also explain why, of all the cinematographers discussed in this volume, Folsey was the most compliant when early Technicolor was introduced into the studio system; he created some memorable, if overly idyllic, images of small-town America for Vincente Minnelli's classic musical *Meet Me in St. Louis* (1944), in large part because he embraced the supervision of Natalie Kalmus,

Technicolor's on-the-set watchdog on all their productions in the 1930s and 1940s. The almost blindingly bright "hard" colors of 1930s and 1940s Technicolor practically pleaded to be softened with a more refined palette, but for Folsey, Kalmus's input proved an invaluable asset.

Still, when he was given the assignment to shoot a big-budget film in black and white, Folsey seized the opportunity to create an impressive and poetic visual world of light and shadows on Victor Saville's historical romance *Green Dolphin Street* (1947), which won him another Academy Award nomination. As Folsey told Wanamaker, he pushed his work with bounce lighting to new extremes in the film, which ultimately had a very different look from other MGM films of the late 1940s. Said Folsey, "People said that this film was a breakthrough with reflected light. I was interested in bounce light techniques for many years, as you know. But with this film, I had a lot of latitude to work with. I would bounce the light off of big silk sheets placed around the set. They all talked about reflected light being a new thing. I laughed, because I had been experimenting with it long before it became a 'new' technique" (Wanamaker 47).

The technique is still used today. In 1989 I had a chance to observe firsthand as two-time Academy Award–winning cinematographer Freddie Francis worked on the set of the otherwise undistinguished film *Her Alibi* (dir. Bruce Beresford, 1989). The film was shot on location in an enormous private house, and so the lighting had to be adjusted for each sequence within decidedly cramped quarters. For a simple shot of star Tom Selleck shaving in the bathroom, the crew was momentarily stymied as to how to light the scene—there was simply no room in the extremely small space. Almost intuitively, Francis immediately effected a solution. Placing a light in the hallway outside the bathroom, Francis bounced the light off the bathroom mirror onto Selleck's face, thus accomplishing two objectives in a single stroke. The shot now had a much softer, more atmospheric look, and it kept the production moving at top speed. "That's why I get paid the big bucks," Francis joked after setting up the lights with his gaffer. The sequence was filmed in a matter of minutes.

Folsey increasingly seemed more at home on such Technicolor extravaganzas as Vincente Minnelli, Richard Whorf, and George Sidney's epic biopic on the life of Broadway composer Jerome Kern, *Till the Clouds Roll By* (1946, co-photographed with Harry Stradling Sr.), and as a dependable company man, he would also cheerfully knock out such

program assignments as *Andy Hardy's Double Life* (dir. George B. Seitz, 1942) or *Dr. Gillespie's New Assistant* (dir. Willis Goldbeck, 1942) at the same time as he worked on prestige assignments like Minnelli and Fred Zinnemann's black-and-white romance *The Clock* (1945) or Frank Capra's political comedy/drama *State of the Union* (1948), also in black and white, one of the celebrated teamings of MGM stars Katharine Hepburn and Spencer Tracy.

Folsey would go on to photograph in black and white George Cukor's *Adam's Rib* (1949), one of the best of the Hepburn/Tracy vehicles, and Robert Wise's corporate takeover drama *Executive Suite* (1954), before filming Stanley Donen's Technicolor and CinemaScope musical *Seven Brides for Seven Brothers* (1954), which, again, exists in a world of bold, blazing color evenly lit throughout the frame, and is considered one of the finest musicals of the era. One of Folsey's last assignments for MGM was Fred M. Wilcox's Shakespearean-themed science-fiction classic *Forbidden Planet* (1956), an equally "set defined" film, with all its exterior sequences shot in the studio. Yet on *Forbidden Planet*, this strategy worked in creating the artificial paradise of the distant planet Altair IV, which harbors a terrible secret: "monsters from the Id," who threaten to destroy all newcomers. Shot in the new one-strip Eastmancolor process rather than in Technicolor, the film's color range and subtlety is a complete departure from Folsey's harder-edged work on the musicals he photographed in the 1940s; this allowed him to create a world of sinuous menace and deep shadows, remote and yet utterly tangible.

Leaving MGM, Folsey began work on one of his most unusual projects, the black-and-white film adaptation of Jean Genet's allegorical drama *The Balcony* (1963), produced by theatrical impresario Joseph Strick, with Shelley Winters, Peter Falk, Leonard Nimoy, and Lee Grant in the leading roles. Set in a house of prostitution, *The Balcony* was decidedly not a film that could have been made in MGM's golden era; its controversial subject matter and edgy dialogue led to it receiving only a token theatrical release. Nevertheless, Folsey's gritty, realistic work on the film earned him yet another Academy Award nomination for Best Cinematography, extremely rare for an outré, modestly budgeted independent production. It was clearly a departure from his best known efforts; yet Folsey remained so identified with MGM musicals that it seemed only right for the studio to lure him out of retirement for the linking segments

in *That's Entertainment II*. In many ways, Folsey *was* the MGM look during its most influential and prolific period as a Hollywood film factory.

Ray June, another cinematic pioneer, has received almost no attention in most histories of cinematography, black and white or color, despite amassing an impressive 181 credits as a director of cinematography. He served in the Army Signal Corps in World War I and used the training he received there to help him break into the industry, beginning his career with James Gordon, Leonard Wharton, and Theodore Wharton's short film *The New Adventures of Rufus J. Wallingford* in 1915, and moving right through the sound era to encompass such cinema classics as Stanley Donen's *Funny Face* (1957), Melvin Frank and Norman Panama's *The Court Jester* (1955), John Ford's *Arrowsmith* (1931), and Norman Z. McLeod's Marx Brothers' vehicle *Horse Feathers* (1932). Of this last film, June observed in an interview with Wayne Palma, "One can't possibly give [the Marx Brothers] treatment or composition. They never act as they have rehearsed, because they never know what they mean to do. They dive under tables, they leap over furniture, they play hide and seek with the scenery. You set the camera for them, but they are never where you expect them; so the cameraman piles in all the fire [i.e., light] he can get and just shoots" (Palma 17).

June was both matter-of-fact and adaptable in all his work, which encompassed a truly amazing range of projects, from Frank Borzage's *Secrets* (1933), Mary Pickford's last feature, long after the craze for "Little Mary" as an eternal juvenile had passed; to Frank Tuttle's Eddie Cantor musical *Roman Scandals* (1933), which, as with *Horse Feathers*, "piled in all the fire" June could get to effectively shoot the film with a bright, white, gleaming patina; to the sweep and romance of Victor Fleming's film adaptation of *Treasure Island* (1934), still one of the most effective versions of this oft-told tale; and then to Richard Thorpe's dark thriller *Night Must Fall* (1937), an atypical project for MGM, in which Danny (Robert Montgomery), a psychotic murderer, befriends an elderly woman (Dame May Whitty) whom he intends to kill for her money. Photographed with a brooding intensity and making excellent use of carefully designed practical lighting (lights used for cinematography that are actually in the shot, such as lamps, fireplaces, and the like), *Night Must Fall* created an atmosphere of mounting suspense.

As the 1930s progressed, June became, like George Folsey, yet another member of the MGM corps of technicians, obliged to shoot almost

anything that came along, but unlike Folsey, June never really adopted a signature style, which is perhaps why his work is so marginalized in conventional cinema histories. June's almost instantaneous adaptability to each new assignment marks him as a superior craftsman, who could change his style to fit almost any genre. Working in the hardboiled genre, June lensed Richard Thorpe and Victor Saville's gritty political melodrama *The Earl of Chicago* (1940, with assistance from an uncredited Karl Freund) using high-key lighting and an abundance of shadows, but then was able to shift gears entirely and photograph Busby Berkeley's late musical *Strike Up the Band* (1940) in a sparkling, brightly lit manner more suited to the subject matter.

Pressed into service to shoot Harold S. Bucquet's program picture *Calling Dr. Gillespie* (1942), June completed the assignment in an almost antiseptic manner in a matter of weeks, but for Jack Conway's Myrna Loy/William Powell marital comedy *Love Crazy* (1941), June alternated soft-focus love sequences with evenly lit comedy interludes (including Powell in drag as his own "sister"). The next year, for W. S. Van Dyke and Herbert Kline's wartime drama *Journey for Margaret* (1942), June convincingly re-created the ravages of London's World War II blitz in the studio, with dramatic lighting, intercutting soft-focus scenes of domestic life with images of war from Europe.

In 1943, MGM teamed Red Skelton with director Vincente Minnelli in the laborious comedy *I Dood It*, and although the entire film is shot through with an undeniable feeling of tediousness, June's consistently workmanlike cinematography never falters. Such a film, of course, is far removed from Norman Taurog's documentary-styled *The Beginning or the End* (1947), a sober and meticulously crafted narrative detailing the development of the first atomic bomb and its subsequent use in Hiroshima, which June photographs in a flat, almost distanced style, as if content to observe the proceedings without really becoming involved.

Throughout his career, June bounced from director to director, seldom working for the same person twice, yet remaining consistently in demand. Such versatility made him the ideal candidate to tackle Fred M. Wilcox's color and black-and-white screen adaptation of Frances Hodgson Burnett's classic children's novel *The Secret Garden* (1949). In the sequences depicting the supposedly invalid Colin Craven (Dean Stockwell) confined to his bed in an enormous Gothic mansion, constantly supervised by his overprotective father Archibald (Herbert Marshall),

June creates an overwhelmingly oppressive, dark, oak-paneled atmosphere of unrelieved gloom, which lifts only when Colin and Mary Lennox (Margaret O'Brien), the young girl who persuades Colin that he isn't incapacitated after all, venture into the "secret garden" outside the mansion; it is only then that the film magically shifts to explosive, verdant color. *The Secret Garden* was a challenging assignment, but June handled it with style, aplomb, and a certain self-effacement in which the narrative is always being served by his camerawork rather than the reverse.

Another series of shifts was signaled in June's subsequent films. In British auteur Pat Jackson's noirish *Shadow on the Wall* (1950), Ann Sothern stars as a ruthless murderess who kills her sister, and then plots to kill her sister's husband's daughter Susan (Gigi Perreau) to cover up the crime. Jackson, a no-nonsense British documentarian whose most famous project was the early Technicolor documentary feature *Western Approaches* (1944, d.p. Jack Cardiff), had little patience for studio politics. The MGM factory style just wasn't suited to his sense of personal integrity, and he appreciated June's practicality when shooting the film; shortly thereafter, Jackson returned to England.

Shadow on the Wall was followed by the even more off-beat *Crisis* (1950), Richard Brooks's first film as a director, in which Cary Grant was effectively cast against type as world-weary brain surgeon Dr. Eugene Ferguson on vacation in a small South American country, forced against his will to operate on megalomaniacal dictator Raoul Farrago (José Ferrer). The film was a project that no one else at the studio wanted to touch, and was only made because Grant read Brooks's script, loved it, saw it as a break from the constant string of romantic comedies he was obliged to appear in, and committed himself to the project. June yet again reinvents himself as a cinematographer here, conveying the oppressive heat and dust of a tropical third world country as well as the weight of an authoritarian regime in a series of darkly lit close-ups, heavily drenched in shadows, that alternate with brightly lit, almost clinical shots in the dialogue scenes as Grant wrestles with his conscience—why should he save the life of a merciless dictator?

From this point in his career, things got even more curious, and it seemed that June never stopped experimenting, creating each new approach only to abandon it once he had mastered it. As a favor to the *Andy Hardy* series star Mickey Rooney, June shot the pilot for Rooney's

first television series in 1954 in two days; then quickly moved over to Paramount to shoot Melvin Frank and Norman Panama's Danny Kaye vehicle *The Court Jester*, a lavish production in VistaVision and Technicolor, with assistance from an uncredited Ray Rennahan; and then in 1957 got the plum assignment of shooting *Funny Face* for Stanley Donen, a thoroughly modern romantic comedy infused with Fred Astaire's ineffable grace as a dancer, the gamin charm of Audrey Hepburn, and a revolutionary sense of color design, which makes the film seem as contemporary today as when it was first produced. For his innovative work on the film, June received one of his three Oscar nominations for Best Cinematography.

June rounded out his career lensing Vincente Minnelli's Metrocolor production of *Gigi* (1958) with Joseph Ruttenberg—though June received no screen credit—and then photographed Melville Shavelson's family comedy *Houseboat* (1958), again in a distinctly New Wave style, replete with color filters used in an aggressively Brechtian fashion (as he had done on *Funny Face*), jump cuts, and a good deal of location work, seamlessly integrated with studio settings.

As with that of many of his peers, June's work began in the silents and extended well into the sound era, but unlike most of his colleagues, he continuously pushed the envelope to achieve new effects in his work. Fortunately, some footage survives of June at work in the MGM promotional short *You Can't Fool a Camera* (dir. Jackson Rose, 1941), a ten-minute short that serves, for the most part, as a plug for forthcoming MGM releases. Also in the film, working on various projects, are George Folsey, Karl Freund, William Daniels, and Joseph Ruttenberg—the cinematographic "aces" of MGM. Though their work in the 1940s and 1950s is excellent, it is for their work in the 1930s that we remember them most, solid professionals willing to take on almost any new project, ready to solve whatever problems they were given while making it look easy.

Ruttenberg was another key member of the MGM photographic stock company in the studio's golden era. He started out, as did many of his colleagues, as a newsreel cameraman in 1915, and then broke into feature films with William Nigh's western *The Blue Streak* (1917), co-photographed with A. Lloyd Lewis—a film that Nigh, a future program director for Monogram in the 1940s, wrote, directed, and starred in for the fledgling Fox Film Corporation. Ruttenberg freelanced in New York between 1927 and 1934, then found his home at MGM, becoming one

of the primary masters of the black-and-white cinema, even working for D. W. Griffith on his last feature, 1931's *The Struggle*, along with an uncredited Nick Rogalli (Koszarski and Koszarski 65).

Nominated for an Academy Award for Best Cinematography ten times, Ruttenberg took home the coveted trophy on four occasions, for Julien Duvivier and Victor Fleming's Johann Strauss biopic *The Great Waltz* (1938); William Wyler's hymn to British courage in the face of the Nazi onslaught, *Mrs. Miniver* (1942); Robert Wise's biopic of fighter Rocky Graziano (as played by Paul Newman), *Somebody Up There Likes Me* (1956)—all photographed in black and white; and the color production of *Gigi*, which, as noted, Ruttenberg shot with an uncredited Ray June.

By the time he completed his final assignment, Norman Taurog's Elvis Presley vehicle *Speedway* in 1968, Ruttenberg had amassed more than 130 credits in features and short films, creating his best work in the 1930s and 1940s at MGM, with such standouts as Fritz Lang's indictment of lynch mob mentality, *Fury* (1936); Sam Wood's Marx Brothers entry *A Day at the Races* (1937); Frank Borzage's World War I drama *Three Comrades* (1938), the only film on which writer F. Scott Fitzgerald ever received an official screen credit; Harold S. Bucquet's sentimental drama *On Borrowed Time* (1939); George Cukor's classic comedy *The Philadelphia Story* (1940); and Cukor's suspense thriller *Gaslight* (1944).

In 1976, Ruttenberg was interviewed by cinema historians Diane and Richard Koszarski about his work and long career behind the camera. Ruttenberg recalled his first days at MGM, after a long apprenticeship in New York, and the MGM studio style, for which he had little fondness. As he recalled his first days on the MGM lot:

> When I came, a representative from the production department took me around the studio and showed me my first picture [first assignment as a DP], and said, "This is your gaffer"—now, we never had any gaffers back East— we did all our own setting of lights. . . . And I came in the next day, and it was like Grand Central Station, lights all over the place, big parallels on top; we never had so many parallels in my life. I took a look and the gaffer said, "This is the way we do it here." And I said, "Fine. This isn't the way I do it, and if you don't want to change it, get your boss over here and we'll discuss it, because this is not the way I like it. We have to change the whole lighting system." Because there was no character to the set whatsoever, there was

nothing, there wasn't a shadow in the place; they would throw a light every place you went. (Koszarski and Koszarski 82–83)

Ruttenberg's "Grand Central Station" reference is an apt description of the studio's standard lighting strategy: pour on the light so the scene "reads" anywhere, and forget about atmosphere or, for that matter, artistry. By the time that Ruttenberg got the chance to work with Wyler on *Mrs. Miniver*, his standing at the studio, plus Wyler's backing, helped him to achieve the kind of depth-filled, atmospheric black-and-white work he longed to do. As he told the Koszarskis, "There we got into the mood of the scene. The light was natural; it came from the sources, as much as we could, it came from the windows, it came from the practical lights. We did everything in the mood; we didn't put a lot of lights in the thing" (83).

While *Mrs. Miniver* is often deeply unrealistic in its ultra-patriotic, flag-waving vision of wartime Britain, Ruttenberg's "natural" cinematography was an essential element in making the film seem as plausible as possible—indeed, it is one of the chief assets of the film. However, as the thirties and forties morphed into the fifties and sixties, and color became the dominant production medium, Ruttenberg began, by his own admission, to care less about the images he created, just so long as something got in the can—a surprising accommodation to changing production circumstances.

As with many of the cinematographers discussed in this volume, Ruttenberg felt that black-and-white cinema offered more creative possibilities than color, where, to a large degree, pictorial values are built into every scene through costuming, set design, and makeup. As the all-color world of film production closed in around him, Ruttenberg felt that something essential was being lost. "When color came in," the Koszarskis asked him, "were you happy to see all pictures practically being made in color?" Ruttenberg emphatically replied, "No I wasn't, I was against color. I was against working [with] color. I felt I was afraid I couldn't do the things with color to get shadows that I wanted. The effects, the halftones and so forth, particularly with Technicolor, because Technicolor had to use big units of light. It was quite a job" (92).

While in his later years Ruttenberg was still able to get the occasional black-and-white film assignment, such as Gordon Douglas's odd romantic drama *Sylvia* (1965), his work on a string of indifferent color films—the

Dean Martin comedy *Who's Got the Action?* (1962), the Elvis Presley musical *It Happened at the World's Fair* (1963), the tired and humorless *A Global Affair* (1964), starring Bob Hope—made it clear that he no longer cared. Gordon Douglas's frankly exploitational biopic *Harlow* (1965), for example, was photographed in precisely the "flat" style that Ruttenberg had always abhorred—even lighting throughout, minimal shadows, and no concern other than getting the film shot as quickly as possible. Paramount made *Harlow* as rapidly as it could to forestall competition from a parallel project, Alex Segal's *Harlow* (1965), shot in black-and-white Electronovision (an early video-to-film process) in just eight days by TV cameraman Jim Kilgore, whose most prominent work was for the teleseries *The Dating Game* (1965) and *The Newlywed Game* (1966).

Ruttenberg is thus another example of an artist who did his best work in black and white but was forced out of monochrome by economic concerns alone. Looking at one of his last films, Russell Rouse's cheap, shabby, show business exposé *The Oscar* (1966), with a thoroughly pulpy narrative and by-the-numbers photography and direction, it's hard to reconcile the work with the care and detail that went into *Gaslight*, or *The Philadelphia Story*, or *Mrs. Miniver.* To the end of his life, black and white was nearest to Ruttenberg's heart and central to his artistic sensibility; he never really felt at home in the Technicolor universe.

The same could be said of Boris Kaufman, born Boris Abelevich Kaufman, the younger brother of famed Soviet filmmakers and theorists Mikhail Kaufman (born Mikhail Abramovich Kaufman) and Dziga Vertov (born Denis Abramovich Kaufman), whose "pure cinema" feature documentary *Man with a Movie Camera* (1929), directed by Vertov and shot by Mikhail Kaufman, remains one of the most dazzling and innovative films of all time, notable not only for its naturalistic location photography but also for its staggeringly complex editorial mise-en-scène, which has perhaps never been equaled in cinema history. Born in Poland in 1897, Boris Kaufman eventually moved to Paris, attended university there, and then turned his attention to cinematography.

Most famously, Kaufman collaborated with the maverick director Jean Vigo on all of his projects, beginning with the experimental, impressionist silent documentary *À propos de Nice* (1930); continuing on with the sound short *Taris, roi de l'eau* (also known as *La Natation par Jean Taris,* or *Jean Taris, Swimming Champion,* 1931), in which the Olympic swimmer is seen walking on water in the film's final moments; and Vigo's last

two films, both certifiable masterpieces, the forty-five-minute featurette *Zero for Conduct* (1933), centering on a tale of youthful rebellion at a strict, corrupt boarding school, and *L'Atalante* (1934), a tender romance that takes place, for the most part, on a river barge, between Jean (Jean Dasté) and his young bride, Juliette (Dita Parlo).

Rounding out the cast in *L'Atalante* are perennial star Michel Simon as Père Jules, an old hand who has seen it all, and Louis Lefebvre as a cabin boy. The film was poorly received upon its initial release, due in large measure to interference from the producer, who savagely cut and rescored the film, but it now exists in a fully restored edition, completed in 2001, and was finally released on DVD in 2011—seventy-seven years after the film's completion. Shockingly, Vigo died of tuberculosis shortly after the film's release in 1934 at the age of twenty-nine, one of the true martyrs of the cinema. In recognition of his achievement in the cinema, the French government now annually awards the Prix Jean Vigo to promising new filmmakers, artists who reinvent the rules of the cinema—one of the past recipients being Jean-Luc Godard.

Though *L'Atalante* was partly shot in the studio and partly on location, the finished product has such an air of naturalism as to seem almost effortless, as if the scenes in the film were snatched from life on the sly. This strategy belied the detailed and painstaking work that Vigo did on the project, shooting the film mostly in sequence during the winter months of 1933, which only served to further weaken Vigo's already fragile health. Nevertheless, Boris Kaufman described working with Vigo as "cinematic paradise" (Gomes 156), and the resulting film is a masterpiece of acute humanist observation, routinely listed on the Top Ten lists of critics throughout the world.

But Kaufman's career as a cinematographer was only beginning. In the immediate aftermath of *L'Atalante*, he worked with director Marc Allégret on *Zouzou* (1934), a Josephine Baker musical, and with the avantgarde filmmaker Dimitri Kirsanoff on his sound short *Les Berceaux* (1935). Until the early 1950s, however, Kaufman labored in obscurity, supporting himself by shooting a number of indifferent documentaries, such as two entries in the Paramount Pacemaker series of short promotional films, *Caribbean Capers* (1949) and *Country Cop* (1950). It was then that director Elia Kazan, who had long admired his location shooting in *L'Atalante*, asked Kaufman to shoot the classic labor drama *On the Waterfront* (1954), thus creating one of the most stunning comebacks in

cinema history, with Kaufman winning an Academy Award for Best Cinematography, Black and White, for his work on the film.

Immediately after *On the Waterfront*, Kaufman was deluged with offers of work, and in rapid succession shot *Baby Doll* (1956), directed by Kazan from an original screenplay by Tennessee Williams; Rod Serling's acerbic *Patterns* (1956), directed by Fielder Cook, dealing with life at the top in the executive suite; Sidney Lumet's claustrophobic first feature film, the courtroom drama *12 Angry Men* (1957); and Lumet's 174-minute adaptation of Eugene O'Neill's classic play *Long Day's Journey into Night* (1962).

Kaufman wrote of the challenges and opportunities that marked his long and unusual career as a director of cinematography working mostly in black and white:

> When the artist attempts to put a subject matter into visual form, he has to rely on his intuition, his feeling for the subject, and his knowledge of the medium he is to employ. A painter has nothing between him and the canvas but paint and brushes to express what he has to say. If the same condition applied to the art of the cinema, better pictures would be made. However, the complexity of this medium should not preclude the cinema's being a form of art. If an art form is defined by its ability to express by its own means, then the cinema deserves to be called an art. Its title as such has been defended or denied since its invention. The importance of this question is not a purely academic one, but is of the essence. It is true that the commercial aspect of the cinema obscures the issue, and the fact of its being a mass entertainment, one that involves compromises, tends to obscure it the more. Yet an artist involved in the making of a picture has to believe in cinema as an art precisely so as to be able to carry through his task under the pressures of convention, of schedules, or a budget, and to bring his work to the spectator in a relatively pure form. After all, the screen is only a blank canvas that once in a while reflects an authentic work of art. ("Film Making as an Art" 138)

Kaufman also shot Lumet's groundbreaking study of an aging survivor of a Nazi concentration camp trying to come to terms with both his past and the changing face of New York City in *The Pawnbroker* (1964), as well as Lumet's not altogether successful adaptation of Mary McCarthy's novel *The Group* (1966). Kaufman's final film as a DP was Otto

Boris Kaufman (back to camera, with gray hair and glasses) doing some location shooting for director Sidney Lumet (first from left, popping out of the top of the Volkswagen) for Lumet's *The Pawnbroker* (1964)

Preminger's decidedly offbeat drama *Tell Me That You Love Me, Junie Moon* (1970), in which a group of differently abled people, ostracized by society, gather together to live in a communal household and thus face the world with a united front. *Junie Moon* is a flawed but impassioned film, a fitting final project for a cinematographer who always sided with the unusual and experimental in cinema, and whose career spanned more than four decades.

In Germany, the shift to sound was more sinister, with the indigenous film industries rapidly pressed into service of the Nazi regime. Joseph Goebbels created the Reichsfilmkammer (Reich Film Chamber) in 1933 and made himself the sole authority on what could and could not be shown on the screen. The following year saw the passage of the infamous Reichlichtspielgesetz (Reich Motion Picture Act), which made it illegal for Jews to work in the German cinema. Many talented film artists left the country almost immediately, most conspicuously Fritz Lang, but also directors Billy Wilder, Frank Wisbar (aka Franz Wysbar), Douglas Sirk, and Robert Siodmak; actors Peter Lorre, Oskar Homolka, Anton Walbrook, and Albert Bassermann; composer Franz Waxman;

cinematographers Franz Planer and Eugen Schüfftan, as well as other gifted writers, directors, actors, and technicians, thus enriching the cinema of not only the United States, but also France, England, and other countries as well, where these refugees from tyranny eventually found permanent homes.

Notable in the Nazis' use of the cinema to further their own ends was the career of propagandist and documentarian Leni Riefenstahl. Born in Berlin in 1902, Riefenstahl rapidly emerged as the foremost filmmaker of the Reich. Riefenstahl lent her considerable skills to the Nazi cause, most notably in her "documentary" of the 1934 Nazi Party Congress at Nuremberg, *Triumph des Willens* (*Triumph of the Will*, 1935), photographed by a battalion of nineteen cameramen under the direction of Sepp Allgeier. The sets were designed by the Nazis' in-house architect, Albert Speer, and the production included a vast amphitheater with camera cars moving up and down amid the swastika-emblazoned banners for spectacular crane and wide-angle shots. Most of the film was shot silently, with music added later; Riefenstahl not only edited the film herself but also supervised the music recording sessions. When she found that the conductor could not keep to the beat of the soldiers' marching feet on the screen, she pushed him from the podium and conducted the orchestra herself, achieving perfect synchronization.

More than eighty years later, *Triumph of the Will* is still studied as a classic propaganda film, because it astonishingly manages to make both Hitler and the then-rising Third Reich seem simultaneously attractive and an agent for "positive" social change. Indeed, as Frank Capra and others discovered during World War II when they tried to reedit the film to discredit the regime, *Triumph of the Will* is edit-proof. It contains no scenes of book burning, no speeches of racial hatred, and no incitements to war; rather, it depicts the Nazi movement as an unstoppable juggernaut that everyone, seemingly, should embrace. The result is both hypnotic and repellent, but it attracted enormous attention, and Riefenstahl next embarked on the creation of *Olympia* (1938), a two-part record of the 1936 Olympic Games.

Again assembling an army of cameramen and technical assistants, Riefenstahl and her crew photographed every aspect of the 1936 Berlin Olympics, from the athletes relaxing in their guest quarters to the drama of the events themselves, linking the entire event (in a lengthy prologue) to the glories of ancient Greece. For *Olympia*, she used forty-five cameras,

Nazi pageantry in Leni Riefenstahl's *Triumph of the Will* (1935), photographed by a battalion of cameramen under the direction of Sepp Allgeier

shot more than two hundred hours of film, and then locked herself in a cutting room for two years, editing the footage down to a 220-minute, two-part epic that employed slow motion, underwater photography, and even reverse motion to produce a kaleidoscopic hymn to the human body in motion, creating perhaps the greatest sports film ever made. Yet the unmistakable taint of Nazi ideology suffuses every frame. Riefenstahl herself served as the "actual" DP on *Olympia*, in fact if not in name, supervising no fewer than twenty-three camera operators, and the final result is a dazzling tour de force of genuinely kinetic cinema.

Meanwhile, back in Hollywood, the studio system continued to rely on the talents of a host of gifted DPs. One relatively forgotten but

remarkably prolific director of cinematography was Sid Hickox, who shot a total of 163 features and television episodes without winning a single Academy Award throughout his entire career. Hickox, like so many of the DPs discussed in this chapter, began his career as an assistant cameraman at the Biograph Studios in New York, starting in 1915, and then served in the photographic corps of the U.S. Navy during World War I.

When the war ended in 1918, Hickox joined First National Pictures, starting again as an assistant, but became a full-fledged director of cinematography with director William Nigh's comedy *The Little Giant* (1926). This began a career that was spent, for the most part, working at Warner Bros., but looking at Hickox's considerable credits it's thoroughly astounding that he hasn't received more recognition. Along with an avalanche of program pictures—in the 1930s, Hickox averaged eight feature films per year—Hickox's more notable films include William Wellman's feminist drama *Safe in Hell* (1931); George Cukor's *A Bill of Divorcement* (1932), on loan to RKO, which was Katharine Hepburn's screen debut and one of John Barrymore's last truly exceptional films; Wellman's

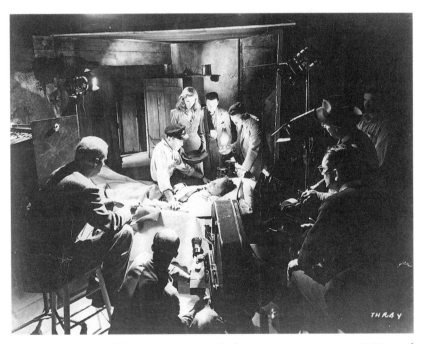

Cinematographer Sid Hickox, extreme right, with glasses, supervising a scene in *To Have and Have Not* (1944), as director Howard Hawks, left, seated on stool, watches the action

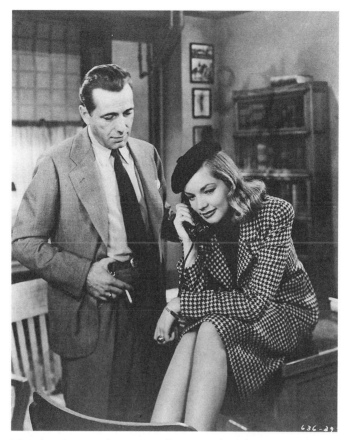

Humphrey Bogart and Lauren Bacall in Howard Hawks's *The Big Sleep* (1946), gorgeously photographed by Sid Hickox

adaptation of Edna Ferber's popular novel *So Big!* (1932); John G. Adolfi's Depression-themed drama *Central Park* (1932); Mervyn LeRoy's remarkable film *Heat Lightning* (1934), in which two sisters run a gas station and motel in the Mojave Desert and are soon enmeshed in a web of tragedy and intrigue; Ray Enright and Busby Berkeley's musical *Dames* (1934); Lloyd Bacon's unflinching prison drama *San Quentin* (1937); Howard Hawks's classic Hemingway adaptation *To Have and Have Not* (1944); Hawks's equally compelling Raymond Chandler adaptation *The Big Sleep* (1946), considered by many to be one of Humphrey Bogart and Lauren Bacall's best films, and a key work in the noir canon; Raoul Walsh's *White Heat* (1949), one of the last great Warner Bros. gangster films; and the

science-fiction classic *Them!* (1954), in which a horde of giant ants threatens to invade Los Angeles.

This incredible career was followed by years of work in television, including stints on *Our Miss Brooks* in 1955, Betty White's early series *Date with the Angels* in 1957–1958, and *I Spy* in 1965, before Hickox settled down with *The Andy Griffith Show*, where he shot 226 half-hour episodes between 1960 and 1968, switching from black and white to color in 1965. So strong was Hickox's bond with series star Andy Griffith that when the show ended in 1968, Hickox was picked up to shoot the short-lived sequel *Mayberry R.F.D.*, completing an additional seventy-eight episodes of that series between 1968 and 1971. Yet for all this work, especially his films at Warner Bros. in the 1930s and 1940s, Hickox received no industry accolades and almost no recognition outside the business as anything other than a superbly reliable and versatile technician. But if one considers the wide variety of projects that Hickox worked on, in conjunction with his seemingly indefatigable productivity, this master of black-and-white artistry certainly deserves a place in the pantheon of the cinema's most accomplished artists, and emblematically stands for all the other DPs, too numerous to mention here, who dependably created outstanding individual work on a steady basis, and yet, because of their own personal reticence or the caprices of the industry, never achieved even a small measure of the attention they so richly deserved.

In the midst of the gangster films, the musicals, and the Depression-era hard luck dramas, one black-and-white film of the 1930s has a place all its own: Merian C. Cooper and Ernest B. Schoedsack's *King Kong* (1933), with special effects by the legendary Willis O'Brien. O'Brien, a pioneer in stop-motion model animation, made his first big impact with the 1925 version of Sir Arthur Conan Doyle's *The Lost World*, directed by Harry O. Hoyt, in which prehistoric dinosaurs roam the streets of London during the film's climax. Four cinematographers labored to bring *King Kong* to life: Edward Linden, who worked mostly in program pictures; J. O. Taylor, another journeyman whose output was, on the whole, undistinguished; Vernon L. Walker, an ace special effects cinematographer who compiled an astounding 222 credits in that capacity between 1932's *The Most Dangerous Game*, directed by Irving Pichel, and 1948's *Variety Time*, directed by Hal Yates, as well as an additional 72 credits as a director of cinematography stretching from Denison Clift and Charles Swickard's western *The Last Straw* (1920) to Fred Guiol's Wheeler and

Woolsey comedy *Mummy's Boys* (1936); and Kenneth Peach, for whom *King Kong* was his first major project, and who went on to a long career as a DP on various television series, ending with his work on fifty-nine episodes of the sitcom *Taxi* in the 1980s.

To create the moody, entirely artificial world of *King Kong*, the two directors, four cinematographers (along with an array of assistants), and O'Brien's special effects crew worked with sets left over from *The Most Dangerous Game* for some of the film's live action sequences. All told, the film would take a full eight months to shoot, a remarkable amount of time to devote to one production, but quite reasonable when one considers the vast amount of nearly nonstop special effects animation the project entailed: Kong battles one prehistoric creature after another on Skull Island and then later terrorizes New York in search of Ann Darrow (Fay Wray), Kong's "love object"—the "Beauty" who ultimately, in the words of explorer Carl Denham (Robert Armstrong), "killed the Beast" as Kong is shot down after making a last, desperate stand atop the newly constructed Empire State Building.

King Kong's intricate web of shadows, matte paintings, miniature model animation sequences, and live action combined to create a compelling, dark narrative, accurately mirroring the day-to-day life of Depression-era America. Every day was a fight to survive, and Kong's seemingly endless series of battles with his prehistoric nemeses, and later with the airplanes that shoot him down from the Empire State Building, was the perfect metaphor for daily life in the 1930s: an unceasing fight just to keep on living. Audiences could easily identify with the heroine, Ann Darrow, as she tries to steal an apple in the film's opening moments to keep from starving to death; offered a chance to embark on a voyage in search of Kong, Darrow signs on because she has no other choice— it's either that or the streets. Alone, frightened, exploited, and ultimately destroyed by the forces of "civilization," Kong was the epitome of the grim 1930s. Gangsters shot their way to riches; dancers prayed for a hit show; and any way to make a dollar was acceptable when more than a quarter of the population was out of work. *King Kong* had a simple message, which it delivered with an unrelieved brutalism that resonated with all those who saw it: The world is against you. If you don't fight back, you will die.

Thus, the 1930s was a period of intense change and creative activity in the cinema, with the coming of sound, new lighting systems, the rise

and solidification of the studio system, and the birth of the various guilds and unions to represent the technicians who labored in Hollywood, not to mention the enormous economic upheaval caused by the Depression, which made going to the movies all the more indispensable as the only means of escape from lives that often bordered on the desperate. Movie-going became a weekly habit, and several of the major studios, such as Loew's/MGM, Paramount, and RKO, owned their own chains of theaters, thus assuring a reliable marketplace for their wares and necessitating a factory-like system of churning out films on a weekly basis.

The A-films were released when their directors and producers agreed that they were completed, but the studio assembly line reliably pumped out several pictures a week to satisfy the public's demands for either the top or bottom half of the double bill. As the 1940s dawned, the Hollywood studio system would create even slicker, more highly polished films. The technical problems of the 1930s were overcome, leading up to the boom year of 1946 in which, according to historian Tim Purtell, "more than 80 million people—57 percent of [all] Americans—went to theaters every week." What lured them to the movies? Escape, romance, drama, comedy, spectacle—the essence of the cinema as photographed by some of the most accomplished artists in cinema history, one of whom, working with a young director, Orson Welles, on his first feature film, *Citizen Kane* (1941), would radically alter the language of the cinema: Gregg Toland.

3

The 1940s

• •

A Black-and-White World

The great Technicolor spectacles of 1939, considered by many to be the cinema's most distinguished year in terms of the quality of films produced, such as Victor Fleming's *Gone with the Wind* and *The Wizard of Oz*, suddenly seemed both excessive and remote as America waged war in both Europe and the Pacific. The country was now geared toward conserving resources to build planes, tanks, guns, and other weapons of war, and everything—raw film stock, developing chemicals, paper, materials for film sets—was suddenly strictly rationed. Color film was expensive while black and white was cheap and reliable, and its inherently stark, dramatic palette perfectly suited the fervor of the times. Black and white could be softened for a tale of wartime romance, polished to a high sheen for a drama of intrigue, or bleached out by the sun for battleground epics.

The new cinematic look that defined this most resolutely black-and-white era was the result of more than two decades of refinement and experimentation, and as the 1940s dawned the technical problems that had plagued early sound recording as well as lighting had been vanquished: the black-and-white camera was just as mobile on a soundstage

as it had been in the silent era. The studios were now full-tilt factories, churning out not only films in support of the war effort, but also escapist musicals, primitive comedies, and action and adventure films that possessed a new sense of urgency and commitment. The nation was in the fight of its life, and although in retrospect the outcome of World War II may have been inevitable once the United States entered the conflict, even a casual glance at the unfolding events of the war demonstrates that as late as 1943, there was a significant chance that the Allies would not, in fact, prevail. This was a life-or-death struggle in every sense of the word, and filmmakers responded with a torrent of conventional genre films as well as more thoughtful fare.

Black and white was the medium for newsreels, as well as for the *Why We Fight* series of seven "informational films" produced by the War Department, from *Prelude to War* (1942) to *War Comes to America* (1945). Supervised by Frank Capra, with animation by the Walt Disney Studios, these somber, feature-length films, many of which used footage from Nazi filmmaker Leni Riefenstahl's infamous propaganda film *Triumph of the Will* (1935), were screened nationwide and throughout Allied countries, offering a simple, and often simplistic, explanation as to precisely why the Allies were at war.

One of the most influential and well-known cinematographers of the era was Gregg Toland, who filmed sixty-six features before his death at the age of forty-four, but whose influence on the cinema remains indelible to the present day. Toland, of course, photographed Orson Welles's first film, *Citizen Kane* (1941), on which Welles shared the director's title card with Toland in gratitude for Toland's considerable, even crucial input on the film, but before that Toland served a long apprenticeship in the business, breaking into the industry as an office boy at the William Fox Studios in Los Angeles at the age of fifteen; by the time Toland was in his late teens, he was working full-time as an assistant cameraman.

Fascinated by the potential of the cinema, Toland spent all his free time figuring out new ways to photograph the world around him; as he later told an interviewer, he found the cinematographer's job "so glamorous . . . I made up my mind that's what I wanted to be. . . . I used to stay on nights and polish [the camera]. It just seemed exciting to sling a tripod over your shoulder, and it seemed mysterious to go into a darkroom and load film" (Als 48). By 1926, Toland was assisting DP Arthur Edeson on Roland West's Gothic melodrama *The Bat*, and the equally respected

George Barnes on Henry King's *The Winning of Barbara Worth*. But Toland always had a deeply experimental streak, and he next collaborated with up-and-coming special effects and editorial montage expert Slavko Vorkapich, director Robert Florey, and production designer/director William Cameron Menzies on the bizarre fifteen-minute films *The Love of Zero* and *Johann the Coffinmaker* (both 1927). This led to Toland's most famous early collaboration, the impressionistic Hollywood rise-and-fall parable *The Life and Death of 9413, a Hollywood Extra* (1928), which Florey and Vorkapich directed, and Toland photographed on a minuscule budget, credited simply as "Gregg."

During this period, Toland was also one of a number of cinematographers who labored on Erich von Stroheim's troubled production of *Queen Kelly*, released in 1929, but subsequently rereleased in 1932 with a new ending photographed by Toland at the behest of the film's star, Gloria Swanson. Toland continued his labors on more conventional fare with F. Richard Jones's early talkie *Bulldog Drummond* (1929), on which he assisted DP George Barnes, using sets designed by William Cameron Menzies; Alfred Santell's romantic comedy *This Is Heaven* (1929); as well as Wesley Ruggles's tropical drama *Condemned*, Edmund Goulding's Gloria Swanson vehicle *The Trespasser* (both 1929), and George Fitzmaurice and Harry d'Arrast's gentlemanly crime drama *Raffles* (1930). More assignments of a similarly generic nature followed, of which the most memorable is King Vidor's unforgiving hard-luck drama *Street Scene* (1931), based on the play by Elmer Rice. Toland's first feature as a full-fledged DP followed soon after, A. Edward Sutherland's Eddie Cantor musical *Palmy Days* (1931), in which his work is surprisingly unadventurous.

There really wasn't a sudden explosion of Toland's bravura style, though his appropriately dark, moody work on Richard Boleslawski's version of Victor Hugo's *Les Misérables* (1935) won Toland an Oscar nomination for Best Cinematography. More indicative of Toland's later work is his collaboration with cinematographer/director Karl Freund on Freund's *Mad Love* (1935), previously discussed, on which Toland teamed with cinematographer Chester Lyons, whose own career would end with his death in 1936. *Mad Love* was so outré that it was banned and censored in numerous countries throughout the world; it also proved to be Freund's last film as a director. *Mad Love* was far from the usual MGM fare, but working with the autocratic yet inventive Freund was a valuable experience for Toland.

The turning point for Toland, who could also be rather autocratic himself, was his collaboration with director William Wyler on *These Three* (1936), the first adaptation of Lillian Hellman's controversial play *The Children's Hour*, considerably toned down for the screen. Hilton Als described the first few days of Wyler and Toland working together:

> Like many other directors of the era, Wyler regard[ed] cinematographers as little more than glorified mechanics. In the past, he . . . often directed the camerawork himself. "I was in the habit of saying, 'Put the camera here with a forty-millimeter lens, move it this way, pan over here, do this,'" Wyler remarked. . . . This approach [didn't] work with Toland: after several days, he [asked producer Samuel] Goldwyn to transfer him off Wyler's set. When Wyler, bruised, demand[ed] an explanation, he learn[ed] that, with Toland, "you didn't tell him what lens to use, but what you wanted. And he would help you by suggesting the best way to photograph it." The two men reconcile[d], and [went] on to make six films together, including *Wuthering Heights* (1939) and *The Best Years of Our Lives* (1946). "We discussed every move," Wyler said. "He was an artist." (Als 46)

Toland won his first Academy Award for his brooding, Gothic work on *Wuthering Heights*, but always seeking new challenges, and well aware of Orson Welles's flair for the dramatic and the unusual—as evidenced by Welles's 1938 Mercury Theatre radio adaptation of H. G. Wells's *War of the Worlds*—Toland sought Welles out and campaigned for the job of director of cinematography on *Citizen Kane*. As Hilton Als reports, Welles was grateful for Toland's offer of assistance, telling him, "I know nothing at all about filmmaking," to which Toland replied, "That's why I want to work with you. That's the only way to learn anything—from somebody who doesn't know anything" (Als 49).

Future producer William Alland remembers it slightly differently, which is not all that surprising given the constant fabulism that surrounds Welles and his films. As Alland recalled,

> I remember sitting in a production meeting with Orson and a few others before the start of *Citizen Kane*. The time had arrived to select a cameraman, and Orson said, "If I could only get Gregg Toland—that's the man I want." Orson had never even met Gregg, but he had admired Gregg's work in John Ford's *Grapes of Wrath* and *The Long Voyage Home*. Someone at the meeting

spoke up: "There's no chance of getting Toland. He's under contract to Sam Goldwyn." "I know that," said Orson. "But I'd still like to have him photograph the picture." Just then the telephone rang, and Orson answered. A voice on the other end of the line said: "This is Gregg Toland. I understand that you're making a picture at RKO. I'd like to work with you on it." Thus began one of the most successful artistic relationships I've ever seen. Orson and Gregg respected each other, and they got along beautifully. No matter what Orson wanted, Gregg would try to get it for him. Gregg had a tremendous responsibility because Orson was in almost every scene. But Gregg kept an eye on everything. (Alland)

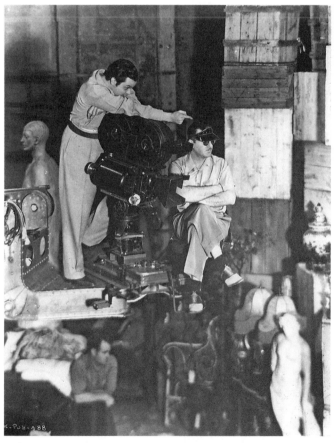

Orson Welles pointing for emphasis as cinematographer Gregg Toland, legs crossed, looks on during the production of Welles's *Citizen Kane* (1941)

Unlike his more loquacious colleague of the era, the equally talented but more overtly self-promotional John Alton, Toland, while not reticent about his accomplishments, confined his remarks on working with both Wyler and Welles to just a few articles and interviews. But in his essay "The Motion Picture Cameraman," published shortly after *Kane* wrapped, Toland had some trenchant thoughts on the cinematographic process, rendered in diverting and accessible style. Toland's self-assurance—one might almost say egotism—is evident in the first few lines of the essay:

> I enjoy being a motion picture cameraman. Of all the people who make up a movie production unit, the cameraman is the only one who can call himself a free soul. He is certainly the least inhibited. The producer, director, film editor, the players, all act as checks upon the creative impulses of one another. *But the cameraman may do exactly what he wants to do* [emphasis added], for the simple reason that while the work of the others is visually obvious at the time it is being performed, the work of the cameraman is not revealed until twenty-four hours later when the film which has passed through his camera is flashed upon the screen in a projection room. ("The Motion Picture Cameraman")

While Cecil B. DeMille would probably not have agreed that "the cameraman may do exactly what he wants to do," Toland, as we have seen, was perfectly capable of walking off a picture if he didn't get his way. This independent streak, coupled with Toland's undoubted genius, soon made him the most sought after and highly paid cameraman in 1940s Hollywood, but Toland was extremely choosy about which films he would work on. Regarding *The Little Foxes*, Toland wrote,

> My work began six weeks before we shot the first scene. There were long conferences with the producer, with William Wyler, the director, with the architect who designed the sets, with the property man and other artisans. . . . We built knock-down miniature models of the most important sets and juggled the walls about for the purpose of fixing upon the best angles, the best places to set up the camera. We took into consideration color values, types of wallpaper or background finishes, the color and styles of costumes to be worn by the principals, the furnishings and investiture. We set the

photographic key for various sequences—the light or gay ones, dramatically speaking, in a high key of light, the more somber or moody scenes in a low and more "contrasty" key. We determined that Bette Davis, the star, should wear a pure white make-up. This is revolutionary, but it is a potent device in suggesting the kind of character she portrays in the story—a woman waging the eternal conflict with age, trying to cling to her fading beauty. But because of the contrast between her make-up and that of the other principals, we had to discover exactly the balance of light [that] would illuminate both to advantage. Ascertaining this light balance required extensive make-up tests. . . . It is obvious that the relationship of the cameraman to his director must be one of complete coordination. The director will have his own ideas about camera angles, but in the final analysis it is the cameraman who must determine whether those ideas are workable and what the results will be. ("The Motion Picture Cameraman")

Note, of course, that when Toland is speaking about "color values," "the color and styles of costumes," and the like, he is considering these aspects of the film's physical production from the point of view of a cinematographer who is about to create a film entirely photographed in black and white. Thus Toland, who confidently asserted in the same article that he could "step onto a lighted set which he ha[d] never seen before and predict with astonishing accuracy what kind of scene is about to be photographed," and further that "to the eye of an expert cameraman, the manner in which a set is lighted is an infallible key to the mood to be established," is already working in transmutational fashion—seeing the world in color, but translating it to black and white in his mind's eye.

Clearly, Toland was a master at understanding precisely how certain colors, fabrics, and flesh tones would register on the screen, but he wasn't about to institute the rigid "four colors and four shades" method of black-and-white cinematography instituted at Universal (see page 69) to ensure a consistency in the studio's overall "look" in each production. For Toland, every new film was an adventure, as it was for most cameramen, but Toland had the necessary degree of self-confidence to make any film uniquely his own, to the point that others clearly tried to copy his style on their own projects. Yet Toland's world remains entirely his own, as with any great artist, and he instinctively and vigorously sought out those directors who would respect his abilities, refusing to work with

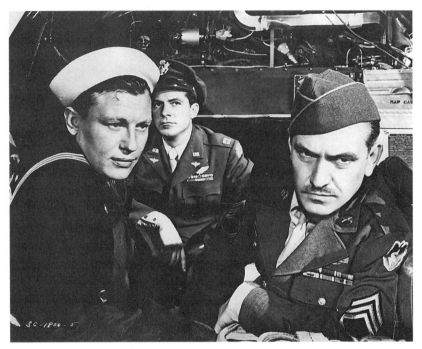

William Wyler's tale of returning World War II veterans *The Best Years of Our Lives* (1946), photographed by Gregg Toland

those filmmakers who wouldn't allow him the necessary creative input to remain faithful to his own vision of what the finished film should look like.

Working with Welles on *Citizen Kane*, of course, was the pinnacle of Toland's career, and it is for this film alone that he is best remembered. It was a film on which Welles had total creative freedom, perhaps for the only time in his life, and Toland was determined to see that the young, visionary director got whatever he wanted. The results were often revolutionary: from faking period newsreels for the opening *News on the March* sequences to a plethora of ingeniously crafted matte shots; sets designed with ceilings for added realism, which made both lighting and photography much more difficult; and, most famously, deep-focus cinematography, as in an early scene where the young Kane is sledding outside in the background as the camera dollies back to reveal the interior of the Kane home, where his mother, his father, and the banker Mr. Thatcher, all in

perfect focus, argue over the young Kane's new fortune. As Toland said regarding the technique of deep focus:

> Through its use, it is possible to photograph action from a range of eighteen inches from the camera lens to over two hundred feet away, with extreme foreground and background figures and action both recorded in sharp relief. Hitherto, the camera had to be focused either for a close or a distant shot, all efforts to encompass both at the same time resulting in one or the other being out of focus. This handicap necessitated the breaking up of a scene into long and short angles, with much consequent loss of realism. With [deep focus], the camera, like the human eye, sees an entire panorama at once, with everything clear and lifelike.
>
> [Deep focus] was only possible after the development of speedy new film, enabling the cameraman to stop down his lens to the small aperture required for sharp focus. With the slow sensitivity characteristic of the film of a few years ago, this would have been impossible as not enough light could have gotten through such as a small aperture to expose the film properly. Today, we get as much value out of fifty candlepower light as we once would have obtained from two hundred candlepower, so sensitive is the modern speed film. ("The Motion Picture Cameraman")

And what did Toland think of the future of motion picture cinematography?

> Color will continue to be improved but will never be a hundred per cent successful. Nor will it ever entirely replace black and white film because of the inflexibility of light in color photography and the consequent sacrifice of dramatic contrasts. Anything done in the gay, high-key light [that] color photography necessitates for its existence (such as musical comedies) will continue to be suitable as a subject for color film. But the low-key, more dramatic use of light seems to me automatically to rule color out in pictures of another type.
>
> Paradoxically enough, realism suffers in the color medium. The sky, as reproduced, is many shades deeper than its natural blue. The faces of the characters are usually a straw shade. Three prime colors are now utilized [in three-strip Technicolor, soon to be replaced by single-strip Eastman Color film], but not enough shades are possible with those three. More basic colors

would involve too complex a problem to be economically practicable. In the black and white picture, color is automatically supplied by the imagination of the spectator and the imagination is infallible, always supplying exactly the right shade. That is something physical science will continue to find tough competition. ("The Motion Picture Cameraman")

Of course, when Toland suggested that the imagination of the spectator is "infallible" in supplying the precise shadings of color to a black-and-white film, he could hardly have imagined that, in the era of IMAX, 3-D, and CGI, there would be almost no imagination left at all, and that audiences would want all the work of interpreting a film done for them.

Another major figure in the 1940s whose work is far less celebrated, and yet whose visual style is instantly recognizable over a whole range of films over more than four decades, was Nicholas Musuraca, easily one of the most underappreciated directors of photography in American cinema history; as Veronica Klein writes,

> His reputation, [based] on a batch of black-and-white movies he photographed whilst under contract as director of photography at RKO . . . features some of the most languorous and dreamlike sequences [in cinematic history]. In contrast to fellow cinematographer John Alton, Musuraca's was a simplistic [vision] in place of . . . "technical window dressing." Yet however frills free were his methods, his results—such as the flamboyant nightmare sequences suffered by the vulnerable protagonists in *Stranger on the Third Floor* (1940), which is considered [a] prime candidate for being the very first film noir entry, [as well as his work on] Robert Siodmak's *Spiral Staircase* (1945)—remain virtually indefinable.

But what is truly astonishing is how much work Musuraca did and, despite his noir typing, how many different styles of cinematography he embraced.

Musuraca's first full-fledged credit as a director of cinematography was on J. Stuart Blackton's *The Virgin Queen* in 1923; he followed that project with other films for Blackton and various small program pictures. These early, rough-and-tumble productions were nothing more than passable genre entertainments, yet Musuraca found them invaluable later in his career. Shooting on natural locations for the outdoor work and in hastily propped studios for the interior scenes, Musuraca had to learn to work

quickly and efficiently and yet still obtain excellent results. Then, too, the fact that these films were silent, even in films after *The Jazz Singer*, gave Musuraca a chance to experiment with camera angles, shadows, close-ups, and wide shots without having to worry about early sound technology and the noise often produced by camera movement. Musuraca finally broke out of the western genre with Malcolm St. Clair's crime drama *Side Street* (1929). From that point on, Musuraca photographed whatever the studio asked him to do, with a minimum of fuss and with genuine expediency, from the brightly lit comedy short *The Gay Nighties* (1933), directed by promising newcomer Mark Sandrich, to George Archainbaud's *Murder on the Blackboard* (1934). From 1933 through 1939, Musuraca labored in the trenches at RKO, averaging as many as ten films a year until he got his first near A-picture assignment, John Farrow's aviation survival drama *Five Came Back* (1939).

A plane crashes in the South American jungle in an area populated by headhunting cannibals; when the plane is repaired, it has only enough power to carry five passengers to safety. Who will live and who will be left behind? Farrow's direction is suitably taut; and though shot almost entirely on interior sets, Musuraca creates a subtly torrid atmosphere through the use of gauzes, filters, and "cookies" to cast menacing shadows as the jungle night closes in on the protagonists. With an excellent cast, including a young Lucille Ball, John Carradine, and Joseph Calleia, the film attracted decidedly favorable notices upon its release, helping move Musuraca a notch up the studio ladder.

Now more promising projects came his way: Rouben Mamoulian's boxing drama *Golden Boy* (1939), based on the play by Clifford Odets, starring a young William Holden and Barbara Stanwyck, which he photographed with the great Karl Freund on loan out to Columbia Pictures; Robert Stevenson's classic coming-of-age story *Tom Brown's School Days* (1940), starring Sir Cedric Hardwicke and Freddie Bartholomew; Boris Ingster's absolutely nightmarish thriller *Stranger on the Third Floor* (1940), starring Peter Lorre as a homicidal maniac, a small production that nevertheless was deeply influential, depicting a world of poverty, madness, corruption, and injustice, all set in a land of eternal shadows; and finally, in 1942, the real breakthrough for Musuraca, as well as director Jacques Tourneur and producer Val Lewton, the classic horror film *Cat People* (1942).

Designed as a frankly commercial project, *Cat People* was RKO's answer to Universal and its successful horror films. But RKO got much

more than it bargained for; produced for less than $150,000, *Cat People* ultimately raked in an astounding $8 million in rentals, and RKO immediately began an aggressive campaign to make as many horror films with producer Lewton as possible. Between 1942 and 1946, Lewton would produce nine Gothic thrillers, in addition to several other films for the studio, and Musuraca would photograph four of the most memorable: Mark Robson's *The Seventh Victim* and *The Ghost Ship* (both 1943), as well as Robert Wise and Gunther von Fritsch's *Curse of the Cat People* (1944; Wise replaced von Fritsch, who was moving too slowly), and Robson's *Bedlam* (1946), the final entry in the Lewton/RKO horror series.

At this point, RKO unwisely reasoned that if Lewton, Musuraca, and Tourneur were such a good team together, they would be even more effective separately, which, of course, did not turn out to be the case. Lewton's career went into eclipse shortly thereafter, and Tourneur's would be similarly uneven, but Musuraca managed to absorb all the combined lessons from his now two-decade tenure at RKO and create some of his most enduring masterpieces.

Musuraca's gritty cinematography on Edward Dmytryk's classic war film *Back to Bataan* (1945), starring John Wayne, was one of RKO's finest contributions to the war effort, though it arrived late in the conflict; his superbly dark and menacing work on Robert Siodmak's suspense thriller *The Spiral Staircase* (1945), in which a homicidal strangler, whose identity is unknown to both the audience and the characters in the film, stalks his victims—all women with various congenital birth defects or other afflictions—in turn-of-the-century New England, was even more successful, and Musuraca seemed destined for one A-picture after another.

And for a short while, this was true. But it wouldn't last; like the *maudit* characters who populated his domain of shadows, Musuraca would soon find himself cut adrift by the studio system, through no fault of his own. His next assignment, John Brahm's *The Locket* (1946), a psychological thriller with a complex "flashback within a flashback within a flashback" narrative structure, centering on Nancy (Laraine Day), a young woman who, as the result of childhood trauma, is a compulsive liar and kleptomaniac, offered Musuraca the chance to fully explore the darker, more atmospheric style that he had perfected on the Lewton films.

But this was just a warm-up for Jacques Tourneur's *Out of the Past* (1947), considered by many to be one of the finest noir thrillers ever made, with perpetual tough guy Robert Mitchum as Jeff Bailey, a former private

investigator who now runs a gas station in a futile attempt to escape his shadowy past. But when smooth crime boss Whit Sterling (Kirk Douglas, in one of his earliest roles) asks him to find his "girlfriend" Kathie Moffat (Jane Greer), who has absconded with $40,000 of Whit's money, things just get more complex from there. Soon Jeff is smitten with Kathie and smooth-talked into betraying Whit, and, of course, as in any true noir, everything ends very badly.

In an interview with *American Cinematographer* in February 1941, Musuraca commented that "while theories may be fine, the best way to do a thing is usually the simplest—and we can always find that simplest way if we reason things out looking for simplicity and logic instead of technical window dressing." As George Turner wrote: "He did not agree with the cinematic convention that heavy drama must be lit in a low key, comedy in high key, and romance in soft focus, but that the style should be determined by the logic of the scene" (*"Out of the Past"* 32). But for all his talk of simplicity, Musuraca had a clearly defined strategy in his classical 1940s work, which historian and critic Eric Schaefer broke down into "five consistent fragments":

The use of the complete tonal range of black and white; the low placement of lighting sources; narrow beams of high-key light within a dark frame; a silhouetting technique with an emphasis on lighting for contour; and a penchant for abstraction. The first of these stylistic signatures is the use of the full tonal range of black and white. Best exemplified by the outdoor sequences in *Out of the Past*, Musuraca created the moving equivalent of Ansel Adams's Zone System of photography in which deep blacks, smooth grays, and sharp whites coexist within the frame. The motion pictures which Musuraca photographed possess a richness and variety of tone that give even the low-budget films an opulent texture. His second rule provided a naturalistic means to achieve an expressionistic result. The low placement of light sources—often in the guise of table lamps, but also fireplaces and campfires—netted a highly expressionistic look as the illuminated subject was trapped by his or her own shadow looming on the walls and ceiling above. The third Musuraca trait called for tightly defined high-key light focused on objects, most often faces, in the black void. The technique simultaneously directs the eye to the primary point of interest within the frame while emphasizing the surrounding darkness leading to a tension as the conflicting tones attempt to dominate. Musuraca's fourth and most readily identifiable

trademark is a skimming-silhouetting technique. Figures of faces in the foreground are lit from the side or rear, emphasizing contour while leaving the front largely dark. The resulting highlighted contour of the silhouetted object separates it from the background adding depth to the frame. . . . [The] fifth trait is evident in a number of the films he photographed as the frame is shattered into geometric patterns of light and shadow. In *The Seventh Victim* a cosmetics factory at night becomes little more than a collection of rectangular shapes of varying tone. Similarly, many shots of nocturnal San Francisco in *Out of the Past* suggest that the city is constructed of black quadrangles and white squares of light rather than brick and mortar. In *Cat People* threat is conveyed by the changing density of the reflected patterns of rippling water on the walls and ceiling surrounding an indoor pool. ("Nicholas Musuraca")

Out of the Past arguably represents the peak of Musuraca's career, and the cast, the direction, and the screenplay all conspire to create one of the most compelling visions of death and corruption ever filmed, which has lost little of its power with the passing of years. But Musuraca's career would soon enter a steep decline.

George Stevens's family drama *I Remember Mama* (1948), which garnered Musuraca his only Academy Award nomination for Best Cinematography, was a much more conventional, straightforward project, not at all typical of his other work, but, of course, as a mainstream project it received extensive popular acclaim, and at 134 minutes, the film was a leisurely, diverting entertainment. By 1950, however, the eccentric industrialist Howard Hughes was making his presence known at RKO, and the studio began to come apart under his erratic reign. Old studio hands like Musuraca could only watch from a distance and wonder what had happened to the studio where they had labored so faithfully for so long. Under Hughes's management, Musuraca was forced to lens Robert Stevenson's risible anticommunist tract *The Woman on Pier 13* (aka *I Married a Communist*, 1949); John Farrow's indifferent noir *Where Danger Lives* (1950), starring Hughes's protégée Faith Domergue; and William Cameron Menzies's equally hysterical polemic *The Whip Hand* (1951), a suspense thriller centering on communist biological warfare, to name just a few of his later RKO assignments.

All these films involved extensive reshooting, since Hughes, the consummate control freak, seemingly couldn't let anything end. *The Whip*

Hand, for example, started out as a film about neo-Nazi biological warfare, with a still-living Adolf Hitler personally supervising the proceedings. The film was entirely complete when Hughes suddenly decided that neo-Nazis were passé, and reshot much of the film to make the Soviet Union the villain of the piece. Out went Hitler (Bobby Watson), whose scenes now fell to the cutting room floor; in came Stalin's minions. Musuraca and his crew had no choice but to comply with Hughes's dictates; it was a job, and Musuraca needed the work.

Relief of a sort came when Ida Lupino tapped Musuraca to lens her tense suspense drama *The Hitch-Hiker* (1953), a low-budget RKO release actually produced by Lupino's own company, the Filmakers, with extensive location work at Lone Pine, California, as psychopathic killer Emmett Myers (William Talman) terrorizes two men on a fishing trip, Roy Collins (Edmond O'Brien) and Gilbert Bowen (Frank Lovejoy), who pick Myers up when he thumbs a ride. Based on the real-life case of killer Billy Cook, who went on a similarly murderous rampage, and clocking in at a taut seventy-one minutes, *The Hitch-Hiker* is one of Musuraca's finest late films, a modestly budgeted project that, like the Val Lewton films he photographed in the early 1940s, carried real emotional impact.

Musuraca had the uncanny ability to size up any scene, interior or exterior, and almost immediately discern precisely what tools he would need to present the desired image on the screen effectively. Interiors were relatively easy to accomplish; a splash of light across the set, maybe one or two fill lights, with the resultant shadows, and you were home—as Val Lewton once commented on his films with Musuraca, "We're great ones for dark patches" (Siegel 32)—but Musuraca brought this same instinct for simplicity to his exterior work as well. As he told Walter Blanchard in 1941,

> The same [technique] applies to making exterior scenes. One of the commonest sources of unnecessary complication is in overdoing filtering. Just because the research scientists have evolved a range of several score filters of different colors and densities isn't by any means a reason that we've got to use them—or even burden ourselves down with them! On my own part, I've always found that the simplest filtering is the best. Give me a good yellow filter, for mild correction effects, and a good red or red-orange one for heavier corrections, and I'll guarantee to bring you back almost any sort of exterior effects (other than night scenes) that you'll need in the average production.

And by the way—when in doubt about filtering—don't. Nine times out of ten you're better off that way, especially if there are people in the scene. ("Aces of the Camera II" 56).

All in all, Musuraca leaves a complex legacy. Clearly, his work in black and white in the 1940s is a major achievement artistically and left a lasting influence on the then-nascent noir genre. But Musuraca is also sadly emblematic of the plight of the reliable studio technician who lacks the survival skills to exist comfortably in a freelance world. Musuraca's seductive universe could only subsist as long as the studio system thrived; his later television work, for the most part, could have been shot by anyone. Black and white was his medium; with artists like Jacques Tourneur and sympathetic producers like Val Lewton, Musuraca could create miracles with a minimum of time and resources, using just a few well-placed lighting sources to create a world that was at once menacing and alluring. Such opportunities were rare, as one might expect. Then as now, Hollywood was a bottom-line industry. On many of his films, Mursuraca was fighting against the clock, and even with his speed and efficiency, just "making the pages" for a day's work was a continual challenge. Despite the "speed up" in studio production methods as the 1940s progressed, Musuraca, one of the very greatest of all the Hollywood studio technicians, continued to seek new approaches to his work, refusing to be stuck in just one style of lighting, searching for the simplicity, beauty, and sincerity in his work, even if he sometimes had to accept assignments that were not his first choice. As the technological landscape changed around him, Musuraca evolved as an artist, but he refused to succumb to the gimmickry that many lesser cameramen employed in their work—a splash of light here, a shadow there, simply to set the mood without any real meaning behind the placement of the lighting sources. For Musuraca, there had to be a reason for the way the film was shot—he wasn't just recording an image; he was interpreting each scene for the audience. And yet he remained resolutely grounded in reality. Above all other considerations, what guided Nick Musuraca during his golden era in the 1940s was practicality. As Blanchard observed,

[For] Musuraca . . . there must be a reason for everything. His whole approach to his work seems predicated on the eternal question, "Why am I doing this, and why am I doing it this particular way?" . . . Before he is satisfied, he must have a practical, commonsense reason that makes direct appeal

to his strong sense of logic. If, to get that reason, he has to break established traditions, or evolve new methods, he does it. But he must convince himself that whatever it is is being done in the best and most sensible way possible. ... To Nick's mind, there can never be any fixed rule for lighting a given type of set or action, for each scene is a complete photodramatic entity in itself. ... Another point upon which Musuraca feels strongly is that in many ways modern photography has become too complicated—unnecessarily complicated. "There are more than enough things that really have to be done," he says, "to make any kind of a picture today: why should we go out of our way to add complication—and make ourselves a lot of extra work?" ("Aces of the Camera II" 56).

Musuraca's desire to keep things simple is the essence of his artistry; just a few strategically placed lights and a scene is lit, not flooded with random light. In his careful use of illumination, often "practical" lights on the set, Musuraca created a hyperreal world for his characters, at once artificial and yet subtly compelling nonetheless.

Musuraca teamed with an aging Fritz Lang in the early 1950s, and shot two of the director's most acerbic visions of American malaise, *Clash by Night* (1952) and *The Blue Gardenia* (1953). Soon after he lensed director Dick Powell's interesting suspense thriller *Split Second* (1953) and Frank Tashlin's comedy *Susan Slept Here* (1954), which oddly enough starred Dick Powell, but that was pretty much the end of the story. As RKO had been transformed into Desilu, it made sense for Musuraca to stay on, so he wound up his career shooting episodic television for numerous series at Desilu and other production companies, such as *The Lone Wolf* (1954–1955), *Four Star Playhouse* (1953–1956), *The Jack Benny Program* (1962–1965), and his very last assignment, *F Troop* (1966), which was shot at Warner Bros. All in all, Nicholas Musuraca racked up a total of 212 credits as a director of cinematography, with one other odd footnote. When RKO decided to savagely recut Orson Welles's *The Magnificent Ambersons* in 1942, Musuraca was brought in to shoot the "additional material" directed by the film's editor, Robert Wise, and the film's assistant director, one Fred Fleck, after Stanley Cortez, the film's cinematographer, refused to participate in the reshoots.

If one factor dominated the life of the studio cinematographer more than any other during the 1940s, it was simple economics. Jack Warner, the dictatorial and penurious head of production at Warner Bros. from

the 1950s to the 1960s, issued a constant stream of memos from his office urging his cameramen to economize whenever possible, and not necessarily to strive for technical or artistic perfection—for Warner, the bottom line was all that mattered.

Obviously, this is the exact opposite of what Gregg Toland expressed in his remarks on *Citizen Kane*, but *Kane* was a dangerous film in more ways than one—it aspired to being something more than merely another item on the studio balance sheet, and the moment art began to interfere with commerce, executives got worried. Warner, as well as Harry Cohn at Columbia and Louis B. Mayer at MGM, realized that a studio boss had to pay some sort of lip service to artistic intent, but in reality that's all it was. If directors, cinematographers, actors, writers, and set designers did good work, with a certain visual and dramatic flair, that was fine—after all, Academy Award nominations, as well as wins, helped to sell films and raise a studio's business profile—but it was profit margins that were sacred.

In this atmosphere, some of the most prolific DPs of the 1940s had to make a fundamental decision as they approached each new project: would they go along with the ruling regime's dictates, or conspire with a sympathetic director to create something exceptional, or, most often, do the work as they saw fit and keep their thoughts to themselves? As DP Arthur C. Miller noted in an interview with Walter Blanchard in April 1942,

> There are directors who seem to defy you to get even decent photography—men to whom photography, good or bad, doesn't seem to mean a thing. And then there are men like John Ford, who directed *How Green Was My Valley*. Ford appreciates the value of good photography, not only from a decorative standpoint, but for its dramatic value, as an aid to his own work. He'll go out of his way to help you. Working with John Ford, even on the most difficult sort of production, is a pleasure that cannot come any too often to any of us. ... And then there are producers like [Twentieth Century–Fox's] Darryl Zanuck ... Zanuck's camera-mindedness makes things better for all of us out at his studio. For example, he is one of the very few producers who have ever had the wisdom to put at the head of their camera department an experienced cinematographer. ("Aces of the Camera XVI" 182)

Ford is often held up as an example of a director who cared passionately about the pictorial quality of his films, but even such journeymen as John L. Russell, who labored for the most part in episodic television

or extremely low-budget films such as Edgar G. Ulmer's *The Man from Planet X* (1951) and Fred C. Brannon's indifferent Republic serial *Government Agents vs. Phantom Legion* (1951), brought to their most pedestrian projects a sense of personal commitment. When a truly engaging project fell into his lap by chance, such as Orson Welles's stark, moody adaptation of *Macbeth* (1948), shot at Republic, Russell immediately rose to the challenge, delivering dramatic, spare lighting, reminiscent of film noir, to Welles's bare suggestion of sets. His work on Frank Borzage's dark drama *Moonrise* (1948), also for Republic, demonstrates that Russell had the soul of an artist, but for most of his career he was instructed just to "get it, then forget it." Recognizing that in such instances resistance was futile, Russell complied with the less imaginative directors with whom he often had to work.

With directors possessing some originality, Russell could work miracles. For perennially impoverished auteur Samuel Fuller's love letter to the New York newspaper business in the 1880s, *Park Row* (1952), Russell conjured up a convincing feeling of gas-lit, cobblestone Manhattan on an absolutely Spartan budget. But faced with an intractable deadline, as he was in Alfred E. Green's exploitational Red Scare film, *Invasion U.S.A.* (1952), in which copious amounts of stock footage—or perhaps more accurately "stock mileage"—from World War II is used to tell the tale of a Soviet sneak attack on the United States, with Soviet troops wearing U.S. uniforms as a disguise, Russell simply shot the film as fast as possible, completing the entire project in six days on a budget of $127,000.

Yet when Eugène Lourié, the Ukrainian émigré who early in his career served as the production designer/art director on Jean Renoir's classic antiwar film *Grand Illusion* (1937), needed someone quickly and efficiently to shoot his low-budget but highly inventive nonstop science-fiction epic *The Beast from 20,000 Fathoms* (1953), it was Russell whom he sought for the assignment. The results belied the meager resources at Lourié's disposal in every respect, affording the film a rich, deep look with highly saturated blacks and whites that greatly enhanced Ray Harryhausen's special effects, in this case bringing a prehistoric dinosaur to life, with a rousing climax staged on a battered roller coaster at night in an outdoor amusement park. (For Russell's later work with Alfred Hitchcock, see chapter 5.)

The ultimate noir protagonist of the 1940s was undoubtedly the Whistler, who starred in a series of eight films for Columbia Pictures in the

1940s. *The Whistler* series was based on a popular radio program of the period, in which the mysterious title character ("I am the Whistler, and I know many things, for I walk by night . . .") narrated stories of crime, deception, and murder, all with a twist ending in which the characters in the various narratives were tripped up by their own errors, or by the caprices of fate. Almost 700 episodes of the radio series were broadcast, with Bill Forman in the title role for most of them, but when Columbia brought the series to the screen, they made an audacious decision: the Whistler would never be seen, but depicted only as a shadow, sardonically commenting on the foolishness of the "men and women who have stepped into the shadows," as he put it, and embarked on various criminal enterprises inevitably doomed to failure. These films were all meticulously designed exercises in deep shadows and high-key lighting, and the cinematographers who shot them are yet more proof of the nearly bottomless technical talent pool of 1940s Hollywood.

Space doesn't permit an extended discussion of the lesser known DPs responsible for photographing these films, but in the 1940s, the art of black-and-white cinematography was at its zenith. People such as James S. Brown, L. William O'Connell, Harry Neumann, George Meehan, and Jack Marta, who much later served as the DP on Steven Spielberg's 1971 TV movie *Duel* and accumulated more than 220 credits in his long career, were dependable technicians who could be counted on to deliver crisp, resonant imagery quickly and efficiently—as in *The Whistler* series, still the only film franchise whose main character is only a shadow, persistently trailing the other characters in each film and seemingly controlling their fate.

Another superb yet generally unacknowledged master of black-and-white cinema in the 1940s was J. Roy Hunt, who labored alongside Nicholas Musuraca at RKO Radio. As with most of the DPs discussed in this volume, Hunt started out in the early days of the cinema, but unlike Musuraca his career didn't last nearly as long. Hunt broke into the business in the early teens, working with no less than seven other pioneering cinematographers, including another unsung master, Marcel Le Picard, on Herbert Brenon's 180-minute drama *A Daughter of the Gods* (1916), a forgotten epic that rivals D. W. Griffith's *Intolerance* in both its scope and ambitions.

By 1922, Hunt was the sole cinematographer on Albert Parker's groundbreaking version of *Dr. Jekyll and Mr. Hyde*, starring a still-dashing

John Barrymore in the title role. As sound came in, Hunt was tapped by director Victor Fleming to lens *The Virginian* (1929), an early sound western that helped to make Gary Cooper one of the defining stars of the 1930s and immortalized the line, "If you want to call me that, smile!" as the Virginian (Cooper) helps to break up a gang of cattle rustlers in the 1880s. Shot for the most part on location, with studio settings intercut for expositional dialogue, Fleming's macho naturalism was a perfect fit for Hunt's dry and arid approach to the material, but Hunt was something of a chameleon in his work, able to adapt his style not only to reflect the subject matter of a film, but even to emulate—up to a point—the work of another cameraman.

Thus, with Thornton Freeland's breezy musical *Flying Down to Rio* (1933), often cited for its aggressive use of "wipes" to push one image off the screen in favor of another and its almost plastic use of editing, foreshadowing the approach Richard Lester used in his first film with the Beatles, *A Hard Day's Night* (1964, d.p. Gilbert Taylor), Hunt adopted an entirely different style from his earlier, more straightforward work, alternating highly lit dance numbers by Fred Astaire and Ginger Rogers with comic shadow work, in which the film's villains, a group of powerful bankers, are rendered as caricatures of the plutocracy. One of the guiding principles of Hunt's work was his seemingly endless curiosity and his willingness to tackle new ideas and technological shifts.

But Hunt's most famous work was yet to come, on Jacques Tourneur's *I Walked with a Zombie* (1943), a film that, as Joel Siegel put it, "magically evoked the West Indies" (43) with its narrative of Haitian voodoo possession, grafted onto a narrative clearly derived from *Jane Eyre.* On the classic noir *Crossfire* (1947), the director Edward Dmytryk remembered that because of the film's "troublesome" subject matter (antisemitism leading to the murder of a World War II veteran), RKO cut the film's budget to the bone, requiring that the entire film be shot in a mere twenty days, an extraordinarily tight schedule for an A-film. Yet Hunt rose to the occasion, and, as Dmytryk noted, age hadn't slowed Hunt down one bit. Said Dmytryk,

> In 1947 he was almost seventy [actually sixty-three]. He had gotten into pictures about Year One by building his own camera, and he had never stopped inventing. Half the improvements on RKO's special sound camera—the best in the business at that time—were of his design.... Because of Roy's

speed in lighting, we were also able to reverse the usual statistics on time of preparing versus time of shooting. On the average short-schedule film, setting up and lighting take five to ten times as long as the actual shooting. On *Crossfire*, my actors and I were in action at least twice as long as Hunt and his crew. (Stafford)

Other key films Hunt shot in the late 1940s include Ernest B. Schoedsack's "miniature" version of *King Kong, Mighty Joe Young* (1949), with immaculate process work, especially in the nightclub scene in which captive wild animals break through their glass enclosures to terrorize the crowd, further enlivened by the special effects of Willis O'Brien and a young Ray Harryhausen. But with Dmytryk's post–World War II drama *The Juggler* (1953), Hunt decided that it was time to retire. With more than 180 credits under his belt as a director of cinematography, Hunt was yet another invaluable member of the 1940s Hollywood cinematic corps.

Stanley Cortez was another major figure in 1940s Hollywood. Born Stanislaus Kranz in New York City in 1908, he studied at New York University, worked as a still photographer at the Bachrach Studios, and then joined Gloria Swanson Productions as a camera assistant. Cortez's first film as a fully credited DP was Sidney Salkow's *Four Days' Wonder* (1936), a minor mystery film, even if it was loosely based on a novel by *Winnie the Pooh* author A. A. Milne, followed by a series of distinctly undistinguished program pictures, such as Albert S. Rogell's altogether unsuccessful horror "comedy" *The Black Cat* (1941), which had nothing to do with Edgar Allan Poe's short story and featured a young Broderick Crawford as a comedic lead. But somehow, as empty as that film is, it possessed a certain style and assurance that, surprisingly, convinced Orson Welles to give Cortez the job of photographing his follow-up to *Citizen Kane, The Magnificent Ambersons* (1942), which was, in fact, Cortez's first really significant assignment, and an enormous logistic, aesthetic, and technical challenge.

But when Welles left for South America to work on the documentary *It's All True*, there was a change in management at RKO, and the studio's new chief executive, Charles Koerner, unimpressed with the film, ordered savage cuts, even to the point of shooting a new happy ending for the film. Welles's original cut for *Ambersons* was 148 minutes; a revised version clocked in at 131 minutes; and the final edit came to just 88 minutes, with roughly 40 essential minutes eliminated and the negative trims

subsequently destroyed. As Welles later said, "They destroyed *Ambersons*, and it destroyed me" (Carringer, *Magnificent Ambersons* 29); Cortez also lamented the loss of some "of my best work . . . , magnificent things," as he put it (qtd. in Higham 102). The film's mutilation remains one of the great tragedies of cinema history, and, as with von Stroheim's *Greed*, it seems that the original version of *Ambersons* is lost forever.

The studio dropped *Ambersons* onto the bottom half of a double bill with Leslie Goodwins's lowbrow slapstick comedy *Mexican Spitfire Sees a Ghost* (1942), marking a truly humiliating comedown for Welles and Cortez, to say nothing of the actors in the film—Joseph Cotten, Agnes Moorehead, Ray Collins, Tim Holt—who gave superlative performances. Welles's career never really recovered, and Cortez discovered, much to his chagrin, that in the studio's eyes he was somehow to blame as well. Some interesting work came his way, such as Julien Duvivier's multipart *Flesh and Fantasy* (1943), a remarkable film in many respects; John Cromwell and Edward F. Cline's homefront World War II drama *Since You Went Away* (1944); and John Huston's postwar documentary about returning soldiers suffering from post-traumatic stress syndrome, *Let There Be Light* (1946), which was, however, suppressed for many years as supposedly detrimental to the nation's jittery nerves in the uncertain era after the war.

But now the assignments became thinner, as with Stuart Heisler's melodramatic Susan Hayward vehicle *Smash-Up: The Story of a Woman* (1947), centering on the rapid rise and fall of nightclub singer Angie Evans, who finds solace in the bottle when career pressures become overwhelming. Fritz Lang's downbeat *Secret Beyond the Door* (1947), though beautifully mounted and exquisitely photographed, is one of Lang's lesser films, and by 1952, Cortez found himself working on Charles Lamont's *Abbott and Costello Meet Captain Kidd* (1952), shot in the cheap Cinecolor process, and later Richard Carlson and Herbert L. Strock's lowbudget science-fiction entry *Riders to the Stars* (1954), also shot in washed-out, two-tone Cinecolor, the poor man's Technicolor, a process usually reserved for program westerns.

A definite reprieve came in 1955 when Cortez was tapped by Charles Laughton for his only directorial effort *The Night of the Hunter* (1955), a classic thriller starring Robert Mitchum, Shelley Winters, and the everresilient Lillian Gish, with an exceptionally literate screenplay by James Agee. Oddly enough, this assignment came about because Laughton,

who had lowered himself to play Captain Kidd with Abbott and Costello, knew and admired Cortez's work on *Ambersons*, and the two men became friends. But apart from some subsequent work for maverick director Samuel Fuller, *Shock Corridor* (1963) and *The Naked Kiss* (1964), Cortez's career began to deteriorate.

In 1963, Cortez photographed David Bradley's preposterous *Madmen of Mandoras*, in which a group of neo-Nazis have kept Hitler's disembodied head alive artificially and, following Der Führer's instructions, once again plot to take over the world. Despite the film's poor production values, Cortez managed to get something out of this distinctly unpromising material, and yet all his work came to naught when the film's producers, anxious to release the film to television, hired several UCLA graduate students in 1969 to shoot an additional twenty minutes of footage to increase the film's running time. The end result was truly disastrous, and Cortez's name ignominiously remained as the sole cinematographic credit on the film, further damaging his already tattered reputation.

John Guillermin's routine war drama *The Bridge at Remagen* (1969) offered Cortez no real challenges; still, it was a resolutely A-level film, something that Cortez desperately needed at the time. In 1974, Cortez was hired by Roman Polanski, a film aficionado much taken with Cortez's work in the 1940s, to shoot his classic neo-noir *Chinatown*, but was replaced by John A. Alonzo after just one week's shooting. In 1977, however, Cortez successfully rounded out his career on a high note with Claude Lelouch's gently idiosyncratic "western" *Another Man, Another Chance* (1977), starring James Caan as David Williams, a photographer who has been hired to photograph the vanishing American West in the 1880s. This quiet, elegiac film was an appropriately graceful exit for Cortez, and he remained active as an observer and occasional participant in the machinery of Hollywood, memorably testifying, for example, on the deleterious effects of "colorization"—the artificial, digital addition of color to black-and-white films, first popularized by media mogul Ted Turner in the mid-1980s. Speaking before a Senate subcommittee hearing in October 1989, Cortez stated flatly:

> When a motion picture which was originally photographed in black and white is then colorized, it is not the actor's acting which is changed, nor the writer's writing, nor the composer's music, nor the editor's editing, nor the director's directing. No. It is the cameraman's photography which is totally

altered—from what was an expressive work of intricately refined light and shadow to a totally different form, completely foreign to the cinematographer's vision of the story. . . . I concur with the ASC's position that producers should have the right, as owners of films, to exploit them in whatever economic manner they have available to them, *provided, however*, that any material alterations they allow to be made should be clearly labeled to indicate that they were made to the original version and were done without the collaboration or consent of the cinematographer. This is absolutely necessary to protect our integrity and reputation as artists. . . . I know that perhaps some young people in America today scorn the impressionistic beauty of the classic black and white film—the master achievement of Hollywood's Golden Era. But because *some* people do not appreciate the black and white picture does not mean *all* should be robbed of the joy of seeing a classic in its original beauty and splendor. . . . I believe firmly in the preservation of the historical black and white image . . . to tamper with it would be sacrilegious, no matter what method is used. This would be tantamount to altering a single note of Beethoven's 9th Symphony, which is unthinkable. ("Stanley Cortez")

Yet even as he said these words, Cortez knew that as a contemporary production medium, black and white was no longer commercially viable. As he told Charles Higham,

I've always maintained that color photography—and we in Hollywood can only talk in terms of color, now that black and white is dead—should not be naturalistic, that one should always feel free to make mistakes. We have so often had to follow the studios' specific styles. I remember that M-G-M and 20th used to fight; Louis B. Mayer [of MGM] saw one of Zanuck's pictures [at Twentieth Century–Fox] in the early days, and Mayer decided to change all his pictures from soft to hard color as a result, and told Karl Freund and his other cameramen what to do. The other studios followed suit.

So as a result we got "Christmas package" colors in Hollywood films of the forties and after—a distorted sense of color values in which everyone wanted to put more and more color in. Nowadays, we are getting the opposite problem: purism, a classical approach to color. In those days the color was too bright, now it's too dark, but in neither case have most cameramen here been bold, gone out to try new things. Even though a thing might be technically wrong, to me that wrong thing can be *dramatically* right. To hell

with all this caution! To hell with this 'academic' approach! You must *distort* color, play around with it, make it work for *you*, intentionally throw it off balance. You can mirror emotions in color. There are times when nature is dull: change it. (Higham 98)

In short, for Cortez, color was only valuable if one could distort it and create a world as artificial and interpretational as black and white. His career thus stands as a testament to the whims of Hollywood; despite Gregg Toland's self-assured boast that cameramen were the most independent technicians in Hollywood, unless you knew how to play the game, curry favor with studio bosses, and perhaps, most importantly, keep up a good front, one might be exiled to the outer fringes of the cinematic firmament, no matter how much talent you possessed.

Burnett Guffey, fortunately, was made of much sterner stuff. In considering Guffey's long career, which started out in 1923 as an assistant, before he was suddenly and fortuitously promoted to second unit work on Ford's great early western *The Iron Horse* (1924), one is immediately struck by the enormously wide variety of projects that he handled. And yet his road to two Academy Awards was a long and difficult trek. After his work on *The Iron Horse*, Guffey dropped back to the ranks of assistant cameraman when Ford unceremoniously demoted him. This was a typical Fordian strategy; a small taste of authority was quickly snatched away, but for a purpose, however harsh. The extra time as assistant gave Guffey that much more opportunity to hone his skills, even if, in the short run, it was a real disappointment.

Hired by Famous Players–Lasky Studios in 1927, Guffey became a full-time camera operator in 1928, but again, other than a comedy short, John J. Mescall's *Fairways and Foul* (1929), it wasn't until Lew Landers and Budd Boetticher's war drama *U-Boat Prisoner* (1944), a film Landers started but Boetticher finished, that Guffey got his first full credit as DP. In between 1928 and 1944, however, Guffey was far from idle, working as the uncredited camera operator on numerous films, most notably John Ford's *The Informer* (1935), Fritz Lang's *You Only Live Once* (1937, once again as an assistant cameraman), and Alfred Hitchcock's *Foreign Correspondent* (1940, now back to the position of camera operator, but still with no formal credit), among others.

So by the time Guffey finally moved up to the director of cinematography slot in 1944, twenty years after his work on *The Iron Horse*, he

had paid his dues many times over. And yet this was far from the end of Guffey's long climb to the top; as the low man on the Columbia roster, he was assigned to anything that Harry Cohn, the studio's chief executive, wanted Guffey to shoot, and so he lensed a series of pedestrian B-programmers, such as Will Jason's *Soul of a Monster* (1944), Del Lord's almost "no budget" musical *Kansas City Kitty* (1944), and Jason's musical comedy *Eve Knew Her Apples* (1945), before he drew the assignment that would offer him his first real taste of recognition: Joseph H. Lewis's classic, flamboyant noir *My Name Is Julia Ross* (1945). Briefly, the film's narrative centers on a young woman in wartime London, the eponymous Julia Ross (Nina Foch), who, desperate for money, takes a job as a live-in secretary for the wealthy and reclusive Mrs. Hughes (Dame May Whitty). However, Julia is drugged soon after arriving at Mrs. Hughes's palatial mansion, and when she awakens she is told that she is the wife of Mrs. Hughes's son, Ralph (perennial villain George Macready). In fact, Ralph has murdered his wife and plans to pass off Julia as his late spouse and then murder her, making it look like a suicide.

Designed as yet another program picture, Lewis, who was also eager to make his mark, devised an intricate series of complex deep-focus shots, chiaroscuro lighting designs, and high- and low-angle shots for dramatic emphasis. Though Lewis claimed the lion's share of attention for the success of the film, it was clearly Guffey's command of the visual possibilities of the camera that made the world of *Julia Ross* at once sinister and appropriately claustrophobic. Lewis was loath to give his cameramen any credit at all on his films. Ever the aggressive self-promoter, Lewis—known as "Wagon Wheel Joe" for his habit of dragging around half a broken covered wagon wheel on the sets of his many B-westerns and then sticking it in the foreground of nearly every shot—once said, "I've never known a cameraman yet to make a setup for me" (Bogdanovich, *Who the Devil* 655). But this was clearly an exaggeration. Guffey knew exactly what he was doing and how to get the results Lewis wanted. In any case, despite Lewis's unwillingness to share any credit for the film with Guffey, the film propelled both men to the front of the studio hierarchy on the basis of a low-budget, ten-day film, which is today often regarded as a classic film noir. For his part, Guffey was used to being shortchanged when it came to plaudits for his work, but Harry Cohn wasn't fooled by Lewis's bravado, and over time Guffey began to receive much more prestigious assignments.

Still, Guffey was also called upon to photograph such routine films as Lew Landers's *A Close Call for Boston Blackie* (1946) and D. Ross Lederman's *The Notorious Lone Wolf* (1946), which, with its complex plot of lust, murder, and betrayal, is almost as intriguing as *Julia Ross*, and one of the most memorable of his early assignments. Guffey shot another, less successful noir with Lewis, *So Dark the Night* (1946), in which French detective Henri Cassin (character actor Steven Geray) hunts for a murderer, only to discover that he has unknowingly committed the crime himself. The film's premise is certainly promising, but the back-lot French village used in the film is rather unconvincing, unlike the surprisingly effective "British" studio settings for *Julia Ross*. Guffey next teamed with rising director Robert Rossen for the by-the-numbers Dick Powell murder mystery *Johnny O'Clock* (1947), then with director John Sturges for the over-the-top family melodrama *The Sign of the Ram* (1948), but then got the opportunity to work with a young Nicholas Ray on his juvenile delinquency drama *Knock on Any Door* (1949), starring Humphrey Bogart as crusading attorney Andrew Morton, defending teenager Nick Romano (a young John Derek) on a charge of murder, which Morton blames on Romano's slum child upbringing. It's an earnest film, but still a misfire, as was Guffey's final teaming with Lewis, the noir crime drama *The Undercover Man* (1949).

Yet great things were finally around the corner for Guffey. For director Max Ophüls, he photographed *The Reckless Moment* (1949), a film composed almost entirely of the director's signature tracking shots, eschewing standard montage technique for detailed, extended scenes in which camera movement replaced editing. Then came the film that firmly established Guffey as a cinematographer of the first rank, Robert Rossen's political drama *All the King's Men* (1949), starring Broderick Crawford as ruthless politician Willie Stark, who will stop at nothing to realize his ambitious dreams of power. Adapted from the novel by Robert Penn Warren, itself thinly based on the notorious career of the late Louisiana governor and senator Huey P. Long, a real-life political operator whose corrupt thirst for wealth and influence led to his assassination by a disgruntled constituent in 1935, *All the King's Men* was shot in a neorealist, newsreel style on location in Stockton, California (doubling for the Deep South), and used numerous nonprofessionals in crowd scenes and bit parts. As Bob Thomas noted in his book *King Cohn*, while Columbia

studio head Harry Cohn was impressed with Crawford's performance in the leading role, he

> became alarmed as the rushes arrived from the Stockton location. Rossen was filming scenes that were nowhere to be found in the finished script. [Guffey's] photography had none of the polish of the usual Columbia product. What's more, many of the performances by townspeople recruited by Rossen were downright amateurish. Cohn took note of the criticisms and forwarded them to Rossen. The director exploded, firing off an angry telegram in reply. Cohn telephoned him.
>
> "What you're saying is 'Go fuck yourself,'" Cohn suggested.
>
> "That's right," said Rossen.
>
> "Okay, go ahead with the picture," [said Cohn]. . . .
>
> Rossen completed *All the King's Men* for less than $1,000,000, receiving only $25,000 for his services as writer, director, and producer. . . . A few weeks later Cohn telephoned Rossen to say, "I just thought I'd tell you that much to my surprise *All the King's Men* won the best-picture award of the New York Film Critics." (B. Thomas 264–265)

The film also won the Academy Award for Best Picture, but Guffey wasn't even nominated for his work, although he did receive a Golden Globe nomination. Next came Nicholas Ray's acerbic Hollywood noir *In a Lonely Place* (1950), in which struggling screenwriter Dixon Steele (Humphrey Bogart) battles his propensity for violence while trying to complete a screenplay he truly believes in, even as he comes under suspicion of murder; Phil Karlson's stunningly vicious *Scandal Sheet* (1952), in which stop-at-nothing tabloid newspaper editor Mark Chapman (Broderick Crawford) kills the wife he deserted long ago and then tries to cover it up while paradoxically exploiting the murder to increase his paper's circulation; Edward Dmytryk's equally violent *The Sniper* (1952), centering on a mentally ill serial killer (Arthur Franz) who preys on young women; and Fred Zinnemann's lavish production of *From Here to Eternity* (1954), for which Guffey finally won an Oscar for Best Cinematography.

Guffey continued at a torrid pace, lensing Fritz Lang's *Human Desire* (1954), Don Siegel's *Private Hell 36* (1954), Phil Karlson's *Tight Spot* (1955), Mark Robson's boxing drama *The Harder They Fall* (1956) with

Burnett Guffey, third from left, with light meter, taking a reading on the set of *From Here to Eternity* (1953), as stars Donna Reed and Montgomery Clift rehearse a scene and director Fred Zinnemann, far left, looks on

Humphrey Bogart in his last film, Jacques Tourneur's offbeat thriller *Nightfall* (1957), Karlson's *The Brothers Rico* (1957), Gerd Oswald's *Screaming Mimi* (1958), among other projects, all of them created in a gritty, hard style, with dark, forbidding cinematography that evenly matched the relentless narratives. Showcasing his versatility, however, Guffey then shot Paul Wendkos's teenage comedy *Gidget* (1959) in a cheerful, brightly lit fashion before launching into the parched, sun-dried landscapes of Robert Rossen's violent western *They Came to Cordura* (1959). In 1961, Guffey lent his considerable expertise to "shock" director William Castle on his films *Homicidal* and *Mr. Sardonicus*, two of Castle's more successful projects.

Most these films, of course, were in black and white. As late as 1965 Guffey made it clear that he preferred black-and-white cinematography over color. Opening an essay with a quotation from Plato—"Beauty of style and harmony and grace and good rhythm depend on simplicity"—Guffey noted:

> By simplicity I mean a single source light, little fill light, and a minimum of camera movement for its own sake. I also mean simplicity in costuming, makeup, and decoration of sets. This is one reason I enjoy doing B&W photography. For it seems to me that even today, three decades after the color revolution in motion pictures, we still find ourselves too often using color for color's sake, where color becomes not the medium, but the end product, where color is used not to enhance the story, but to *be* the story. I've done enough work in both color and B&W to convince me that it's more of a challenge to do a good job in B&W than it is in color. And I'm in total agreement with the writer who said, "Black-and-white photography seems better suited to a certain type of film drama, such as the mystery or melodrama." (777)

Yet, Guffey was leaving the world of black and white behind, with the late exceptions of John Frankenheimer's prison drama *Birdman of Alcatraz* (1962) and Bryan Forbes's World War II prison camp drama *King Rat* (1965), which he knew at the time represented his last work in monochrome. In 1967, he famously lensed Arthur Penn's *Bonnie and Clyde* in a palette of muted, drab color alternating with brilliant splotches of red during the film's more violent, blood-soaked sequences, particularly the infamous slow-motion machine-gun death of the title characters. Clearly influenced by the style of the French New Wave cinematographers of the period (the director François Truffaut had been attached to the project at one point), Guffey's romantic yet simultaneously naturalistic work deservedly won him a second Academy Award.

At the ceremony, Guffey may have set a record for modesty and reticence when he accepted the award by stating, "Thanks, everybody that helped me do it . . . that's all I can say." In his last years as a DP, Guffey continued his string of artistic triumphs, now solely in color, with such films as famed still photographer Gordon Parks's first feature film *The Learning Tree* (1969), Bryan Forbes's *The Madwoman of Chaillot* (1969), and Martin Ritt's superb *The Great White Hope* (1970). Looking back at

Guffey's long and remarkable career, one is struck by his modesty, his persistence, and his unquenchable desire to move on from one assignment to the next, professional to the end. The man who started in the silent era was a force in cinematography for nearly five decades, but his best work, as he clearly knew, was in black and white.

The 1940s in Hollywood was truly the era of monochrome magic, and while we've discussed the work of many important figures of the era, it's impossible to include them all. Rudolph Maté, a key architect of the black-and-white image, secured his first career triumph as the director of cinematography on Carl Th. Dreyer's classic *The Passion of Joan of Arc* (1928), with subsequent triumphs such as Dreyer's first sound film, *Vampyr* (1932), and Fritz Lang's *Liliom* (1934). After emigrating to the United States, Maté shot William Wyler's *Dodsworth* (1936), King Vidor's maternal melodrama *Stella Dallas* (1937), Alfred Hitchcock's *Foreign Correspondent* (1940), Ernst Lubitsch's satire of the Nazis *To Be or Not to Be* (1942), and two films from Charles Vidor starring Rita Hayworth, *Cover Girl* (1944) and *Gilda* (1946). He was uncredited for his work on Orson Welles's intricately complex thriller *The Lady from Shanghai* (1947, co-photographed with Joseph Walker and Charles Lawton Jr.; only Lawton received screen credit). Afterward, Maté turned his attention solely to directing, with decidedly uneven results.

Milton Krasner was another industry veteran who started his career in the early days of the cinema. His many films of the 1940s include Edward Cline's classic W. C. Fields comedy *The Bank Dick* (1940), several films in the long-running Abbott and Costello series at Universal, where Krasner spent much of his career, Erle C. Kenton's atmospheric *The Ghost of Frankenstein* (1942)—"I always liked to do the effects stuff with light and shadow," Krasner noted (Turner, "Cinemasters" 42)—and Ray Enright's ultra-patriotic World War II drama *Gung Ho!* (1943), based on the real-life raid on Makin Island in the South Pacific. Other standout films of the 1940s for Krasner include Fritz Lang's noir *Scarlet Street* (1945), independently made by Lang and star Joan Bennett's Diana Productions, but released to considerable controversy by Universal; Robert Siodmak's psychological thriller *The Dark Mirror* (1946), using copious split-screen work to tell the story of twin sisters, Terry and Ruth Collins (both played by Olivia de Havilland), one innocent, the other a murderess; George Cukor's tragic drama *A Double Life* (1947), in which Shakespearean

actor Anthony John (Ronald Colman, who won an Oscar for his work in the film) slowly goes mad as he identifies too closely with the lead role in *Othello;* and Joseph L. Mankiewicz's classic Broadway backstage drama *All About Eve* (1950), which won six Academy Awards, including Best Picture, and was nominated for eight more Oscars, including Best Black and White Cinematography. Krasner did not take home the prize that year, however; that honor went to Robert Krasker for his Dutch-angled work on Carol Reed's *The Third Man* (actually released in 1949, but still eligible for the competition). Of all these films, surprisingly, Krasner enjoyed working with Robert Siodmak on *The Dark Mirror* the most, with less pleasant memories of working with Claudette Colbert in Mervyn LeRoy's unusual comedy *Without Reservations* (1946), which teamed Colbert with John Wayne. But Colbert was the real director of the film, as Krasner remembered, because

> she had only one side to photograph. One morning Mervyn LeRoy, the director, came in and we rehearsed the scene in the Mexican place with everybody around the table. I said, "Merv, you're on the wrong side of her face." He didn't pay any attention. When they were through rehearsing, two or three hours later, she said, "Now, Mr. LeRoy, do it on the other side." She wouldn't be photographed on the right side because of that flat nose of hers. He looked at me and said, "You're right." I knew how to photograph her because I did several pictures with her. It was the same way with Loretta Young. I always got those tough babies. (Turner, "Cinemasters" 44)

Moving to color, Krasner finally won an Academy Award for Best Cinematography for Jean Negulesco's romantic Technicolor drama *Three Coins in the Fountain* (1954) and began working almost exclusively in color from 1955 onward, doing some of his best work for Nicholas Ray in his underrated biblical drama *King of Kings* (1961); for Vincente Minnelli in his quasi-sequel to *The Bad and the Beautiful* (1952), *Two Weeks in Another Town* (1962); and for Henry Hathaway on his segments of the Cinerama epic *How the West Was Won* (1962).

Oddly enough, Krasner did some of his finest late work for director Roger Corman on his first big studio film for Twentieth Century–Fox, after leaving American-International Pictures and DP Floyd Crosby, on the 1967 production of *The St. Valentine's Day Massacre*, starring Jason

Robards as Al Capone. As with many of his contemporaries, Krasner ended his career in television, shooting numerous episodes of *McMillan and Wife* at Universal from 1972 to 1977. Krasner had little affection for the business toward the end of his life, remembering how carefully he once worked in black and white. For Krasner, cinematographers in the 1980s were "under pressure and they have to just pour the light in and let it go. And they don't have the directors we had. Too many directors and writers today think dirty, they can't make a clean story. I used to come to the set wearing a tie and the director was dressed up. Today he sometimes looks like a butcher" (Turner, "Cinemasters" 47).

Thus, these men, along with a host of other superb cinematographers, such as Reggie Lanning and Bud Thackery at Republic; the rough-

Alfred Hitchcock lining up a scene with director of cinematography Ted Tetzlaff (partially obscured by Hitchcock's hand) for his thriller *Notorious* (1946)

and-tumble Jack Greenhalgh at Producers Releasing Corporation; Ted Tetzlaff, a freelancer whose many credits include Alfred Hitchcock's *Notorious* (1946), René Clair's *I Married a Witch* (1942), Gregory La Cava's *My Man Godfrey* (1936), and numerous other films before he turned to direction, most notably with the suspense thriller *The Window* (1949); and Leon Shamroy, one of the giants of the industry, helped to create the sinuous world of shadows that dominated the screen in the 1940s.

Shamroy, whose credits include Alfred L. Werker's *The Adventures of Sherlock Holmes* (1939); Andrew L. Stone's African American musical *Stormy Weather* (1943), featuring Lena Horne and Bill "Bojangles" Robinson as an unlikely pair of lovers; and Elia Kazan's memorable adaptation of Betty Smith's popular novel *A Tree Grows in Brooklyn* (1945), was yet another DP who started from the ground up at the dawn of the cinema, working at Fox Films (later Twentieth Century–Fox) where he spent most of his career, for an initial salary of eighteen dollars a week developing film. As he described it to Kevin Thomas in a 1966 interview, "It was like working in a hot wash laundry—I wore nothing but rubber boots and shorts," before he went on to become second unit cameraman at Pathé Studios for Charles Hutchison, an actor/director/writer/producer who specialized in low-budget westerns and serials. "That was a great school," he told Thomas. "We made pictures in six days with 85 camera set-ups a day. There was only one take, and there were no light meters" (K. Thomas M6).

And yet Shamroy was always looking toward the future. In a 1947 essay in *American Cinematographer*, he noted:

> The stature of the motion picture as an art has grown, and with it the art of the cinematographer. For many years, the men behind the camera have sought to erase the popular misconception that they are [nothing] more than mechanics who point the camera and get the picture right every time. A director of photography makes something more than a mere technical contribution to a motion picture. What the writer has created in the written word must be translated to the screen [through] the eyes and minds of the director and the cinematographer. With the proper lighting, a mood can be established, an emotion emphasized, and realism heightened.
>
> The trend toward realism, however, has put many a cameraman in the position of a tightrope walker. While called upon to inject realism, he knows

that to millions of filmgoers, the motion picture is a welcome escape from their everyday trials and tribulations. The basis of this escape is bound up in the illusion of the medium. . . . In the face of contemporary skeptics, the collective imagination of cinematographers is stimulated by new engineering developments that loom on the horizon.

Not too far off is the "electronic camera." A compact, lightweight box no larger than a Kodak Brownie, it will contain a highly sensitive pickup tube, 100 times faster than present-day film stocks. A single lens system will adjust to any focal length by the operator merely turning a knob, and will replace the cumbersome interchangeable lenses [of] today. Cranes and dollies weighing tons will be replaced by lightweight perambulators. The camera will be linked to the film recorder by coaxial cable or radio. The actual recording of the scene on film will take place at a remote station, under ideal conditions.

Instead of waiting for a day—or days, in the case of shooting with color—electronic monitor screens connected into the system will make it possible to view the scene as it is being recorded. Control of contrast and color will be possible before development. . . . In terms of cinematographic art, it will [place] a more refined instrument in the hands of the cameramen, an instrument of greater sensitivity and mobility. (128)

And as with the other cameramen discussed in this volume, simplicity was always a guiding principle in Shamroy's work. Fond of saying that "God was a great cinematographer. He'd only gotten one light" (Higham 27), Shamroy's techniques mirror those of his many colleagues—keep it simple and try to avoid the unnecessary frills. As the 1940s ended, Shamroy moved almost exclusively into color; one can see from his 1947 article that he anticipated the contemporary digital cinema and eagerly embraced it, long before many of his peers. His later work, no matter how proficient, nevertheless betrays his long allegiance to one studio look, as Shamroy himself admitted late in his career. As he told Charles Higham,

Zanuck gave me complete freedom at 20th. . . . Here I developed my technique of using the absolute minimum of lights on a set. . . . To light economically is a rarity in this business: most cameramen put a light in front, others at the sides, fix up backlighting here and there; I don't. . . . Every light has to mean something, be fully justified, like words in a sentence. I think

one drawback in my many years at 20th was that I became too slick, too polished; everything started to look like magazine illustrations with those gelatins I was using. (*Hollywood Cameramen* 27)

This hard and bright approach to color reached its apotheosis for Shamroy with John M. Stahl's delirious Technicolor noir *Leave Her to Heaven* (1945), for which Shamroy won his third Academy Award for Cinematography; the second was for Zanuck's ambitious biopic *Wilson* (1944), and the first for Henry King's swashbuckler *The Black Swan* (1942), all of which have the same hard-edged Technicolor look. As he forthrightly put it, "My technique was twenties' technique anyway," so, in a sense, Shamroy was carrying over the lessons of black-and-white cinematography into an all-color world. In all, Shamroy would be nominated for an Academy Award fifteen times, winning four, the last for Twentieth Century–Fox's lavishly overproduced spectacle *Cleopatra* (1963), an onerously long film (192 minutes in its shortest cut) whose massive expense and production delays nearly sank the studio. But if Shamroy's honors all came in the color world, by his own admission he was really still shooting in black and white in his mind, with every pictorial plane popping out of the screen with sharp angularity.

This leaves one major Hollywood master to be discussed from the 1940s, considered by many observers to be the absolute master of black-and-white cinematography: John Alton. Yet unlike so many of the cameramen in this volume, Alton was almost universally disliked by his colleagues, as MGM production executive Walter Strohm noted when Alton was hired to shoot the multi-hued ballet scene for Vincente Minnelli's *An American in Paris* (1951). Said Strohm,

Most people hated him. They said, "How can Minnelli put Alton on the ballet?" I said, "Because he knows how to light." Believe me, he knew how to light! . . . He had none of this old studio technique.

Some cameramen used the same lighting technique every time to light a set, because, the more units they had up there to light with, the more electricians it gave jobs to. Alton didn't give a damn about any of that. He was interested in getting an effect, and he could get an effect like *that*. He was very fast. Of course, that killed them; he was too fast for them. They didn't like that. He was ready, and the director was left holding the set. He just said

to the director, "I'm ready." The director wanted to take two hours while they rehearsed and fussed around and Alton said, "No, I'm ready. Anytime you want to." (McCarthy xxxvi)

Alton's maverick tendencies even bucked MGM's ironclad rule of using overhead lighting, a rule that was almost never broken. When Alton worked at MGM, he was constantly being harassed by John Arnold, the head of MGM's camera department, for his supposed heresies; in one instance, Alton resigned from the American Society of Cinematographers in 1944 "when Arnold started to get rough with me [which] didn't do me any good later" (McCarthy xxxiv). But MGM studio vice-president Joseph Cohn admired Alton's work immensely, paying him $500 a week to work for the studio, which was, as Cohn later noted,

> more money than I was paying any other cameraman. I gave him that salary because I wanted to hire him and he wouldn't work for less, and I wanted to shake up the other cameramen. I thought our cameramen had become too complacent, and I felt we needed a cameraman who would shake the hell out of the place, and I thought Alton could do that for me. In lighting, he saved a lot of time by lighting only from the floor. This made him very unpopular with the other cameramen. (McCarthy xxxiii)

This sentiment was echoed by director Vincente Minnelli, who was unhappy with the work done on the bulk of *An American in Paris*, shot by Alfred Gilks in the traditional "museum lighting" style for which MGM was well known; ironically, Alton wound up sharing the Academy Award for Best Color Cinematography with Gilks. But for the ballet sequence, which lasted about twenty minutes and is clearly the highlight of the picture, Minnelli insisted on hiring Alton. As Minnelli noted, Alton

> was disliked, however, by the other cameramen because he had written a book called *Painting With Light*. They all thought he was egotistical. But he was so fast and used so few lights. I got along just wonderfully with him. I felt that the ballet needed someone who would live dangerously. We had to take chances because in the ballet there is nothing that was done afterwards in the lab; everything you see was done on the set. So I decided it needed John Alton. (McCarthy xxxiv)

The film's star, Gene Kelly, agreed, adding that during the filming of *An American in Paris*,

> Vincente suggested a lot of the light effects. We'd say, "Wouldn't this be great?" but often they took a lot of time, because cameramen can get very stubborn. But we found Alton willing to try anything. We'd say, "Can you do this?" He'd say, "Yeah, that's easy. Yeah." And for the first few days we were sort of worried because we'd been used to a lot of cameramen saying, "You guys are nuts. You can't do that." It seemed that about every picture we'd try something new and the person with whom we'd be working would say, "No, you can't do that," because they had never done it before. (McCarthy xxxiv–xxxv)

Alton was always ready to take risks, even at the beginning of his career. He had immigrated to the United States from Hungary at an early age, and by 1924 was working at the MGM film laboratories. From there Alton drifted over to Paramount and then suddenly decamped to France and later Argentina, where he wrote and directed one film, *El hijo de papá* (1934), and then served as the cinematographer on more than ten others.

Returning to the United States, Alton fell in with fellow maverick Bernard Vorhaus, who then was laboring on program pictures such as *Meet Dr. Christian* (1939), on which Alton worked in an uncredited capacity as cinematographer. Continuing on with Vorhaus, and this time receiving credit for his work, Alton shot a follow-up film in the series *The Courageous Dr. Christian* (1940), and then Vorhaus's John Wayne western *Three Faces West* (1940). More modest pictures followed, such as Vorhaus's *The Affairs of Jimmy Valentine* (1942), and Alfred Zeisler's bizarre *Enemy of Women* (1944), an exploitational biopic of the notorious Joseph Goebbels, the minister of propaganda for the Third Reich.

By 1944, Alton was shooting films for Republic Pictures, such as George Sherman's *The Lady and the Monster* (1944), based on Curt Siodmak's 1942 science-fiction novel *Donovan's Brain*, Wilhelm Thiele's moody mystery *The Madonna's Secret* (1946), George Blair's modest comedy *The Ghost Goes Wild* (1947), and Vorhaus's stunningly cheap ski resort romance *Winter Wonderland* (1947), with some of the most obvious back projection work in motion picture history. All these films were competent but none were truly exceptional, until Alton moved over to

Eagle-Lion Films and teamed with Anthony Mann for the noir crime classic *T-Men* (1947), which instantly brought both men considerable industry, audience, and critical acclaim. As with Alton's other films during this era, *T-Men* was a very tightly budgeted production, with no real stars—except for Mann's compositional skills and Alton's starkly dramatic lighting design. As Todd McCarthy wrote of the film,

> Creating tremendously dramatic images and tense moments by enshrouding much of the action in utter blackness, Alton and Mann didn't invent film noir, but they created some of the most indelible examples of it, pushing the style further than anyone had dared up to that time. "I found a director in Tony Mann who thought like I did," Alton explained. "He not only accepted what I did, he demanded it.
>
> "Other cameramen illuminated for exposure. They'd put a lot of light in it so the audience could see everything. I used light for mood. All my pictures looked different. That's what made my name, that's what set me apart. People asked for me. I gambled. In most cases, the studios objected. They had the idea that the audience should be able to see everything. But when I started making dark pictures, the audience saw there was a purpose to it." (McCarthy xxx)

Eagle-Lion, which had risen out of the ashes of Producers Releasing Corporation as a supposedly "up market" studio, would last only a short time, trying to compete with the majors without the considerable resources those studios had at their disposal. But as long as it lasted, Mann and Alton worked at Eagle-Lion with ferocious intensity, creating the crime drama *Raw Deal* (1948), the brooding noir *He Walked by Night* (1948; started by director Alfred Werker, but taken over by Mann roughly halfway through the film, though Mann received no credit), and Eagle-Lion's low-budget attempt at re-creating the French Revolution, *Reign of Terror* (aka *The Black Book*, 1949), with uncredited but patently obvious art direction by the film's producer, William Cameron Menzies.

Though produced on a shoestring, *Reign of Terror* so impressed incoming MGM studio chief Dore Schary that he hired Mann and Alton almost on the spot, taking over production of Mann's searing exposé on the plight of illegal migrant farm workers, *Border Incident* (1949), which Eagle-Lion could no longer afford to bankroll (McCarthy xxxiii). Directed and photographed in Mann and Alton's usual stark style, the

Sam Wood, seated, directing a scene from *Hold Your Man* (1933), starring Jean Harlow and Clark Gable, as cinematographer Harold Rosson looks on

film was an anomaly in the artificially cheerful, brightly lit MGM universe, and Alton was soon pressed into service on more traditional MGM fare, such as Robert Z. Leonard's musical comedy *Grounds for Marriage* (1951), Vincente Minnelli's romantic comedy *Father's Little Dividend* (actually completed before Alton's work on *American in Paris*, 1951), starring a young Elizabeth Taylor and the reliably irascible Spencer Tracy, and John Sturges's uneasy legal drama *The People Against O'Hara* (1951), turning in polished but unremarkable work on all his assignments.

Surprisingly, Alton started work on Stanley Donen and Gene Kelly's iconic musical *Singin' in the Rain* (1952) shortly after his Oscar win, but was fired after two weeks and replaced by Harold Rosson (McCarthy xxxvi). Assigned "as punishment" (McCarthy xxxvi) to young director David Bradley's modest thriller *Talk About a Stranger* (1952), Alton took his demotion in stride and worked smoothly with Bradley, who was in awe of Alton's reputation. Following this, Alton worked on a number of other middling projects, but he made his next major mark with Joseph H. Lewis's noir crime drama *The Big Combo* (1951), a low-budget Allied

Artists production starring Cornel Wilde and his wife, Jean Wallace, with capable support from veteran heavies Richard Conte, Brian Donlevy, and Lee Van Cleef. As Todd McCarthy perceptively notes, the film is Alton's last great achievement in black and white: "One last time, Alton pushed his impulse toward severe black-and-white contrasts and silhouetting of characters to the limit. Many scenes are clearly lit with only one source, and the final shot, with the figures of a man and woman outlined in a warehouse against a foggy nightscape and illuminated by a single beacon, makes one of the quintessentially anti-sentimental noir statements about the place of humanity in the existential void" (xxxix).

But Alton was able to use these same strategies in Allan Dwan's color and "Superscope" noir *Slightly Scarlet* (1956), one of RKO Radio's final productions, featuring fading star Arlene Dahl as Dorothy Lyons, a kleptomaniac paroled into the custody of her sister June (Rhonda Fleming), who is the secretary and girlfriend of local politician Frank Jansen (Kent Taylor). But, as would be expected in a film based on a novel by James M. Cain, trouble soon comes calling in the person of crime syndicate kingpin Solly Caspar (Ted de Corsia) and Caspar's factotum, Ben Grace (John Payne), and the film's narrative ends in a maelstrom of violence. One of the most unusual films ever made from a strictly visual standpoint, with its deeply saturated colors almost replicating the dark intensity of Alton's best monochrome work, *Slightly Scarlet* is a memorably hellish, desperate film, a compelling vision of society in collapse.

From here, however, Alton's work becomes more scattershot. Daniel Mann's indifferent comedy *Teahouse of the August Moon* (1956), Vincente Minnelli's *Tea and Sympathy* (1956), Minnelli's *Designing Woman* (1957), and Richard Brooks's epic *The Brothers Karamazov* (1958) are all competent but unremarkable films, both from a directorial and cinematographic standpoint, and it wasn't until Brooks's *Elmer Gantry* (1960), with a mesmerizing performance in the lead role by Burt Lancaster, that Alton again created some truly kinetic and memorable work behind the camera, though he received scant attention for his contribution to the film.

Elmer Gantry, however, proved to be Alton's last hurrah. He started work with director Charles Crichton on *Birdman of Alcatraz* (1962), starring Burt Lancaster as convicted murderer Robert Stroud, who against all odds becomes something of an expert ornithologist in prison. But after one week of shooting, Crichton was fired and replaced by John

Frankenheimer, and Frankenheimer and Alton almost immediately clashed. As Frankenheimer remembered,

> It lasted a day, or a day-and-a-half at the most. It was just a conflict of personalities from the first day. It was just not my kind of shooting. He was used to working with directors who perhaps were not so specific as I was about how to shoot a scene, who let him do what he wanted. I knew I wanted a gritty, semi-documentary look, and he was lighting a lot of things that weren't even going to be in the shots. It was painful because I had great respect for him and I'm sorry it didn't work out. (McCarthy xl)

And with that ignominious experience, John Alton was through in Hollywood, after more than thirty years as a cinematographer. With a mixture of anger, resignation, and defiance, he walked away from the industry, financially secure for the short term, and decamped to Europe to paint and reflect on his past accomplishments. Except for one final, exceedingly atypical credit—photographing the pilot for the wildly successful television series *Mission: Impossible* in 1966—Alton never worked in the cinema again. At times, he seemed to regret his decision to leave Hollywood—"The only mistake I made was quitting when I was 59. The producers in these days were so shortsighted. I wanted to do quality. I thought about coming back later, but I found that the industry had changed" (McCarthy xli)—while at other moments, he seemed satisfied that his career was behind him, reflecting in 1979 that "after I finished *Elmer Gantry*, I decided to take a well-earned vacation. This was in 1959, and I am still enjoying it" (McCarthy xlii).

However, with the production of Arnold Glassman, Todd McCarthy, and Stuart Samuel's documentary *Visions of Light: The Art of Cinematography* (1992), after a lengthy series of missed opportunities and cancelled speaking engagements, Alton returned to the public eye, most notably in a question-and-answer session with director Bertrand Tavernier and McCarthy at the Telluride Film Festival in 1993. Subsequently, Alton made a number of appearances at festivals and ceremonies honoring his work, which led him to muse, "It's a strange thing that, when I travel to all these festivals, they show all the small, dark pictures we made in 12 days, not the big pictures we took months to shoot" (McCarthy xliii). But, of course, it is in these "small, dark pictures" that Alton clearly did his best

work, and in addition, Alton, who died at the age of ninety-four in 1996, left behind perhaps the most valuable "how to" manual ever written by a cinematographer.

Much more than a series of f-stops and technical instructions, *Painting with Light* is a treatise on aesthetics in the cinema, begun as a series of articles for *International Photographer* magazine in 1945, and then collected, revised, and published by Macmillan in 1949 to positive reviews from both the critics and the public, though unsurprisingly, given Alton's maverick reputation, with little notice from his colleagues. Amazingly, it was eight years before *American Cinematographer* published even a short review of the book, stating that while the volume was "of interest to the student cinematographer, it falls far short of the mark set by its title" (McCarthy xliii). But contemporary cinematographers have a much different opinion, and *Painting with Light* has become a classic in the field, as a practical yet theoretical text that deconstructs lighting strategies, and explains in detail how these effects are obtained. As DP Allen Daviau, whose many credits include Steven Spielberg's *E.T. the Extra-Terrestrial* (1982) and Barry Levinson's *Bugsy* (1991), enthused,

> At the time the book came out, no one was going to tell you any secrets about cinematography, and he had instructions! It was the only case of an insider telling you what he did. It was a basic book from a master, and that was so important. This was the one and only book at the time that had some 'how to' to it. You just learned a lot of the tricks of the trade. The influence the book had on a whole group of us was tremendous—we studied cinematography through *Painting with Light*. Later, I enjoyed watching him break his own rules in some of his films. But because of the influence of the book, I've always looked at Alton as this teacher who also did these great films. So his impact as a cinematographer was doubled or tripled by the fact of this book. (McCarthy xliii–xliv)

It's easy to see why *Painting with Light* did Alton no favors within the profession, and aroused as much jealousy as it did among his often secretive, clannish colleagues: Alton was giving the game away. In the book, lavishly illustrated with both stills from Alton's work as well as set-ups designed specifically for the text, Alton covers such topics as "mystery lighting" (obviously a specialty), "special illumination" (rain, fog, interiors), "the Hollywood close-up" (how to place reflectors, basic rules for

illumination), "outdoor photography" (moods, composition, filters), and even the creation of what Alton terms "visual music," of which he notes,

> When we look at a beautiful countryside, we like it and derive pleasure from it. We receive light sensations of different colors, different wavelengths reflected by the various objects all over the field of vision. This concert of light is similar to one played by a hundred different musical instruments, in other words, a *symphony of visual music.* A musical symphony is an audible picture of what its composer had in mind, visualized, or actually witnessed at the time he composed it. In photography, it is the other way around. When an artistic photographer listens to good music, he is inspired; he visualizes pictures, which he paints with light, to be seen later on paper or the motion picture screen. (Alton 158)

In short, for Alton, the world itself was the ultimate source of his pictorial inspiration; as he put it in his conclusion,

> *The eye is not only the mirror of the soul* [original emphasis], but also the lens of the human camera. . . . When we look at any picture, it is instantly photographed. We do not see the negative at all. It is delivered to our conscious mind in the form of a finished positive print. Invisible little gremlins wash the picture off the sensitive plate, the retina, and resensitize it for the next image. Few people associate thinking with photography. In reality they are so close that we cannot tell one from the other. When a person is thinking, he is either viewing pictures of the past on his psychic screen, or, by planning the future, is creating new ones. (Alton 187–189)

To Alton, the entire world was the raw material for the visuals he so passionately cared about and lived to create. As an outsider in the cinematographic profession—even though he worked, at one point, for arguably the most dominant of the classical-era Hollywood majors, MGM—Alton chose his own values and his own images, and was refreshingly direct and egalitarian about the tricks of his trade. He broke an unspoken though rigidly enforced taboo by writing *Painting with Light*, and also left behind a legacy of brilliant imagery in shimmering black and white.

Throughout the rest of the world, of course, film lighting was already considered an art, even on the most quotidian productions. In the 1940s,

such gifted practitioners as Gabriel Figueroa, who early on became a major force in the Mexican cinema, worked their way up the professional ladders to become masters of their craft. Born in Mexico City in 1907, Figueroa was orphaned at the age of 7, and became involved in the Mexican industry in his teens. After working as an assistant on various films, he photographed Grigori Aleksandrov and Sergei M. Eisenstein's *¡Que viva Mexico!* (1932) with Eduard Tisse, and then studied cinematography for a year in 1935 with Gregg Toland in Hollywood. Returning to Mexico, Figueroa photographed his first solo effort, *Allá en el Rancho Grande* (*Out on the Big Ranch*, dir. Fernando de Fuentes, 1936), after which he worked with several generations of legendary directors from around the world (Cotter C24).

In his long career, Figueroa served as the director of cinematography for such eminent directors as Emilio Fernández, most notably on his gorgeous romantic drama *María Candelaria* (1944); John Ford on *The Fugitive* (1947); Luis Buñuel on his breakthrough comeback study of life in Mexico City's notorious slums, *Los Olvidados* (1950), as well as Buñuel's *Nazarin* (1959) and the forty-five-minute featurette *The Exterminating Angel* (1962); in addition to working with John Huston on *The Night of the Iguana* (1963) and twenty years later on Huston's *Under the Volcano* (1983). As Elena Feder wrote, "With Emilio 'El Indio' Fernández, the most important director of Mexican Golden Age cinema . . . , Figueroa developed that particular blend of expressionistic lighting (chiaroscuro), deep focus, and dramatic composition that became his signature style, a style that joined Renaissance painting with the latest Hollywood techniques and avant-garde experiments of the Mexican visual art movements, muralism, and the graphic arts" (Feder 2).

Figueroa labored on a number of less prestigious projects early on until he finally met Fernández, today best remembered as the rapacious General Mapache in Sam Peckinpah's violent western *The Wild Bunch* (1969), but in the 1940s a major directorial force in Mexican cinema. As Figueroa remembered,

> It was with Fernández that I really began to develop my own style. He allowed me to compose a scene anyway I wanted. He would describe the set-up initially, explain what he wanted to convey, and then say something like, "There, now set up the lights and put the camera wherever you wish."

So I would place the camera, choose the angle, and illuminate a scene, always looking for the desired effect. From the very beginning, when we shot the opening scene of *María Candelaria*, where she holds the piglet in her arms, Fernández told me to place the camera wherever I wanted. He couldn't believe his eyes when he saw the rushes; they went beyond his wildest imagination. Since that point I had complete freedom to continue developing my own style. (Feder 4–5)

As with other cinematographers of the classical 1940s era, Figueroa was greatly influenced by classical painting, in his case, the work of the Mexican painter Gerardo Murillo and his use of curvilinear perspective in his work. As Figueroa noted:

The principle of rectilinear perspective is to guide the gaze to a particular point centered in the frame. Curvilinear perspective, on the other hand, works to split the eye between two distinct perspectival points of entry, joined by means of lines traveling along a curved plane within the frame. This increases the illusion of depth. In addition, the technical development of wide-angle lenses made it possible to add even more depth and content to a particular frame or scene. (Feder 5–6)

With Fernández, Figueroa became accustomed to choosing his own set-ups and having considerable artistic input into any given film. When John Ford chose him to shoot *The Fugitive*, the director allowed Figueroa the same artistic latitude, after being told by producer Merian C. Cooper that Figueroa was "a splendid photographer, but he has the peculiar habit of choosing the composition himself" (Feder 7), much like Gregg Toland, his mentor. As Figueroa told Elena Feder,

Ford found this intriguing and decided to allow me the same freedom. Only with Emilio Fernández, John Ford, Roberto Gavaldón, and Ismael Rodríguez was I free to compose a scene any way I chose. This was not the case with John Huston. On *The Night of the Iguana*, I collaborated in the composition of about 30 percent of the images. As is the case with most directors, Huston disregarded most of my suggestions, insisting instead on his own compositions. The same was true of Luis Buñuel. He arrived on the set with the scene completely fixed in his mind, composed to the smallest

detail, measured down to the second, including the number of steps an actor was to take from one spot to another. You removed the clipboard and the markers on both ends of a shot, and you ended up with a fully edited film. (7)

In view of Ford's own habit of rigidly composing shots from a fixed camera on a tripod while sitting next to the camera and signaling the end of a shot by sticking his fist in front of the lens and yelling "cut!" to indicate the precise editing point, his tolerance for Figueroa's independent approach to cinematography is all the more surprising. And yet Ford obviously recognized that in Figueroa, he had a true collaborator, someone who could make a real contribution to the finished film, which turned out to both men's satisfaction.

Asked what his advice to younger cinematographers would be, Figueroa, like Alton, generously imparted his secrets for future generations in an appropriately simple and direct fashion. Younger DPs, Figueroa said, should "study the work of the great masters, especially the Flemish, Rembrandt and Vermeer, who studied lighting like no one else; also the Spaniards, Velázquez and Goya; and the Mexican muralists, José Clemente Orozco, Diego Rivera, Rufino Tamayo, David Alfaro Siqueiros, from whom I learned the latest innovations in pictorial art. My approach has always been to combine the styles of European and Mexican painters. That is the secret of my style" (Feder 14). Figueroa's place in the pantheon of the truly great cinematographers, with over 200 films to his credit, is absolutely assured.

In France, Henri Alekan rapidly emerged as one of the era's principal cinematographers, working for more than five decades in the industry. Born in 1909 in Montmartre, Alekan became the camera operator for Eugen Schüfftan on Marcel Carné's *Le Quai des brumes* (1938), after helping Jean Renoir shoot the collectively produced agitprop film *La Vie est à nous* (1936) for the French Communist Party. Alekan was one of seven cameramen on the project, including Claude Renoir; the direction was handled by no fewer than eight persons, including Jean Renoir, Henri Cartier-Bresson, and Jacques Becker.

Essentially a series of political skits, intercut with "calls to action," *La Vie est à nous* is a dazzling if polemical film. When World War II broke out, Alekan was one of many imprisoned by the Nazis after they took control of Paris, though Alekan subsequently escaped and joined the

Jean Cocteau gesturing to the camera as Henri Alekan (entirely obscured, peering through the viewfinder under a black cloth) sets up a shot for his classic *Beauty and the Beast* (1946)

French Resistance. In 1946, Alekan photographed René Clément's *The Battle of the Rails*, a paean to the French Resistance and to the railroad workers who engaged in sabotage to help defeat the Nazis; in the same year, he photographed perhaps his most famous film, Jean Cocteau's *La Belle et la bête* (*Beauty and the Beast*, 1946), which marked Cocteau's directorial return to the cinema after a long absence. Cocteau kept a day-by-day diary of the making of the film, which is not at all flattering to Alekan, and in which (perhaps not surprisingly given similar statements by other directors in this text) Cocteau claimed the lion's share of credit for Alekan's exceptional work on the film. In the middle of the production, on October 29, 1945, Cocteau wrote:

> Alekan tells me that all the material I think is admirable is considered by some people at the studio as hopeless, badly lit, white cheese. Doesn't he know yet what I have been used to for years?—every time anybody tries anything out of the ordinary, people go blind and can see only what looks like things they've already seen. People have decided once and for all that

fuzziness is poetic. Now, since in my eyes poetry is precision . . . I'm pushing Alekan in precisely the opposite direction from what fools think is poetic. He is slightly bewildered. He does not yet have my long acquaintance with struggle, my serenity in the face of the follies of the age. . . .

Sometimes I light one face more than another, light a room more or less strongly than it would be naturally, or give a candle the power of a lamp. In the Beast's park I use a sort of twilight which doesn't correspond to the time of day when Beauty goes out. If it suits my purpose, I will link up this twilight with moonlight. And it's not just because I'm dealing with a fairy story that I treat realism in such a high-handed way. A film is a piece of writing in pictures, and I try to give it an atmosphere which will bring out the feeling in the film rather than correspond to the faces. (78)

Perhaps this is because Alekan always favored more natural lighting, whether from interior or exterior sources, in all his work. Despite the fact that *Beauty and the Beast* was advertised as a "super production" on the film's poster, it was in fact made in circumstances of great privation, confronting daily shortages of photographic stock, equipment breakdowns, and power outages that disrupted shooting or ruined film being processed in the laboratory; and so, in such circumstances, it is perhaps a miracle that Alekan managed to get anything at all. As Alekan remarked,

There were the shortages to deal with — not just film, which was carefully rationed, but food as well. You were only given ration tickets for 150 grams of meat per week, and we would often shoot all day with only a piece of bread or two to eat. The conditions were close to impossible. [Yet] I think an artist's best work comes out during hard times. Look at the great masterpieces that Rembrandt and Goya painted when their lives were most difficult. Human beings sometimes need great difficulties to draw out all they have within them. They force you to be resourceful, imaginative, truly creative. And they also arouse the spirit of co-operation. (Trainor 16)

And yet Alekan never worked with Cocteau again, which he said was "one of the great mysteries of my career. In truth, I can only speculate. Perhaps Cocteau felt that he had gone as far as he could in film with me and that he needed another camera operator to explore the limits of the subsequent films he wanted to make, some of which were quite good, but not, I think, in the same class as *La Belle et la bête*" (Trainor 16).

From Cocteau's fantasy world, Alekan returned to the gritty reality of René Clément's *The Damned* (1947), concerning a group of Nazis in the last days of the Third Reich who hope to escape to South America, and then Julien Duvivier's production of *Anna Karenina* (1948) in English, starring Vivien Leigh and Sir Ralph Richardson. By the early 1950s, Alekan made the move to Hollywood with William Wyler's romantic comedy *Roman Holiday* (1953), starring Audrey Hepburn and Gregory Peck, which he co-photographed with Franz Planer. (Planer fell ill during production and was replaced by Alekan, but Planer's material was kept in the final film.) *Roman Holiday* was a huge commercial success, winning three Academy Awards, including one for Audrey Hepburn as Best Actress, and one for blacklisted screenwriter Dalton Trumbo for Best Story, though the credit was officially assigned to Ian McLellan Hunter, and only restored to Trumbo posthumously in 1993, long after his death in 1976. Alekan was perfectly happy to fill in for the ailing Planer, but surprised that Wyler left him largely to his own devices. As Alekan said,

> I loved working with Wyler, a true professional and a great director whom I had long admired. *Roman Holiday* was my first experience as chief operator for an American director, so I didn't know what to expect. The first day of shooting, he walked up to me and said, "Alekan, I don't know a thing about camera technique or lighting, so I'm relying on you; you're in charge of that department." He was very laid back as a director. (Trainor 17)

Obviously, Wyler was underselling himself, or perhaps he realized that the film was frothy, escapist entertainment—even if it did win three Oscars—so why not let Alekan run the show? And as the New Wave dawned in the late 1950s, Alekan preferred to photograph more mainstream fare; he was always something of a traditionalist, keeping his distance from the young Turks such as those who pontificated in *Cahiers du Cinéma*. Among his works from this period were Jean Meyer's *Marriage of Figaro* (1959); Anatole Litvak's English-language *Five Miles to Midnight* (1962), an all-but-forgotten crime drama starring Sophia Loren, Gig Young, and Tony Perkins; and Peter Ustinov's visually undistinguished production of *Lady L* (1965), with Sophia Loren and a desperately miscast Paul Newman, who begged throughout the production to be let go. As Alekan noted of such New Wave cinematographers as Raoul Coutard and Henri Decaë, with a more than slightly paternalistic air:

With the *Nouvelle Vague* a specific form of lighting appeared in the cinema in a form which had basically been employed by English photographers. From France this spread throughout the world under the pretext of a reaction to a certain academicism. The *Nouvelle Vague* was born primarily of the desire of some directors to express themselves outside of the traditional channels of artistic creation, i.e. it was based on unequivocally economic considerations, which finally led to a break with classic and somewhat rigidly structured film production. This need to create with reduced technical and artistic means contributed toward the questioning of obsolescent modes of working which were in danger of stagnating in routine. Looking once again at the technical and artistic aspects of light, we should not forget that the problem of lighting real interiors did not first appear with the *Nouvelle Vague*. Ever since films were first produced shooting has taken place in the most diverse interiors: in palaces, cathedrals, castles, exhibition rooms, stations, etc. (Alekan 91)

The "nouvelle vague," of course, solved this problem primarily by using window light and other natural sources to illuminate interior shots, but for Alekan, the studio environment was more in tune with his classically trained eye.

Matters did not improve with Joseph Losey's late film *The Trout* (1982), considered one of the director's lesser works, but redemption of a sort was just around the corner when Wim Wenders hired Alekan to lens his epic fantasy romance *Wings of Desire* (1987), whose plot centered on two angels, Damiel (Bruno Ganz) and Cassiel (Otto Sander), who wander through the streets of West Berlin watching over the humans below, including actor Peter Falk, referred to in the credits only as "Der Filmstar," who is shooting a film on location set during the Nazi era. Shot in color and black and white, Wenders hired Alekan because he was one of the last authentic survivors in Europe of the monochrome era and thus knew how to light for both mediums; the film was rapturously received by both the public and the press. For his part, Alekan enjoyed working with Wenders immensely and was particularly taken with his strategy of *not* pre-lighting the set but rather waiting for the actors to "block" the scene before starting to design the lighting. As he told Richard Raskin,

> Something very concrete happens. It's the actors' movement before our eyes, the way they play their parts, their place a space, on a surface, in a volume,

which enables us to find the proper lighting. And this proper lighting can only be made very concretely when we have seen what is going to be shot. . . . I don't want to be fooled by lighting that will probably be acceptable in a purely physical sense, because in this physical respect you need a certain level of illumination for the image to be recorded on film. But it must correspond *intimately* with what will happen, with the action. And this is the way I have always worked, on every film.

First of all, . . . illuminate the action. Then, illuminate what is secondary. The secondary is the background. The décor. Occasionally, of course, the décor is the main thing. During several seconds, it's the décor that will determine the meaning of the scene that will follow. . . . But almost always, if it is the décor you illuminate, it's because the décor has a primordial importance at that moment. In other words, you light it as you experience it. . . . So you have to imagine layers of lighting which will in turn attribute importance either to the décor or to the actors. (Raskin 86)

Despite Jean Cocteau's dismissive attitude toward Alekan's work, it's clear that Alekan gave a great deal of thought to each set-up, even as he strove to translate his aesthetic concerns into practical considerations on the set. In his essay "The Magic of Light in Film," Alekan spoke movingly of his love for the black-and-white image, and his theories of how these monochromatic visions were created:

Lighting, whether in photography, at the cinema, on the television or in the theatre, means giving the eye something to see. It also means stimulating people to think, to meditate, to reflect as well as to create feelings. These two acts, the one technical, the other artistic, are combined intimately by the creative will of the lighting designer and conjure up images from the nothingness of darkness so that these images reveal themselves to the spectator. Unidirectional light from the sun is *partisan* light ("lumière partisane") which, by modeling forms and contours, draws the object as well as emphasizing, differentiating, dissecting and sculpturing it, and underlining the essential nature of the forms, whilst rendering the less essential inconspicuous. It has a hierarchical and classifying tendency, one could call it *involved* light ("lumière engagée"). In contrast to this, diffuse lighting, which envelops the "object" in light coming from all sides, has a dispersing character, both objectively and subjectively. The principal is integrated into the secondary. The light does not underline, it combines and softens. It is a disturbing

light: an *annihilating* light ("lumière annihilante"). These forms of light, so contradictory in their physical composition, have radically different artistic natures, which also reveal themselves in different ways in the feelings which are triggered off. (Alekan 86)

At the same time, Alekan took care to differentiate his style of cinematography from the American method of conventional studio lighting:

We should not forget that the [Hollywood] *star system* equips the actors with a certain charisma which is out of the ordinary, and which functions as a means to captivate the spectators. In this kind of system lighting is conceived of as a method of bringing out the positive qualities of a face as optimally as possible. This explains the tremendous development of make-up in the film industry, a development which has its basis more in ideals of beauty than in psychology. Light is used in accordance with hierarchical principles, thus compelling the director to take into account the privileged status attached to actors' looks and to pay tribute to them by showing them in their best light and from the most flattering angles. (92)

As for the debate between color and black and white, Alekan made it very clear where his sympathies lay; even as late as 1993, with a good deal of color cinematography under his belt, he admitted that he missed the mystery and magic of his work in monochrome. As he told Richard Trainor,

I absolutely prefer black and white—for me, color film doesn't exist, at least not yet. Of course we see the world in color, but this color, especially in films, is too realistic for my taste. I believe film should transcend the banal world, and it would almost be more interesting to change the whole color scheme to achieve a more unrealistic effect, to break through color as it were. Of course, many interesting films have been made in color that try to stretch the boundaries of the medium—*One from the Heart* by Coppola, the films of Bertolucci, the cinema of Tarkovsky—and there are many interesting uses of color in the video format, perhaps more so than in cinema. But I still find it inferior to the color you see in the paintings of the great masters—Velasquez, Rembrandt, Goya. In these paintings the shadings of the colors create a three-dimensional effect similar to the effect light and shadow can create in black and white films. Color films never seem to break

the two-dimensional plane, which is why I say there isn't a color cinema yet. (Trainor 17)

Alekan might well be echoing the words of other great cinematographers of the era; Eugen Schüfftan would certainly agree. Schüfftan is best known as the creator of the special effects process that bears his name, which through the use of mirrors allowed the integration of miniatures during actual shooting, rather than in post-production, to give the completed film a "first generation" look throughout. After designing the majority of the process work for Fritz Lang's *Metropolis* (1927), Schüfftan, like many of his colleagues, fled Germany in 1933 to escape the Nazis, first taking up residence in France, where he worked with Max Ophüls on *There's No Tomorrow* (1939, co-photographed with Paul Portier), before fleeing to the United States after it became clear to him that France offered no safe haven.

In the United States, Schüfftan joined Local 644 of IATSE, the East Coast chapter of the International Alliance of Theatrical Stage Employees, but was kept out of the Hollywood chapter of the union. Thus, despite his enormous talent, when he moved to Los Angeles, Schüfftan was unable to find regular studio employment, and had to work without credit at the lowly Producers Releasing Corporation studios. One of his first projects there was Douglas Sirk's *Hitler's Madman* (1943); the resulting film was so beautifully photographed that MGM bought the film outright, shot some additional scenes, and released the micro-budgeted project as one of their own films—the only time this ever happened to a PRC production. Schüfftan also shot Edgar G. Ulmer's *Bluebeard* (1944), *Club Havana* (1945), *Strange Illusion* (1945) and *The Wife of Monte Cristo* (1948), though he was uncredited on all these films due to union interference. Late in life, however, Schüfftan was able to get more prestigious assignments under his own name, such as Georges Franju's poetic horror film *Eyes Without a Face* (1960); Robert Rossen's pool hall drama *The Hustler* (1961), shot for the most part on location in Manhattan billiard parlors, for which Schüfftan finally won an Academy Award; and Rossen's last film, *Lilith* (1964), a haunting tale of madness and seduction, starring Jean Seberg, Peter Fonda, and a young Warren Beatty, all shot in black and white.

Perhaps it's best to conclude this chapter with a few words about those who worked outside the industry mainstream, on wholly independent

and experimental films, often shot in 16 mm, and who eschewed the traditions of narrative and the star system to create unique, poetic visions that were entirely their own. One such artist was Maya Deren, a Russian émigré who came to the United States in 1922 and settled first in Los Angeles and later in New York. Though she made only a handful of films, all in black and white—which she not only directed, but in some instances served as writer, cinematographer, editor, and actor—her influence in cinema history is profound, as one of the first filmmakers in the 1940s—after the French *avant-gardists* of the 1920s, like Man Ray, Marcel Duchamp, and René Clair—to make films as a personal statement, answering to her own vision alone. Her most famous work is perhaps *Meshes of the Afternoon* (1943), photographed by Deren's then-husband, Alexander Hammid; in it, as well as in *At Land* (1944), *A Study in Choreography for Camera* (1945), *Ritual in Transfigured Time* (1946), *Meditation on Violence* (1948), and her final completed project, *The Very Eye of Night* (1958), Deren created an intoxicating world of symbols, carefully crafted images, and shifting geographical locations that are clearly designed to entrance the viewers and transport them to a world of dreams, fantasies, and unreality.

As the 1950s dawned, the cracks in the Hollywood studio system— and in the studio system worldwide—began to show. It would take another decade of shadows and light before the cultural explosion of the 1960s would herald the last great period of black-and-white cinematography as a truly innovative art form, but as Maya Deren, Stanley Kubrick— another outsider in his first films—and others would show, the rules of the game were changing in favor of a less regimented, less constructed, more realistic vision. But first, the studios had to be forced to transform themselves—and cinematographers with them—as the cinema entered the postwar era of the 1950s, an age in which all the values of the first half of the twentieth century would be called into question.

4

The 1950s

● ●

The Age of Anxiety

The 1950s dawned coldly, clearly, and with the gathering realization that the world before the war was not the same one we inhabited anymore. The 1940s suddenly seemed remote, sealed off, part of another era. Hollywood was beginning to see the effects of television, and the watershed year of 1946, when theater attendance reached an all-time high, was only a memory. Technological change in the film industry—television, CinemaScope, single-strip color film, to name a few emerging shifts—signaled that while all might seem calm on the surface, in reality the battle lines had been redrawn.

Black-and-white film production was still the norm in the industry; it remained much cheaper than shooting in color, but audiences were beginning to demand color when they went to the movies, one of many factors that set the theatergoing experience apart from television. CBS experimented with a color broadcast technology as early as 1940, using the "field sequential system," which

> displayed red, green, and blue television images in sequences, and depended upon the retentivity of the eye to merge those into a single color picture. If,

however, flicker and picture sharpness were to be maintained at the level of monochrome television, a field sequential broadcast signal would require three times the bandwidth of monochrome. A compromise or trade off was reached by increasing the bandwidth from 4 to 5 MHz, the number of frames were reduced from 30 to 20 per second, and scanning lines reduced from 525 to 343. For this reason it was incompatible with existing black and white broadcasting. This was a hybrid system. It used a rotating disk, but it was not a scanning disk; it contained red, green, and blue filters arranged in radial arcs. This "color wheel" spun in front of a conventional electronic scanning tube, presenting it with successive red, green, and blue images. The receiver had a similar color wheel, displaying the successive images to reconstruct the full color image. ("Early Color Television")

Needless to say, this caused confusion for television viewers, who would tune into a given program only to discover that it was an indecipherable blur. CBS affiliate station WEWS in Cleveland, for example, displayed this slide before they broadcast an "incompatible" color program, but it did little to mollify viewers:

Set owners, your attention, please! There is nothing wrong with your set. WEWS is broadcasting a CBS network *color* program. The picture cannot be satisfactorily received on your regular black and white set. Please do not attempt to adjust your set. Neither you, your service man nor the dealer from whom you purchased your set can change it simply by *adjusting* it to permit you to see the pictures we are now broadcasting. Please do not call your service man or dealer or attempt yourself to adjust your set. Regular black and white broadcasts will be resumed by WEWS today at approximately 4:15 PM. If you tune your set to Channel 4 or Channel 9—both of which are broadcasting regular black and white programs, chances are you will discover your set working satisfactorily on those channels. WEWS Channel 5 will resume its own regular black and white program schedule at approximately 4:15 PM today. ("Early Color Television")

The results in color were unsatisfactory as well, and even though the FCC initially gave CBS the right to broadcast programs with this "field sequential system," by 1953 it was clear that the process was a failure. At the end of the year, NBC used its "compatible color" system to air a color episode of *Dragnet*, allowing viewers to see a program in either color or

black and white, and by 1954 NBC was producing color programming on a regular basis (Reitan). Black and white suddenly seemed passé, and the public rushed to buy the new RCA "compatible color" television sets, despite the fact that they were prohibitively expensive, at least at first.

The movies fought back with the only weapons in their arsenal: spectacle and gimmickry. Twentieth Century–Fox introduced CinemaScope in 1953, and studio chiefs Darryl F. Zanuck and Spyros P. Skouras decreed that henceforth all Twentieth Century–Fox productions, in color or black and white, would be produced in CinemaScope, which, in contrast to the conventional Academy aspect ratio of 1.37:1, offered a screen image of up to 2.55:1, though more often the less drastic 2.35:1 ratio. This was accomplished through the use of an anamorphic lens during shooting that squeezed the image onto the conventional 35 mm frame. When the film was projected, another lens was used to unsqueeze the image to deliver the full aspect ratio. The first CinemaScope lenses, using the process patented by Henri Chrétien in 1926, were manufactured by Bausch and Lomb, and most cinematographers were not pleased with the results. As Leon Shamroy ruefully remembered,

> Those early Bausch and Lomb lenses were hell; and the films became very granulated. . . . It nearly drove me out of my mind, seeing what happened to my work when it was spread out all over that screen. I fought to get Panavision introduced on the Fox lot, and at last I won. It does help; in some ways it's very good. But those wide-screen 'revolutions': oh my God! You got a stage play again, you put pictures back to the earliest sound days, and you couldn't even do close-ups, because they'd distort so horribly. But though it wrecked the art of film for a decade, wide screen saved the picture business. (Higham 30–31)

As Fritz Lang (playing himself, as the director of a film within a film) in Jean-Luc Godard's *Contempt* (1963) said, CinemaScope was really only suited to "snakes and funerals," but it offered the public a much more immersive filmgoing experience at minimal studio expense—just two lenses, one for shooting and one for projection—and any camera was thus instantly adaptable to scope. Almost immediately, knockoff scope processes began to proliferate, such as Regalscope (Twentieth Century–Fox's CinemaScope process, used solely for their cheaper black-and-white productions); as well as Superscope, used by RKO Radio Pictures; and

the three-camera, three-projector Cinerama process, along with wider gauge films. In addition to standard 35 mm films, 55 mm and 70 mm productions began to appear as studios desperately tried to lure an ever-dwindling audience of patrons into theaters.

Another popular 1950s process was 3-D. The first 3-D film to be mass-marketed during the era is generally agreed to be Arch Oboler's *Bwana Devil* (1952), photographed using Milton Gunzburg's Natural Vision process by Joseph F. Biroc and an uncredited William D. Snyder, and viewed by the audiences using red and green glasses (Lev, 110). *Bwana Devil* was a cheap jungle thriller sold with tag lines such as "A lion in your lap! A lover in your arms!" but nevertheless it was an instant sensation. In response, the majors, led in this case by Warner Bros., jumped into full-color 3-D, using Gunzburg's process for André de Toth's *House of Wax* (1953), photographed by Bert Glennon, J. Peverell Marley, and an uncredited Robert Burks.

Famously, de Toth had sight in only one eye and had to rely on his cameramen to tell him whether or not the 3-D effect was working; less well known is the fact that the film was shot entirely in narrative order to facilitate rapid editing, so that the film would open in theaters before any other major studio film using the process could be released. *House of Wax* made a fortune, and for the next few years Natural Vision 3-D was a commercial success, but the process had inherent flaws from its inception. To shoot a film in color, Natural Vision used two 35 mm film cameras in frame-for-frame synchronization to shoot a film, and then two 35 mm projectors, also in frame-for-frame interlock, to project the two reels on top of each other, to screen the finished production. To work properly, Natural Vision color projection thus required two *perfect* copies of each reel to be run in interlock simultaneously; if just *one frame* was missing from either print, the effect was lost.

This made the process both clumsy and expensive. For the most part, 3-D was used in rather simplistic commercial films, with the notable exception of Alfred Hitchcock's *Dial M for Murder* (1954), immaculately photographed by Robert Burks, and one of the last films made in the first wave of 3-D before Hollywood abandoned it in 1955. *Dial M for Murder* demonstrated that 3-D could be used with style and taste, in contrast to the many horror films and fantasy spectacles that were more typical 3-D fare. Today's contemporary process Real 3D uses a digital camera and

projection system to produce two alternating images that merge into one with the use of polarized glasses—and has become commercially successful because of its relative ease and utility.

Similarly, while black and white was firmly established as the old, reliable way of making a film economically, during this transitional period, major studios and first-rank directors began to shift their attention to color. There were still many exceptional films made in the 1950s in monochrome, but there was a definite sense that the medium had become ordinary, almost plebeian, as if it could offer nothing new to the viewer. This was, of course, entirely untrue—and in the 1960s, as we'll see, black and white would experience its last and most profound period of artistic expression—but for the businessmen who controlled cinema production, black and white was suddenly passé.

With the Red Scare of the 1950s came a wave of paranoid black-and-white exploitation films. Charles G. Clarke (1899–1983), an excellent black-and-white cinematographer who shot more than 140 feature films in addition to work in series television, photographed *The Iron Curtain* (1948), one of the first true "Red Menace" films, for director William Wellman. Clarke's first DP credit was Arthur J. Flaven and Harry Revier's *The Son of Tarzan* (1920), which he photographed with an uncredited Walter Bell; he went on to work on such golden age films as Lewis Seiler's gritty *Guadalcanal Diary* (1943), George Seaton's yuletide perennial *Miracle on 34th Street* (1947, co-photographed with Lloyd Ahern), and Henry King's Tyrone Power swashbuckler *Captain from Castile* (1947, co-photographed with Arthur E. Arling and Joseph LaShelle). Clarke's glossy romantic style in the 1940s (outside of projects such as *Guadalcanal Diary*) gave way in the 1950s to a gray, flat, quotidian approach, as seen in Lewis Allen's *Suddenly* (1954), featuring Frank Sinatra cast against type as a would-be presidential assassin. Even Clarke's color films, such as Nunnally Johnson's *Black Widow* (1954), Richard Fleischer's crime drama *Violent Saturday* (1955), and Johnson's *The Man in the Grey Flannel Suit* (1956), created a world of muted, almost neutral colors, entirely divorced from the enforced Technicolor dynamism of the 1930s and 1940s.

Clarke's work on Johnson's espionage drama *Night People* (1954), though shot in Technicolor and CinemaScope, is about as desaturated as one can imagine, portraying the cloak-and-dagger atmosphere of postwar Berlin as suitably drab and uninviting. Since the film was a Twentieth

Century–Fox release, the CinemaScope format, even for a tale this claustrophobic, was a foregone conclusion, but both Johnson and Clarke do everything they can to make the film seem as real as possible; in fact, much of the film was shot on location. In his final years Clarke seemed to embrace black and white more than color, as witnessed in his remarkably bleak drama set in the advertising world, H. Bruce Humberstone's *Madison Avenue* (1961).

In the midst of all the sensationalistic hullaballoo of the more outlandish Red Scare films, Russell Rouse's somber *The Thief* (1952), photographed by Sam Leavitt, stands out as a unique film in cinema history. This Cold War spy thriller contains not a single word of dialogue, and is told entirely through its crisp, near-documentary black-and-white imagery. *The Thief*'s wordless narrative—of an atomic scientist, Allan Fields (Ray Milland), who reluctantly becomes a Soviet spy—steadily employs a constantly varied stream of images, using every possible camera angle imaginable to get the story line across. Though the film eventually falls victim to its own idiosyncratic structure, as a textbook on how to create a narrative relying solely on visuals, it displays an innovative and aggressive visual style that is unmatched by any other Hollywood film.

Interestingly, Leavitt's first credit as a DP was on *Ljubav i strast* (1932, dir. George Melford; alternative title *Born to Kiss*), a Serbo-Croation language feature film produced by Yugoslavian Pictures Inc., but shot in New York City. Leavitt then photographed two extremely low budget films for director Sam Newfield, *Undercover Men* (1934) and *Thoroughbred* (1935). Though he joined the American Society of Cinematographers in 1935, Leavitt worked for the most part as a camera operator on such films as Albert Lewin's *The Picture of Dorian Gray* (1945), Vincente Minnelli's *The Pirate* (1948), and Charles Walters's *Easter Parade* (1948). After *The Thief*, Leavitt's subsequent work, such as George Cukor's *A Star Is Born* (1954), Otto Preminger's *Carmen Jones* (1954), and Preminger's narcotics drama *The Man with the Golden Arm* (1955), is astonishing in its visual audacity, as was Leavitt's rapid rise into the Hollywood elite; yet Leavitt would then lens a straight-ahead programmer like Leslie Martinson's *Hot Rod Girl* (1956). He would later win an Oscar for his black-and-white cinematography in Stanley Kramer's interracial prison-break drama *The Defiant Ones* (1958).

Leavitt's other credits read like a roll call of some of the most intense monochrome films shot in 1950s America, including Preminger's *Anat-*

omy of a Murder (1955), Lewis Milestone's gripping war drama *Pork Chop Hill* (1959), Samuel Fuller's exoticist crime noir *The Crimson Kimono* (1959), Preminger's color spectacle *Exodus* (1960), Preminger's Washington political drama *Advise and Consent* (1962), based on the best-selling novel by Allen Drury, and J. Lee Thompson's psychological crime drama *Cape Fear* (1962), with a stunning performance by Robert Mitchum as an ex-convict who will stop at nothing to exact revenge upon the man (Gregory Peck) who was instrumental in sending him to prison.

After lensing Denis Sanders's violent thriller *Shock Treatment* (1964), Leavitt photographed Sam Peckinpah's flawed masterpiece *Major Dundee*, no fewer than three films by actor-turned-director William Conrad—*Brainstorm, My Blood Runs Cold*, and *Two on a Guillotine*— as well as Norman Taurog's comedy/science-fiction film *Dr. Goldfoot and the Bikini Machine*, all in 1965. Work after this was nearly all in color, mostly for television, although he photographed the rather stage-bound racial "romance problem" film *Guess Who's Coming to Dinner?* (1967) for Stanley Kramer, and, more typically, two indifferent films in the Matt Helm series starring Dean Martin, Henry Levin's *Murderers' Row* (1966) and Phil Karlson's *The Wrecking Crew* (1969). Leavitt's last really top-flight work, in color by this time in an all-color industry, was on Arthur Hiller's *The Man in the Glass Booth* (1975), a production of the short-lived American Film Theater Company. Leavitt's most impressive work, however, is in black and white, and the brooding sensibility he brought to such films as *Cape Fear, The Crimson Kimono, The Defiant Ones*, and other 1950s dramas remains his most lasting achievement, all of them echoing the experimental approach he so effectively employed on *The Thief.*

At Republic, the workmanlike John MacBurnie photographed R. G. Springsteen's appropriately paranoid film *The Red Menace* (1949), another early entry in the Red Scare sweepstakes; "filmed behind locked doors," as the publicity materials insisted, the film depicts a drab world of cynicism and betrayal with tired efficiency. MacBurnie, who worked for the most part in Republic's serial and western genre films, had a detached, distanced style of cinematography that perfectly suited such "just the facts" projects as Fred C. Brannon's twelve-episode, 167-minute serial *Federal Agents vs. Underworld Inc.* (1949), shot in twenty-one days for a paltry $155,807; Philip Ford's equally economical crime thriller *Hideout* (1949), starring a young Lloyd Bridges; George Blair's no-nonsense

procedural *Post Office Investigator* (1949); or Brannon's bleakly dystopian one-chapter serial *Radar Men from the Moon* (1952), shot in twenty days for $186,000. MacBurnie ended his career in episodic television.

And yet the Cold War film was far from being exhausted as a genre, even as audiences yearned for some daily affirmation in an increasingly uncertain world. Other significant entries in this tide of hysteria included Harry Horner's *Red Planet Mars* (1952), photographed in cold, hard blacks and whites by Joseph Biroc almost entirely within the confines of the studio, in which God is discovered to be alive and well and living on Mars; Alfred L. Werker's *Walk East on Beacon* (1952), photographed in drab *March of Time* newsreel style by Joseph C. Brun; Martin Ritt's long-forgotten interracial waterfront drama *Edge of the City* (1957), also shot by Brun and starring Sidney Poitier and John Cassavetes; Irving Pichel's biopic *Martin Luther* (1953), for which Brun was nominated for an Academy Award for black-and-white cinematography; and Edward Ludwig's dreary anticommunist procedural *Big Jim McClain* (1952), photographed by Archie Stout.

Stout, with more than 130 credits stretching back to the silent era, was one of John Wayne's favorite cinematographers. He knew how to light Wayne's iconic visage to best advantage in everything from James Edward Grant's *Angel and the Badman* (1947) to John Ford's *Fort Apache* (1948), as well as John Farrow's *Hondo* (1953), William Wellman's aviation drama *The High and the Mighty* (1954), and numerous other films. Stout was also a veteran of numerous B-westerns, so he and Wayne came up the hard way together; Stout also has the distinction of photographing three films for director Ida Lupino: *Never Fear* (1949), in which a young woman confronts polio; *Outrage* (1950), the first American film that deals centrally with sexual assault; and *Hard, Fast, and Beautiful* (1951), on the commercial exploitation of what is supposedly amateur tennis.

There were many Red Scare films made in the 1950s, which literally seethed with fear and paranoia. Some of these films were made with minuscule budgets, and some, like Leo McCarey's *My Son John* (1952), were prestige productions, arising out of the almost palpable miasma of uncertainty that pervaded America during this era. In such an atmosphere of fear and repression, the dark, forbidding cinematography of Harry Stradling Sr., who shot *My Son John*, and Leo Tover, who photographed *The Day the Earth Stood Still* (1951), epitomized the visual approach of midcentury Hollywood cinema. Stradling apprenticed in

Hollywood on short subjects and B-films for small studios, then left for Europe where he worked for such luminaries as Jacques Feyder on *Carnival in Flanders* (1935) and *Knight Without Armor* (1937) and Alfred Hitchcock on *Jamaica Inn* (1938). He then returned to the United States to shoot *Mr. and Mrs. Smith* and *Suspicion* (both 1941) for Hitchcock with great success. Stradling's black-and-white work on Elia Kazan's *A Streetcar Named Desire* (1951) is particularly impressive. While the resulting film is nevertheless decidedly theatrical, and the narrative marred by an alternative ending demanded by the Production Code, Stradling, given a free hand by Kazan, got the most out of this promising material, creating "a blending of pungent reality and vague fantasy, spirituality and animal passion, beauty and shabbiness, frustration, loneliness and violence" (Lightman 400).

But though Stradling was best known for his color work, his brooding films in black and white are among his finest achievements, among them such classics as Otto Preminger's fatalistic *Angel Face* (1952), in which ambulance driver Frank Jessup (Robert Mitchum) becomes tragically involved with the mysterious Diana Tremayne (Jean Simmons), triggering a scenario that ends in violent death; the cold, hard, unforgiving world of *My Son John*, which had to be finished with repurposed scenes and outtakes from Hitchcock's *Strangers on a Train*, photographed by Robert Burks, when star Robert Walker unexpectedly died during production; and Kazan's corrosive study of show business hypocrisy and audience manipulation *A Face in the Crowd* (1957), in which faux populist "Lonesome" Rhodes (Andy Griffith) rises to fame and fortune, becoming a "media monster" in the process, drunk on money and power. Stradling was nominated fourteen times for Best Cinematography, winning in the black-and-white category for Albert Lewin's adaptation of Oscar Wilde's *The Picture of Dorian Gray* (1945) and for color cinematography with George Cukor's *My Fair Lady* (1964), which *American Cinematographer* called "the most beautifully photographed motion picture ever produced" (qtd. in Dombrowski 72). But for all the splendor of the latter film's use of color, the cinematography was also praised for its brilliant use of monochrome:

> Stradling's handling of the Ascot race scene is particularly impressive due to its lack of color: dozens of well-heeled couples impassively watch the race, the men dressed strictly in Ascot gray, the women in white with black and

gray trimmings, all standing against a black-and-white pavilion and washed-out grass and sky. In order to create separation and detail with so much white-on-white, Stradling placed lighting units behind the muslin backdrops of the set, building up the illumination to balance the lighting from the front. (Dombrowski 72)

Leo Tover, whose credits as a cinematographer go all the way back to Herbert Brenon's first, silent version of *The Great Gatsby* in 1926, developed into a dependably hardboiled DP by the late 1940s, with such noirish milestones as Jean Renoir's nihilistic *The Woman on the Beach* (1947), Anatole Litvak's exposé of public mental institutions, *The Snake Pit* (1948), and William Wyler's ruthless period "romance" *The Heiress* (1949) to his credit. The cold, metallic precision of the black-and-white cinematography in *The Day the Earth Stood Still*, superbly complemented by Bernard Herrmann's ominous musical score, was matched by Tover's equally clinical and harsh imagery in Andrew L. Stone's *A Blueprint for Murder* (1953), Hugo Fregonese's retelling of Jack the Ripper's crimes in *Man in the Attic* (1953), and Philip Dunne's tragic teenage romance *Blue Denim* (1959). Each of these films depicted a society in flux, in which nothing is certain and there is no safe ground upon which to rely.

Another key cinematographer of the Cold War era was Joseph LaShelle, who pioneered a gray, distanced style in the 1950s in such socially conscious films as Martin Ritt's deeply disturbing study of suburban unease, *No Down Payment* (1957), and most famously Delbert Mann's drab *Marty* (1955), perhaps the least romanticized American film of the era, starring Ernest Borgnine in an Oscar-winning performance as a lonely Bronx butcher looking for love. *Marty* also won Best Picture, Best Screenplay (Paddy Chayefsky), and Best Director, to the industry's general consternation; after all, weren't the movies supposed to be glamorous? (LaShelle was also nominated but didn't win.)

LaShelle continued in this vein with his unforgiving cinematography on Billy Wilder's corrosive study of big city corporate politics, *The Apartment* (1960). LaShelle, like most of his peers during this era, came up the hard way through the studio system, in his case with Twentieth Century–Fox, where he won his only Academy Award for Best Black and White Cinematography on Otto Preminger's *Laura* (1944). By the 1950s, however, LaShelle was leaving the intricate shadow work of the studio system behind for a more naturalistic style, one that conveyed the emptiness

and angst of the Cold War era. The cinematic world of the 1940s favored shadows; but the 1950s had enough shadows in real life and didn't need any more.

One can clearly see LaShelle pursuing this vision of American life in his post-*Marty* work in such films as Gerd Oswald's *Crime of Passion* (1957), starring Barbara Stanwyck as a newspaper columnist who throws away her career to marry a police lieutenant. She vainly tries to live her life through her husband, using manipulation, sex, and finally murder to advance his career. Confounding his colleagues, LaShelle then accepted the decidedly down-market assignment of Gene Fowler Jr.'s forthrightly exploitational *I Was a Teenage Werewolf* (1957), which despite its compromising origins emerged as an effectively dark tale of adolescent alienation, with a standout performance by a young Michael Landon as a troubled teen transformed into a werewolf through "aggression therapy" by an unscrupulous psychiatrist.

The balance of LaShelle's work in the 1950s was equally grim: Andrew V. McLaglen's *The Abductors* (1957), a bizarre nineteenth-century noir in which two men try to steal the body of Abraham Lincoln for ransom; Raoul Walsh's adaptation of Norman Mailer's war novel *The Naked and the Dead* (1958); and into the 1960s with Billy Wilder's most cynical film, *Kiss Me, Stupid* (1964). LaShelle's work in the 1950s is thus additional proof that the slick sheen of 1940s black and white was now giving way to an entirely new aesthetic, one that was deeply disenchanted with the existing order of things.

Another iconic 1950s cinematographer was the highly prolific Russell Metty, with more than 160 credits in a career that lasted from the low-budget precincts of Philip Rosen's *West of the Pecos* (1934) through a series of modest films in the 1930s and 1940s, with the notable exception of his immaculate high-key work on Howard Hawks's *Bringing Up Baby* (1938). Metty then unexpectedly rose to prominence with Edward Dmytryk and an uncredited Irving Reis's micro-budgeted RKO Radio programmer *Hitler's Children* (1943), an enormous and much-needed hit for the studio that accelerated both Metty's and Dmytryk's careers. In 1946, he teamed with Orson Welles for *The Stranger*, which Welles directed and starred in as a Nazi war criminal living as a college professor in New England, though Welles claimed to dislike the finished film.

By 1949, Metty was working in A-picture territory, lensing Michael Gordon's harrowing tale of gaming addiction, *The Lady Gambles*, starring

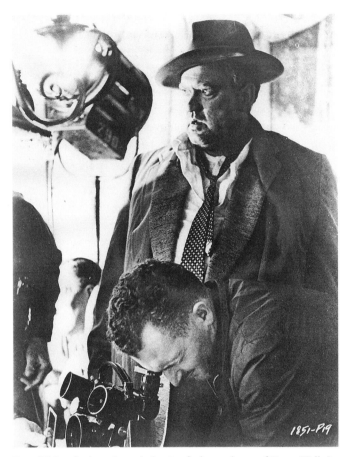

Russell Metty looking through the viewfinder on the set of Orson Welles's
Touch of Evil (1958)

Barbara Stanwyck; working with Douglas Sirk on the Technicolor camp
melodrama *Magnificent Obsession* (1954); yet perfectly willing to take on
less prestigious assignments, such as Jerry Hopper's sensationalistic police
drama *Naked Alibi* (1954), Lewis R. Foster's low-budget crime drama
Crashout (1955), and even a rather outré horror film, Francis D. "Pete"
Lyons's *Cult of the Cobra* (1954).

As one of Universal's most reliable house cinematographers, Metty
was again teamed with Welles on his last Hollywood film, the pulpy, vio-
lent noir *Touch of Evil* (1958), which contains some of his finest, darkest,
and most adventurous monochrome cinematography. Metty relished the
chance to work with Welles on a project over which the director had total

control, unlike *The Stranger*, and was able to do whatever he wanted, thanks to Charleton Heston's support. With the use of handheld camerawork, actual locations rather than studio settings, and a towering performance by Welles himself in the leading role of the utterly corrupt police captain Hank Quinlan, *Touch of Evil* became one of the high points of Metty's long career. As George Turner notes,

> The most remarkable photographic feat is the opening scene, an unbroken 195-second crane shot that ordinarily would have been done in several shots. It begins with a close-up of a time bomb which is being set; the camera swings up as the man planting it looks down the street, pulls back as he runs to the right, and follows his shadow along a building to a Cadillac convertible parked in back. He puts the bomb in the trunk and flees as a politician and a blonde stripper emerge from the back door of a nightclub and get into the car. Pulling away from camera, the car circles behind the building as the camera moves to a high angle to show it pulling out and moving onto the street. The camera then moves down two downtown blocks, covering the action with close-ups, low tracking shots, bird's-eye views, and long shots. The street is crowded with pedestrians and is elaborately night-lighted. [Charlton] Heston and [Janet] Leigh enter the street and the camera moves close to them as they turn and walk ahead of the car. Next, we move ahead to the border checkpoint, where Heston chats with the driver and a guard and the blonde complains about a ticking sound. The auto passes and the camera moves close to Heston and Leigh to pick up their conversation. They are interrupted by an explosion off-screen left; only then does the scene cut to the exploding Cadillac. Metty properly gave credit to camera operator Philip Lathrop, for the virtuosity of this flawless, one-of-a-kind scene. (Turner, "*Touch of Evil*" 146)

In 1960, Metty won the Academy Award for Best Color Cinematography for Stanley Kubrick's *Spartacus* (although Metty and Kubrick clashed violently on the set during production after Kubrick replaced the fired Anthony Mann), and then photographed John Huston's *The Misfits* (1961) from an original screenplay by Arthur Miller, an elegiac western that was famously beset by problems during production. *The Misfits* was Marilyn Monroe's and Clark Gable's last film; Monroe died shortly afterward of a suspected overdose of barbiturates, and Gable suffered a massive heart attack only days after the film wrapped. The almost existential

theme of *The Misfits*, in which a group of loners in the contemporary West band together just to survive, was perfectly conveyed by Metty's parched, flat monochrome imagery, and the film remains one of the finest films of Hollywood's black-and-white era.

The rest of Metty's career, however, was mostly color work, and such undemanding projects as Norman Jewison's Doris Day/James Garner sex comedy *The Thrill of It All* (1963), David Lowell Rich's 1966 remake of *Madame X*, and William A. Graham's Elvis Presley vehicle *Change of Habit* (1969); only Boris Sagal's *The Omega Man* (1971), based on Richard Matheson's famous dystopian science-fiction novel *I Am Legend*, had any real distinction. With Phil Karlson's cult horror movie *Ben* (1972), about a horde of killer rats and their loner "master," and Paul Bogart's execrable Bob Hope "comedy" *Cancel My Reservation* (1972), it was clear that Metty no longer cared about what he was assigned; cinematography had become just a job. Soon he was photographing the television series *Columbo* (1971), *The Waltons* (1972–1975), and even one episode of *The Hardy Boys/Nancy Drew Mysteries* (1977). It was another instance of a superbly talented DP who excelled in black and white but didn't fit into the assembly-line nature of color production.

As the fifties progressed and single-strip color film took hold, more and more films were suddenly being "upgraded" to color, even after initial production had begun. Such was the case with Nicholas Ray's iconic investigation of teenage angst, *Rebel Without a Cause* (1955), which was launched in black and white but after one week of shooting moved up to "Warnercolor"—an Eastmancolor derivative—and CinemaScope, with all the existing footage scrapped and reshot. Photographed by another studio veteran, Ernest Haller, *Rebel* is one of the few films of the era that actually benefits from color cinematography: the "end of the world" planetarium sequence and the bright red of James Dean's jacket in the film are far more compelling than they would be in monochrome. Elsewhere in the film, most of the interior work, particularly in the deserted mansion where the teen protagonists set up a "home," is executed in decidedly muted tones.

Haller had more than 180 credits to his name in a career that spanned more than forty-five years, including such black-and-white masterworks as Michael Curtiz's intricately designed *Mildred Pierce* (1945), in which the characters continually emerge out of the shadows that metaphorically cloud their duplicitous existences, as well as A. Edward Sutherland's

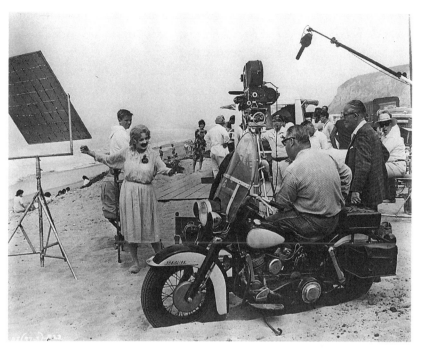

Ernest Haller, far right with glasses, leaning on motorcycle, on the set of Robert Aldrich's (seated, on motorcycle) Gothic horror film *Whatever Happened to Baby Jane?* (1962)

exoticist horror film *Murders in the Zoo* (1933), Sutherland's surreal comedy *International House* (1933), Dudley Murphy's production of Eugene O'Neill's *The Emperor Jones* (1933), William Wyler's *Jezebel* (1938), Edmund Goulding's medical melodrama *Dark Victory* (1939), Raoul Walsh's paean to early twentieth-century gangsterism *The Roaring Twenties* (1939), the Bette Davis "dual identity" thriller *A Stolen Life* (1946), and Robert Aldrich's Gothic horror film *Whatever Happened to Baby Jane?* (1962). Haller also served as the principal photographer on Victor Fleming's epic *Gone with the Wind*, working with an uncredited Lee Garmes. *Gone with the Wind* (1939), of course, was in three-strip Technicolor, but Haller was more comfortable in black and white, as the sinuous shadows of *Mildred Pierce* and, almost twenty years later, *Whatever Happened to Baby Jane?* aptly demonstrate. It's therefore more than a little ironic that of his six Academy Award nominations—five for black-and-white films, the last being Ralph Nelson's *Lilies of the Field* (1964), for which Sidney Poitier captured his lone Oscar—that Haller should have won only for *Gone with the Wind*, with its lurid, oversaturated color

scheme, a result of Technicolor's insistence at the time of controlling every aspect of a film's production. (Haller shared the award with Technicolor's house cameraman Ray Rennahan.)

Perhaps the most iconic western of the early 1950s was Fred Zinnemann's *High Noon* (1952), photographed by Floyd Crosby, in which Marshal Will Kane (Gary Cooper) discovers on his wedding day that desperado Frank Miller (Ian MacDonald), whom Kane sent to prison long ago, has been released from the penitentiary and is returning on the noon train to shoot Kane down in cold blood. Throughout the film's sparse, nearly "real time" eighty-five minutes, Kane asks one town figurehead after another for help—the mayor, the local minister, the retired marshal, a prominent judge—but they all turn him down.

A similar pessimism pervades Howard Hawks's science-fiction allegory *The Thing from Another World* (1951), credited to Hawks's editor Christian Nyby as director but actually helmed by Hawks, shot by Russell Harlan almost entirely on RKO's soundstages, repropped to look like a scientific military outpost at the North Pole. A flying saucer crashes in the ice nearby, and the base's inhabitants, led by Captain Patrick Hendry (Kenneth Tobey), set out to retrieve it, accidentally demolishing the spaceship when they try to break it out of the ice. The craft's occupant, however, survives, frozen solid in a block of ice, and the members of the expedition transport it back to base camp. There, The Thing (James Arness) returns to life when its icy prison melts and sets about methodically trying to kill every member of the base camp for their blood, which it must have to survive. Russell Harlan, who photographed *The Thing*, creates a world of unyielding menace and claustrophobic isolation, illuminating much of the film from "practical" light sources within the frame—dangling light bulbs, table lamps, even the light of a Geiger counter—giving the film an almost documentary look, in keeping with his other work on such prestige black-and-white films as Hawks's dystopic western *Red River* (1948), Joseph H. Lewis's resolutely downbeat tale of murder and betrayal, *Gun Crazy* (1950), and Don Siegel's gritty prison drama *Riot in Cell Block 11* (1954), which was actually shot, after much negotiation, at Folsom State Prison in Represa, California, using inmates as extras.

This same fatalism pervaded European film in the 1950s as well, with Henri-Georges Clouzot's *The Wages of Fear* (1953, d.p. Armand Thirard) serving as perhaps the most pessimistic vision of postwar existence. In a

South American hellhole, four expatriates desperately seek a way back to "civilization" and seem to find it when they are hired by the ruthless head of an American oil company, Bill O'Brien (William Tubbs). Their job is to transport two shipments of decidedly unstable nitroglycerine in decrepit, worn-out trucks without shock absorbers through hostile jungle wasteland to put out an oil well fire. With more than 120 films to his credit, cinematographer Thirard, a former actor who ultimately found his true calling behind the camera, creates a world of crushing heat, misery, cruelty, and exploitation in the film, aided by Clouzot's own corrosive view of humanity. Clouzot and Thirard also worked together on the atmospheric crime drama *Quai des Orfèvres* (1947) and the highly successful suspense thriller *Les Diaboliques* (1953).

Jean Cocteau's death-obsessed fantasy *Orpheus* (1950), photographed by Nicolas Hayer—who worked with Clouzot on *The Raven* (1943)—created a compelling vision of a neorealist hell from the abandoned ruins of deserted factory buildings, photographed at night with newsreel harshness to depict the transient nature of human mortality and the ephemerality of corporeal existence. Robert Bresson's groundbreaking essay in human alienation, *Diary of a Country Priest* (1951), photographed by Léonce-Henry Burel, effectively depicted the tragic, personal effects of social isolation in its story of a young but seriously ill curate, assigned to the French village of Ambicourt, who is either unable or unwilling to help his parishioners. Shot in what would soon become Bresson's signature "undramatic" style, using nonactors, actual lighting whenever possible, and camera compositions which embraced empty, unoccupied space, *Diary of a Country Priest* caused a quiet revolution in world cinema when it was first released. In the midst of this creative ferment, yet another iconoclastic figure of the French cinema emerged, the Lettrist poet and filmmaker Jean-Isidore Isou. Easily the most bizarre film made in France in the 1950s, Isou's black-and-white feature *Venom and Eternity* (1951), caused a scandal when it was screened at the Cannes Film Festival in 1951, where it won the Prix de l'Avant-garde as the most original and audacious film of the exhibition. Isou's film, a product of the Lettrist movement, consists of randomly edited sections of blank film, "countdown" leader (also known as "Academy leader"), upside-down footage of military vehicles, scratched and out-of-focus stock footage, as well as commercials for Isou's numerous books, which interrupt the film at regular intervals.

Much of the film takes the form of a supposed lecture that Isou interrupts with his theories, much to the derision of the rest of the audience, but we only hear this on the sound track; the images are a separate entity altogether. Isou also raises the very interesting and very real question of "what constitutes beauty"—why we deem some images "beautiful" and some not. As he shouts on the film's sound track: "I believe firstly that the cinema is too rich. It is obese. It has reached its limits, its maximum. With the first movement of widening which it will outline, the cinema will burst! Under the blow of a congestion, this greased pig will tear into a thousand pieces. I announce the destruction of the cinema, the first apocalyptic sign of disjunction, of rupture, of this corpulent and bloated organization which calls itself film."

Throughout the film Isou insults the viewer, saying that he "wants to make a film that hurts your eyes," while the opening thirty-minute section of the film offers heroic, angled shots of the director ambling around the streets of Paris, meeting various artistic luminaries at cafés and bars. The film ends with a long section of Lettrist poetry, which takes the form of howls, grunts, screams, and guttural noises. Once seen, *Venom and Eternity* is never forgotten, one of the most confrontational films ever produced by the international avant-garde, and a testament to the continuously adventurous nature of the French cinema, even during the Cold War era. Photographed with calculated insolence by Nat Saufer, in his sole credit as a cinematographer, *Venom and Eternity* remains an outlier in cinema history, but one that gestures toward the more radical experimental films of the 1960s, particularly in the New American Cinema Movement.

In Italy, Roberto Rossellini's unflinching neorealist drama *Rome, Open City* (1945), photographed by the great Ubaldo Arata under conditions of the greatest privation near the end of World War II, electrified audiences worldwide with its rough-hewn look, its use of nonprofessionals for many of the leading roles, and its uncompromising narrative. Arata, who compiled more than 100 credits during his career, had been working in the Italian film industry since the silent era, with such films as Guglielmo Zorzi's *A Siren's Love* (1921), Mario Almirante's *The Carnival of Venice* (1928), Goffredo Alessandrini's *Between Two Worlds* (1936), and Corrado D'Errico's *Trial and Death of Socrates* (1939) to his credit. Like nearly all his contemporaries, he was obliged to work on thinly veiled

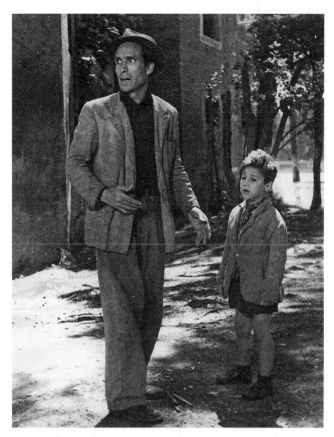

Father and son in desperate straits in Vittorio De Sica's *Bicycle Thieves* (1948), photographed by Carlo Montuori

propaganda films for Benito Mussolini, who built the still extant film studio Cinecittà, then placed his son Vittorio in charge.

The studio's slogan, "Cinema is the most powerful weapon," signified precisely what Cinecittà's initial ambitions were, in such films as Carmine Gallone's *Scipione l'africano: The Defeat of Hannibal* (1937), designed to incite Italy's enthusiastic participation in the military campaign in North Africa. But with the collapse of Il Duce's regime, the Italian cinema began an artistic renaissance of truly international impact, creating masterworks such as Vittorio De Sica's *Bicycle Thieves* (1948), photographed by another master of the Italian black-and-white cinema, Carlo Montuori, who shot more than 150 films between 1907 and 1961.

Like *Open City, Bicycle Thieves* was shot on location, used nonprofessional actors in the leading roles, and presented an unceasing grim view of postwar Italian life, as a poor laborer, Antonio Ricci (Lamberto Maggiorani), desperately seeks work and finally lands a job putting up movie posters (appropriately enough, for Charles Vidor's glossy romance *Gilda*, which shot Rita Hayworth to stardom). Soon, however, his bicycle, essential to his work, is stolen in broad daylight. After searching through the black markets of Rome and getting no help from the police, Antonio tries to steal a bicycle himself, only to be almost instantly apprehended. The film ends with Antonio and his son Bruno (Enzo Staiola) out of options, with no help forthcoming.

This trend continued in the early 1950s in Italy with De Sica's drama of the plight of poverty in old age, *Umberto D* (1952). Photographed in suitably drab monochrome by G. R. Aldo, the film is an unrelieved document of human loneliness and despair, and its ending, in which Umberto D tries to commit suicide by standing on the tracks in front of an oncoming train while holding his beloved dog, Flick, in his hands, only to have the dog escape from his grasp and lead Umberto away from certain death, is both heartbreaking and utterly harrowing. Aldo, who began his career as an actor, shot only fourteen films in his brief forty-eight years on earth, but they include some of the most luminous films of the European cinema. In addition to serving as the on-set still photographer for Jean Cocteau's *Beauty and the Beast*, Aldo photographed Luchino Visconti's neorealist tale of fishermen being exploited by commercial wholesalers, *La terra trema* (1948), as well as De Sica's more modern romantic fantasy *Miracle in Milan* (1951). He then served as the lead cameraman on Orson Welles's troubled production of *Othello* (1952), De Sica's David O. Selznick production of *Indiscretion of an American Wife* (1953), and Visconti's historical romance *Senso* (1954), which was shot in color.

In Sweden, Ingmar Bergman was consolidating a career begun in the late 1940s into a string of deeply personal films that would establish his reputation as a director of the first rank in the 1950s. Working principally with the gifted cinematographers Gunnar Fischer and Sven Nykvist, Bergman first set his stride with the tragic yet briefly idyllic romance *Summer with Monika* (1953, d.p. Fischer), and the circus-themed drama *Sawdust and Tinsel* (1953, d.p. Hilding Bladh and Nykvist), and then went on to a string of iconic masterpieces that changed the face of world cinema.

An expressionistic scene from Ingmar Bergman's *The Seventh Seal* (1957), photographed by Gunnar Fischer, with Bengt Ekerot as Death and Max von Sydow as the Knight

With *The Seventh Seal* (1957, d.p. Fischer), Bergman's allegory of life and death in the era of the Black Death, and the deeply introspective *Wild Strawberries* (1957, d.p. Fischer), starring pioneering director Victor Sjöström as an elderly academic looking back on his life as he is awarded a career achievement award by the university where he has labored for many years, Bergman created a cinematic style that was both intimate and universal, as his characters struggle with issues of life, death, the evanescence of human existence, and the seeming impossibility of connecting with others in an innately hostile universe. However, Bergman and Fischer were becoming less congenial collaborators. As Bergman told Stephen Pizzello,

> For me, two things about a cameraman are fundamental. The first is that he shall be technically absolutely perfect, and at the same time first-class on lighting. The second [is] that he must be first-class at operating his own camera. I don't want any camera operators on my films. The cameraman and I come to an agreement about what is to be included in the image. We also

go through everything to do with lighting and atmosphere in advance. And then the cameraman does everything in the way we've agreed on. [However,] little by little, Gunnar Fischer's ideas and mine parted company, and this meant that the solidarity, the feeling of personal contact and interplay between us, which was so necessary to me, became slack—largely, perhaps, because I became more and more domineering, more and more tyrannical, and more and more aware that I was humiliating him.

Sven Nykvist is a much tougher personality. I've never had any reason to be nasty to him. We've developed a private language, so to speak. We hardly need to say a word. Before the filming begins we go through the film very carefully, to see how we imagine the lighting, check the lighting conditions, and then solve all lighting problems together. The light in the images is something I hardly think can ever be attributed to just one of us. Perhaps I can put it like this: the impulse comes from me, and the enormously careful, subtle and technically clever execution is all Sven Nykvist's work. (74–75)

By 1962 with *Winter Light*, photographed by Nykvist, Bergman had refined his vision into an austere, almost sculptural sensibility of blacks, whites, and varying shades of gray, striving for complete simplicity in all his work. As Nykvist recalled working with Bergman,

The whole crew meets two months before shooting to read the whole script, then we start to make tests. We build sets, and when everyone—the costume designer, the production designer, the makeup artist—is there, we make tests for the whole picture so we will never be surprised when we start shooting. We are already halfway through a picture when we start to shoot it, and that is psychologically very important for all the people because everyone, including the grips and electricians, feels that he or she is as important as all the others. . . . When you are operating the camera, you forget all about the other people around you. You just see this little scene and you live in that and you feel it. For me, operating the camera is a sport and it helps me do better lighting sometimes.

When Ingmar and I made *Winter Light* . . . which takes place in a church on a winter day in Sweden, we decided we should not see any shadow in it at all because there would be no logical shadow in that setting. I said, "Oh, that will be an easy picture for me because the light doesn't change in three hours." Ingmar said, "That's what you think. Let's go to the churches in the north of Sweden." And there we sat for weeks, looking at the light during the

three hours between eleven and two o'clock. We saw that it changed a lot, and it helped him in writing the script because he always writes the moods. . . . I had to start with bounced light and then after that I think I made every picture with bounced light—I really feel ill when I see a direct light coming into faces with its big nose shadow. . . .

It has taken me 30 years to come to simplicity. Earlier, I made a lot of what I thought were beautiful shots with much backlighting and many effects, absolutely none of which were motivated by anything in the film at all. As soon as we had a painting on the wall, we thought it should have a glow around it. It was terrible and I can hardly stand to see my own films on television anymore. . . . I prefer to shoot on location because in the studio you have too many possibilities—too many lights to destroy your whole picture. ("Shooting with Bergman").

Bergman arguably reached the apotheosis of his black-and-white work with *Persona* (1966), shot by Nykvist at Bergman's summer home on the island of Fårö, in which two women face off in a psychological battle of wills that may or may not be an entirely interior struggle, with just one

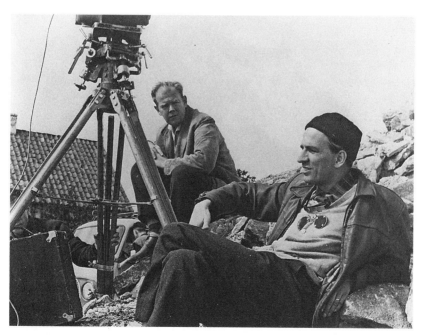

Sven Nykvist and Ingmar Bergman relaxing for a moment on the set of Bergman's *Persona* (1966)

"actual" protagonist. Bergman and Nykvist tried to shoot the film in the studios at Svensk Filmindustri, but the results were unsatisfactory and artificial. When they moved production to Fårö, the natural lighting of the island provided precisely the sort of simple yet nuanced illumination they were striving for, and filming suddenly began to move along at a rapid clip. "To shoot a film is to organize an entire universe," Bergman said, and for him that universe is best preserved in monochrome.

Nevertheless, Bergman embraced color in his last, least adventurous films, particularly *Fanny and Alexander* (1982), for which, ironically, Nykvist won an Academy Award for Best Cinematography. Of his color films Nykvist once observed, "The only critical thing I have to say about my color is that it is too nice. It's too pretty" ("Shooting with Bergman"). Indeed, color exemplifies the sort of preciousness that doesn't belong in Bergman's work. Although *Fanny and Alexander* also won the Oscar for Best Foreign Film, it remains an afterthought in Bergman's career, a sentimental family drama that lacks the austerity and precision of his earliest work.

The contemplative cinema of the great Japanese auteur Yasujirô Ozu was, in large measure, a collaboration with his longtime cinematographer

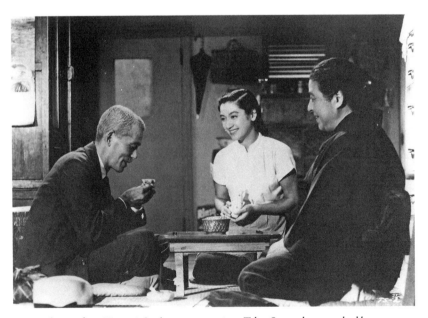

A typical setup from Yasujirô Ozu's 1953 masterpiece *Tokyo Story*, photographed by Yûhara Atsuta

Yûhara Atsuta. A fully accomplished director by the time of his 1932 silent comedy *I Was Born, But* . . . (photographed by Hideo Shigehara), Ozu arguably reached his mature late style with his 1953 masterpiece *Tokyo Story*, photographed by Atsuta, suitably subdued in black and white. Ozu's career began in the silent era, with the co-direction of *Blade of Penitence* (1927, directed with Torajiro Saito, d.p. Isamu Aoki), and continued through fifty-four films to *An Autumn Afternoon* (1962, d.p. Atsuta in color).

Ozu's films are calm, quiet, disciplined, and very much interior works, in which supposedly small-scale family narratives are used to illustrate larger social issues. Ozu is also known for his "tatami mat" cinematography, in which his camera is placed on "baby legs" for a low-level view of the action within a scene. As Donald Richie, perhaps the most perceptive of all of Ozu's many critics, notes:

> The camera's angle and position almost never change. Everything is seen head-on, from the position of a person kneeling on the floor Japanese-fashion. Of the various explanations advanced for Ozu's low camera position, one of the most ingenious is that he happened upon it when making films about children. In *Tokyo Chorus* [1931] there is a scene in which we see the parents only from the waist down. This extremely odd scene is explained when the children enter. It was framed for them. Ozu, it is argued, liked the look of this low-angled scene and continued to use it. This explanation may well be true, for it fully accords with Ozu's unique conception of the role of composition in cinema.
>
> Yet, according to [Yûhara Atsuta], Ozu's cameraman, it was the need for a pictorially balanced composition that dictated the director's camera position: low and almost invariably shooting at right angles to the scene. He remembers Ozu's saying to him: "You know, Atsuta, it's a real pain trying to make a good composition of a Japanese room—especially the corners. The best way to deal with this is to use a low camera position. This makes everything easier." That is, if the camera is positioned low on the tatami and facing into a room, the black bindings of the tatami do not create in the farther corners the acute angles that would detract from a composition conceived as frontal and at right angles to the observer. Rather than seeming to stop at a point to which the director wishes to draw no attention, they seem to proceed uninterruptedly to invisibility. (Richie 114–115)

Thus, Ozu's low-angle black-and-white cinematography draws the viewer inexorably into the action by making the camera "disappear"—it is perhaps not coincidental that of all the directors mentioned in this text, Ozu's inevitable switch from black and white to color (Agfacolor, to be precise) was arguably the most nuanced, with the pastels of his later color films, such as *Equinox Flower* (1958), *Late Autumn* (1960), *The End of Summer* (1961), and *An Autumn Afternoon* blending in smoothly with his monochrome work, in which subtle shifts in shade and tone are the predominant pictorial markers of his careful, meditational style. Atsuta provided the expert cinematography for all these late great works save *The End of Summer*, which was shot by Asakazu Nakai.

In India, director Satyajit Ray pawned nearly all his possessions to create *Pather Panchali* (1955), one of the first realistic visions of daily working-class slum life in that country, with cinematography by the gifted Subrata Mitra. Mitra also photographed the next two films in Ray's "Apu Trilogy," *Aparajito* (1956) and *The World of Apu* (1959), as well as Ray's study of Indian/British colonial culture in collapse, the profoundly moving *The Music Room* (1958), with a hypnotic sitar musical score by Ravi Shankar, who was as yet unknown in the West. In addition, Mitra photographed a number of similar films chronicling the decline of Western influence in India, such as James Ivory's *Shakespeare-Wallah* (1965), about a traveling troupe of itinerant players performing Shakespeare's plays for continually dwindling audiences, and Ivory's romantic drama centering on the Indian movie business, *Bombay Talkie* (1970), which was photographed in Eastmancolor.

A few Soviet films reached the West in the late 1950s, such as Mikhail Kalatozov's *The Cranes Are Flying* (1957), a romantic drama set on the eve of World War II, sensitively photographed by Sergey Urusevskiy, whose other work included Kalatozov's *I Am Cuba* (1964), a semi-documentary study of that country as it moved from the hands of dictator Fulgencio Batista to "revolutionary ruler" Fidel Castro; Kalatozov's *Letter Never Sent* (1959), a romantic adventure film set in Siberia; and Grigory Chukhray's *The Forty-First* (1956), another war-themed romantic drama.

But the end of the 1950s, both from the point of view of monochrome cinema and from a historical perspective as well, belongs to the French and British New Wave, which took hold in 1959 with a vengeance, seemingly erasing the previous ten years with a cascade of stylistic and thematic innovations that represents one of the major turning points in the

development of film as an art form. As is well known, the New Wave in France sprang up from the critical work of such cinéastes as François Truffaut and Jean-Luc Godard (often writing as Hans Lucas), as well as other writers for the journal *Cahiers du Cinéma*, edited by film theorist André Bazin.

Embracing all that was new in the cinema, and intentionally discarding the theatrical sensibility that had ruled the industry for much of its existence, these filmmakers forged a new, plastic, expressive, and often deliberately anarchic style of cinematic expression. Among their trademarks were the frequent use of natural light, jump cuts, direct sound recording, location shooting, and deliberately "distancing" devices such as wipes, freeze-frames, irises, and slow motion, which acknowledged that the cinema was, in essence, a construct, in which every image shared equal weight, and every camera set-up or editorial structure represented a conscious, often invasive decision, rather than adhering to the rules of conventional film grammar. It was, in short, a full-scale revolution.

5

The 1960s

● ●

Endgame

As the 1960s dawned, the cinema seemed to be suddenly transformed; it was sleeker, smoother, and very much the voice of the era. New equipment emerged, putting filmmaking within the reach of seemingly everyone. In a world before the web, social media, and the widespread use of videotape, before global, instantaneous communication became commonplace, it was film—especially 16 mm film—that was the medium of choice for the exchange of ideas, even across international borders. Film was, in short, the "end medium" of its era: the most efficient way to reach the widest number of people, to entertain, persuade, or enlighten. The digital world did not yet exist.

Just six years into the decade, black and white, which had been the principal production medium for the cinema since its inception, would officially be declared an obsolete technology when the Academy of Motion Picture Arts and Sciences awarded the last Oscar for black-and-white cinematography. In these last years before monochrome was unceremoniously abandoned, however, some of the most breathtaking and evocative black-and-white work in film history would be accomplished. It was soon to be an all-color world, but as black and white faded from the

world's theater screens, it went out in a burst of energy and creativity not seen since the 1940s—the last great triumph of the monochrome cinema.

A highlight of this era, not only with regard to cinematography but also changes in production style and choice of subject matter—with a clear influence from French cinema—was undoubtedly Alfred Hitchcock's *Psycho* (1960). After many years shooting various television series, DP John L. Russell contributed significantly to one of the greatest, most innovative, and influential black-and-white films ever made. Russell got the job on *Psycho* because he was among Universal's most reliable staff cinematographers, and in that capacity he had been shooting episodes of *Alfred Hitchcock Presents*, a television series that ran from 1955 through 1965. Hitchcock himself did not direct most of the episodes for the series, but the few that he did, including "Revenge," "Breakdown," "Lamb to the Slaughter," and others, were shot by Russell, and the pair had an excellent working relationship.

As executive producer for the series, Hitchcock usually confined his input to assisting in the selection of stories for dramatization, lending his name and image to the project, and providing a series of darkly comic introductions and postscripts to each teleplay. Most of the early half-hour episodes were shot in two to three days at most, with a Universal TV crew operating at maximum efficiency in serviceable black and white. (The episodes expanded to an hour in 1962.) Working with Russell opened Hitchcock's eyes to a more modern, faster-paced style of filmmaking. The speed and professionalism of the Universal crews astounded him, compared to the relative lassitude of his feature crews at Paramount. Ordinarily bored by the filmmaking process—shooting seemed almost an afterthought to his exquisitely detailed storyboards—Hitchcock now found himself caught up in the excitement of actually shooting a movie.

In addition, Hitchcock also saw an opportunity to keep up with the younger directors coming up in the ranks, especially those of the French New Wave, particularly François Truffaut. Truffaut made his early black-and-white features with a very small crew indeed, and Hitchcock realized that he could do the same—use his television series crew to shoot a film in black and white, quickly and efficiently, keeping costs down at every level, and still create an entirely personal film. But this presented Hitchcock with a problem. The director was under contract to Paramount for the release of his theatrical works, with the studio having first right of

refusal for any new feature project, but he now wanted to make a film with the Universal crew from his television show.

There was also another problem, this one regarding the subject of the new film he wished to make. Having known for some time that his 1950s big-budget romance and suspense films were fast falling out of public favor, Hitchcock cast around for some fresh material and found it in Robert Bloch's novel *Psycho*. Using an intermediary to keep the cost down, Hitchcock bought the rights to the novel and pitched the project to Paramount. But Paramount's executives found the material too exotic, offbeat, and problematic, and refused to finance the film. After much negotiation, Hitchcock resolved the entire situation to his satisfaction: he struck a deal to shoot the film at Universal in black and white using his TV crew, funding the budget of $806,947 entirely with his own money, and also deferring his standard director's fee of $250,000 in return for a 60 percent ownership of the film's negative. But due to his contract, the film would still have to be released through Paramount.

Hitchcock shot the film on a very tight schedule, starting on November 11, 1959, and wrapping on February 1, 1960. When *Psycho* opened, it exceeded the box office of all Hitchcock's previous features and—with its sinuous synthesis of sex, violence, and hitherto uncharted psychiatric territory, at least in a major Hollywood film—signaled the beginning of the end for the old Production Code. With its superficially charming antihero Norman Bates (Anthony Perkins), the brutal murder of Marion Crane (Janet Leigh) in the tour-de-force shower sequence (featuring only one actual point of contact between the knife blade and a Styrofoam torso—Hitchcock always denied such a shot existed, but it's there), and the psychopathology of a dead, mummified mother urging Norman toward homicidal mania, the film's view of inhumanity incarnate was a complete stunner for audiences coming out of the comatose 1950s. Thus, *Psycho* was essentially an independent film, backed by its maker against the objections of a studio that had been making bland mass entertainment for so long it couldn't see that audiences no longer wanted the old formulas. Viewers wanted something fresh, and *Psycho* provided precisely that—the shock of the new.

Russell's contributions to the film should not be understated. While Hitchcock naturally controlled every aspect of the design of the film, with some long-contested help from title designer Saul Bass on the shower scene, it is Russell who delivered the deeply saturated blacks and

whites, the immaculately nuanced interior lighting in the old Bates house, the antithetically bright, antiseptic lighting design in the motel bathroom as Norman cleans up after Marion's murder, and the appropriately quotidian images in the sheriff's office at the film's end, when a psychiatrist delivers a multi-page speech to explain what has just transpired for any audience members still in the dark.

For many observers, *Psycho* is above all proof of the inherent superiority of black and white to create an atmosphere of menace and suspense; one has only to look to Gus Van Sant's 1998 nearly shot-for-shot remake of *Psycho*, photographed in slightly muted color by the great Hong Kong DP Chris Doyle, to see that the sleek planes and dark recesses of black-and-white imagery are essential to *Psycho*'s unsparing vision of homicidal madness. Subsequent full-color sequels—such as Richard Franklin's *Psycho II* (1983), Anthony Perkins's *Psycho III* (1986; his career had declined so precipitously by this point that practically the only work he could get was reprising the role of Norman Bates), and Mick Garris's *Psycho IV: The Beginning* (1990)—offer further proof of this. Russell's black-and-white work on the original film is bold, sharp, and confidently assured, and it's obvious that no matter what his assignments were, Russell was a cinematographer of the first rank. Russell was nominated for an Academy Award for Best Black and White Cinematography for *Psycho*, only to lose out to Freddie Francis for his work on Jack Cardiff's equally impressive black-and-white drama *Sons and Lovers* (1960), based on D. H. Lawrence's novel.

For Russell, the opportunity to work on *Psycho* remained the high point of his career, as he was soon back at work in Universal's television department, lensing episodes of the series *Thriller* (1960–1961), many more episodes of *Alfred Hitchcock Presents* (but without Hitchcock at the helm), as well as *Wagon Train* (1964–1965), *McHale's Navy* (1962–1965), and *Kraft Suspense Theatre* (1964–1965). But the series for which Russell did the most work remained *Alfred Hitchcock Presents*, chalking up a total of seventy-five episodes as DP of the half-hour version and another twenty-one in its hour-long incarnation.

Meanwhile, New Wave filmmakers were showing that you didn't need much equipment to make a movie anymore; a typical crew could consist of a camera operator, a director, a script clerk, and perhaps a sound recordist. In some cases, you didn't need sets, or a studio, or traditional lighting set-ups, or props, or anything other than the daily essence of life

itself. Jean-Luc Godard's first feature film, *Breathless* (1960), caused an international sensation through its use of a free and direct style of shooting: the entire film was shot on actual locations with a handheld Éclair camera, using mostly natural light, with all sound post-synchronized. Of his work on the film, cinematographer Raoul Coutard, perhaps the greatest and certainly one of the most prolific of the New Wave cinematographers, said:

> The big idea was to do more realistic photography. No one had ever proposed shooting an entire fiction film handheld. Of course, we must not forget that there was no budget for the film, and it was considerably cheaper to shoot handheld, on location and without lighting. . . . I had no ideas about what cinema was. If I had known what was involved in shooting a handheld film without lighting, I would not have done it, because I would never have believed that I could do it correctly. (qtd. in Bergery 30)

Coutard's work on *Breathless* was revolutionary because he was doing the direct opposite of what classical cinematographers had been practicing

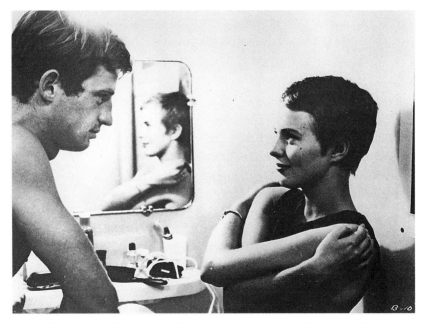

A scene from Jean-Luc Godard's *Breathless* (1960), with Jean-Paul Belmondo and Jean Seberg, photographed by Raoul Coutard

for more than sixty years—making a film with almost no artificial light at all. Wrote Bergery,

> Coutard did not employ artificial illumination in the film, save for two instances: in the hotel bathroom scene, a Photoflood was exchanged for a dim ceiling bulb; and the darkened newspaper office featured a few specially placed fixtures. Ironically, Coutard's initial contribution to the cinematographic look of the *nouvelle vague* can only be characterized as "anti-lighting," in combination with his free-flowing camerawork. . . . Every facet of the film radiates rebellion: Coutard's handheld camera, the location lighting, the pioneering use of jump cuts, the throwaway lines and carefree affect of both Jean Seberg (as American *femme* Patricia Franchini) and Jean-Paul Belmondo (playing petty pilferer Michel Poiccard). It is a tribute to Godard's vision that nearly 40 years later, the film's once-radical style appears completely contemporary. (30)

But, as Coutard pointed out, Godard's style of filmmaking was deceptively simple, and others would attempt to duplicate it at their peril.

> After Jean-Luc did his film, a lot of people thought that you could do anything with anyone and come out with a film. So there were a lot of cinematic experiments that turned out to be catastrophes. These imitators were forgetting that Jean-Luc was not just a guy with talent, he was a guy with genius. . . . He was the only director whom I could take risks with. If we tried something difficult, I would warn him that there might be a problem, and he would say, "Fine, let's try it anyway." I could be sure that if the result wasn't any good, we'd shoot it again. This allowed me to try things that I wouldn't have with other directors. (Bergery 30–31)

Yet it would be a mistake to think that all of the French New Wave filmmakers were so doctrinaire. Coutard, who rapidly became one of the movement's most popular cinematographers, remembered that working with the much more lyrical François Truffaut, things were much more relaxed and even somewhat formal. Coutard shot four films for Truffaut: the comic crime drama *Shoot the Piano Player* (1960), the marital tragedy *The Soft Skin* (1964), the effervescent *Jules and Jim* (1961), and the Hitchcock-inspired *The Bride Wore Black* (1967). *Bride* was the only film of the group in color; the rest were resolutely black and white. *Jules and*

Jim particularly stands out in this group, with its almost Daguerreotype cinematography, effectively evoking the era in which the film begins, pre–World War I Paris. Coutard commented that the CinemaScope sweep of the film—actually "Franscope," a French CinemaScope knockoff with a 2.35:1 aspect ratio—was more complex because

> we had more time and more money. Also, François had a *découpage* [shot breakdown], so it was actually possible to prepare the lighting scheme ahead of time [while noting that] François would tell you what he wanted in the frame, whereas Jean-Luc would tell you what he didn't want. When you're framing for Jean-Luc, you don't follow the character, you follow a curve. He didn't care as much what one saw as he did about the movement itself, whether it was a curve or a straight line. (Bergery 32)

But Godard and Truffaut weren't the only ones who were experimenting with the form and structure of the cinema during this period. Alain Resnais's deliberate, hypnotic *Hiroshima mon amour* (1959), photographed by Sacha Vierny and Michio Takahashi, uses the director's trademark "memory editing" to fill scenarist Marguerite Duras's tale of a man and a woman meeting in Hiroshima, which becomes a metaphoric examination of the effects of the atomic bomb detonation at Hiroshima, as well as personal histories of the two enigmatic protagonists. As Peter Cowie writes, the film explores

> the emotions of [an actress] of thirty-four [Emmanuelle Riva, known only as "Elle"], who, because the brutal war evidence at Hiroshima evokes her first love affair, confesses her tragedy to a Japanese architect [Eiji Okada, known only as "Lui"]. Love grows between them; but she refuses to sacrifice herself to it. She claims that forgetfulness is a stronger force and that she will forget the Japanese just as she has forgotten her first lover—a German soldier shot on Liberation Day—and as the people of Hiroshima have banished their memory of the atomic explosion in 1945. . . . The revolutionary style of the film is compounded of dexterous editing, music that is aligned unforgettably to each situation, and flowing shots that involve the spectator in the drama. (Cowie, *Seventy Years* 227)

Time is like a river in *Hiroshima Mon Amour*, in which the past and present are fused into one ineluctable whole, and the shifting tides of identity

and recollection alter with each passing, dreamlike sequence. Underscoring the multinational origins of the project, this French/Japanese co-production employed a gifted French cinematographer, Sacha Vierny, who would later photograph the equally enigmatic *Last Year at Marienbad* for Resnais in 1961, and still later Luis Buñuel's provocative *Belle de Jour* (1967), along with some seventy other films; and Michio Takahashi, an equally gifted Japanese DP who had labored in the film industry since the mid-1930s and had experienced World War II from his home country. And yet while the film is definitely a work of fiction, a documentary air clings to the narrative, as if we are witnessing actual events from the characters' past. With the events of World War II smoothly intercut with location shooting in Hiroshima, where Elle is working in an antiwar film, *Hiroshima Mon Amour* evokes and perhaps exorcises the horrors of World War II. But in the end, what seems to emerge is only more distance between the couple, despite their emotional attachment; in fact, they are not so much actual personages as metaphoric stand-ins for the opposing forces of France and Japan during the war. In the film's final moments, Elle and Lui reveal their true identities, in an exchange that is both mysterious and ominous.

ELLE: Hi-ro-shi-ma. Hiroshima. That is your name.
LUI: Yes, that is my name. Your name is Ne-vers. Nevers in France.

And on this deeply ambiguous note, the film ends. What's remarkable here is not only the fluidity and assurance of Resnais's constantly shifting mixture of past and present, as well as personal and national identity, but also the seamlessness with which Takahashi and Vierny's cinematography blends smoothly into one utterly coherent whole.

Truffaut's ineffably romantic first feature, *The 400 Blows* (1959), is a semi-autobiographical film based partly on events from Truffaut's own childhood. Antoine is a borderline juvenile delinquent whose home life is unsupportive and chaotic. He's a misguided intellectual, but his working-class mother and father have no idea how to cope with his precociousness, or with his continual disregard for authority. Eventually his parents have Antoine committed to a juvenile detention center. Discipline at the school is harsh; in one indelible scene, Antoine is brutally slapped across the face for a minor infraction. At the film's end, Antoine escapes and, in an extremely long tracking shot, runs away from the school, only to arrive

at the edge of the ocean. As he wanders the beach, pondering his next move, the image freezes, and optically zooms in on his face, creating an unforgettably haunting image of adolescent loneliness and resignation.

Henri Decaë, the cinematographer of *The 400 Blows*, offered a more romantic vision of life in his work than Raoul Coutard's hardheaded practicality. Born in 1915, Decaë served in the French Army during World War II and then took up work as a photojournalist and later a sound engineer and editor (Marie 87). After directing and shooting a few short films of his own, Decaë agreed to work with maverick director Jean-Pierre Melville on his 1949 Resistance drama *The Silence of the Sea*, on which Decaë served as photographer, editor, and sound mixer (Marie 87). The experience was so satisfactory for Melville that he asked Decaë to shoot his adaptation of Jean Cocteau's novel *Les Enfants terribles* in 1950, a much more ambitious project. Decaë then worked with Melville on his superb study of an aging gangster, *Bob le Flambeur* (1956), which remains one of Melville's most accomplished works.

This led to Decaë working for New Wave director Louis Malle on his first two feature films, the suspense thriller *Elevator to the Gallows* (1958), with a superb improvised jazz score by Miles Davis, and *The Lovers* (1958), and later for another New Wave icon, Claude Chabrol, the "French Hitchcock," on his first three features: *Le Beau Serge* (1958), *Les Cousins* (1959), and *Leda* (1959). With his success on all these films, Decaë was now much in demand, and his love of black and white, coupled with his speed on the set and preference for natural light, made him the ideal cinematographer for *The 400 Blows* (Marie 88). The film was shot almost entirely on location on a shoestring budget, in yet another French version of the CinemaScope process, Dyaliscope, using handheld cameras for much of the filming and wheelchairs and/or cars for dolly and tracking shots.

Michel Marie convincingly argues that Decaë's influence on the New Wave was considerable, as "a cinematographer who was willing from the start to adapt to the most precarious and audacious conditions of production; and it was he who liberated the camera from its fixed tripod. He made the New Wave possible [along with Raoul Coutard], backing up Melville, Malle, Chabrol, and Truffaut" (Marie 89). As Kenneth Sweeney writes of Decaë's work in *The 400 Blows*, "Decaë's extensive work on documentaries and industrials gave him a realistic aesthetic that was well suited to the tone of the film. Using the Dyaliscope anamorphic process,

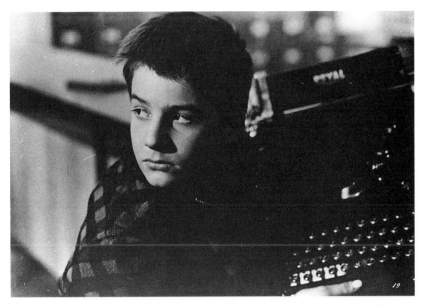

A pensive Antoine Doinel (Jean-Pierre Léaud) in François Truffaut's debut feature, *The 400 Blows* (1959), photographed by Henri Decaë

Decaë's work (much of it handheld and shot in very long takes) is particularly potent as he captures the contrasting urban textures of Paris, which is rendered as both romantic and alienating" (Sweeney).

Decaë's involvement with *The 400 Blows* shot him almost immediately to international prominence: the film was an enormous critical and commercial success and, along with Godard's *Breathless*, one of the most popular films of the French New Wave. Shortly after the film's release, Decaë moved into mainstream color features, such as René Clement's *Purple Noon* (1960), based on Patricia Highsmith's novel *The Talented Mr. Ripley*, and then to a wide variety of disparate projects from Jean-Pierre Melville's World War II drama *Léon Morin, Priest* (1961) to Serge Bourguignon's romantic drama *Sundays and Cybele* (1962); Roger Vadim's sex comedy *Circle of Love* (1964), based on Arthur Schnitzler's play *La Ronde* (which was filmed by Max Ophüls in a more faithful version under its original title in 1950); Anatole Litvak's World War II thriller *Night of the Generals* (1967); and other resolutely commercial projects.

It can clearly be said that by the end of his career, working in the United States on such films as Sydney Pollack's racing drama *Bobby Deerfield* (1977), Franklin J. Schaffner's neo-Nazi themed *The Boys from Brazil*

(1978), and Michael Ritchie's pulpy thriller *The Island* (1980), Decaë had moved away from a naturalistic style, but it can be stated with equal certainty that he is best remembered by both audiences and critics for his innovative work in the early days of the New Wave, where his determination to break all the existing norms of cinematography helped to create an entirely new language of film.

Other key figures of the French New Wave included Eric Rohmer, who worked with cinematographer Daniel Lacambre on one of his earliest films, *Suzanne's Career* (1963); Lacambre, oddly enough, soon after moved to the United States and began working on a long string of films for producer Roger Corman, such as Daniel Haller and Corman's *The Wild Racers* (1968), Stephanie Rothman's feminist horror film *The Velvet Vampire* (1971), and Lewis Teague's period crime film *The Lady in Red* (1979), quite the oddest trajectory of any of the early cinematographers of the New Wave. Rohmer worked with the previously discussed Nicolas Hayer on his more ambitious film *Le Signe du lion* (1962), which was produced by Claude Chabrol, but by the time of his first international hit, *My Night with Maud* (1968), Rohmer had abandoned black and white, which he seemed to use more for economic reasons rather than any aesthetic consideration, and was working in color with the gifted Nestor Almendros.

Similarly, Chris Marker made a stunning international debut after several documentaries with the dystopian science-fiction fable *La Jetée* (1962), told almost entirely through still photographs, shot by Jean Chiabaut and Marker himself. Marker went on to create the insightful documentary feature *Le Joli Mai* (1963), depicting the lives and social attitudes of everyday Parisians in May 1962 in the aftermath of the French/Algerian war, photographed by Étienne Becker, Denys Clerval, Pierre Lhomme, and Pierre Willemin (Lhomme shared co-direction credit on the film, as well). Marker himself photographed *The Koumiko Mystery* (1965) in Eastmancolor and supervised the multi-director protest film *Far from Vietnam* (1967), photographed and directed by a collection of filmmakers and cinematographers that included Godard, Marker, Resnais, Claude Lelouch, Willy Kurant, Denys Clerval, and a number of other influential figures, in color except for some archival footage of the Vietnam War itself. Marker went on to a long career as an "advocate documentarist," working almost exclusively in color and, at the end of his career, with color videotape.

Another important figure in the "documentary" New Wave cinema is the cultural anthropologist Jean Rouch, who made more than 100 features and short films documenting life in both France and, more problematically, colonial Africa. Among them was his feature-length *Chronicle of a Summer* (1961), in which everyday French citizens discuss their hopes and fears in light of then-contemporary social developments; the film was co-directed with Edgar Morin and photographed by Michel Brault, Raoul Coutard, Roger Morillière, and Jean-Jacques Tarbès. Rouch's most notorious work was *The Mad Masters* (1955), a thirty-six-minute 16 mm documentary shot in Accra, Ghana, presenting African tribal rituals in a matter-of-fact fashion that disturbed a number of more thoughtful viewers. Though Rouch always insisted that he let his subjects speak for themselves in his works, the very act of camera placement, shot structure, lighting, and later editorial intervention inevitably mediated his supposedly cinema verité projects. As Matt Losada incisively noted,

> When Jean Rouch traveled to Niger in 1954 to screen *Bataille sur le grand fleuve* [1950–1952] for its protagonists, the group of hippopotamus hunters who had never before seen a film did not naively marvel at the attraction, but instead criticized Rouch's use of music over the hunt, reasoning that, as he quotes, "the hippo has such sensitive ears that even under water they would hear the music and take off . . . during the hunt you hear nothing at all, or there's no hunt." He had decided to use the music "under the influence of the tradition of the Western," but now responded by throwing out cinematic norms and opening his work to improvisation in response to the voice of his subjects. The experience was, as Rouch later said, a revelation, "no doubt the most important moment of my career."

Rouch really didn't care whether or not he used black and white or color in his many films, just so long as a document could be produced that "accurately"—the term needs to be carefully quantified—showed the events unfolding before the camera. Further, despite his willingness to collaborate with others on his projects, Rouch remained something of a solitary individual within the more traditional film community, going so far as to tell one interviewer,

> Personally, I am violently opposed to film crews. My reasons are several. The sound engineer must fully understand the language of the people he is

recording. It is thus indispensable that he belong to the ethnic group being filmed and that he also be trained in the minutiae of his job. Besides, with the present techniques used in direct cinema, the filmmaker must be the cameraman. And the ethnologist alone, in my mind, is the one who knows when, where, and how to film, i.e. to do the production. Finally, and this is doubtless the decisive argument, the ethnologist should spend quite a long time in the field before undertaking the least bit of filmmaking. This period of reflection, of learning, of mutual understanding might be extremely long, but such a stay is incompatible with the schedules and salaries of a team of technicians. ("Jean Rouch")

Another key figure of the French New Wave in the mid- to late 1950s is Agnès Varda, who in many ways was the true progenitor of the movement. Varda's 1955 feature *La Pointe Courte* anticipates the experiments of Godard, Truffaut, Resnais, and her other compatriots by nearly half a decade; in its gentle, measured, elegiac study of a small fishing village, Varda tells multiple tales of everyday life and death in a direct, unadorned manner that is nevertheless deeply sympathetic to her protagonists. With austere, sculptural black-and-white cinematography by Louis Soulanes, Paul Soulignac, and Louis Stein, and its mix of real-life and staged narratives in a seamless flow of images—adeptly edited by Alain Resnais (many observers feel that it is on this film that Resnais began to develop his trademark "memory editing" technique, fusing the past and present together)—*La Pointe Courte* served as both an inspiration and springboard for those who followed Varda, though it is only recently that she has achieved any real measure of the attention that she deserves for her place in New Wave cinema history.

As Varda later remembered of making *La Pointe Courte*, "I'm always amused when people say that I'm the grandmother of the New Wave, because I made my first feature film in 1954. And I had wonderful luck, in that I knew absolutely nothing at all about film-making" (Cowie, *Revolution!* 25). For his part, Resnais agreed that inexperience was a virtue in the creation of the New Wave:

Agnès Varda and Jean-Pierre Melville were the first ones to say, in effect, "No, one does not need formal training to make a film." . . . In those days, there were amateur film societies that would meet once or twice a month and show films on 16mm, 9.5mm or 8mm. I would just play around at

weekends and shoot on 16mm, but not professionally. So when Varda called me, I jumped on my bicycle to her place, not far from where I lived. She showed me her rushes. I first said I couldn't do it, but she insisted. (Cowie, *Revolution!* 29–30)

And the choice was a good one; as Varda recalled,

Resnais was a very good editor. He said, "Editing is not like ironing a badly cut dress. It must honor the decisions initially made by the director." In other words, this was a quite slow and very special film, and he said, "The montage should respect your project," which is so unusual. . . . He has often said that the structure of *Hiroshima mon amour* owed something to the structure of *La Pointe Courte* because there were these two worlds. He helped me generously, he applied his intelligence to the film and he made a self-effacing, discreet montage where my project was concerned. (Cowie, *Revolution!* 30)

This sense of egalitarianism was essential to the New Wave, a world in which friends helped friends without any thought of payment or personal gain. And, of course, the films had a ready audience, hungry for something new in the cinema. As Varda noted, "There were an enormous number of film societies, and the audience that had learned to love the work of the older auteurs was ready also to discover new talents. Thus the New Wave was marked by the auteur theory, and not by studio factory production. On one side you had the cinéphiles, and the pack of critics, and on the other the originals, and I was among the originals" (Cowie, *Revolution!* 38).

Varda followed *La Pointe Courte* with several documentary shorts, but it wasn't until 1962 that Varda had the chance to direct the black-and-white "real time" feature film *Cléo from 5 to 7*, photographed by Paul Bonis, Alain Levent, and Jean Rabier, in which a young woman, the titular Cléo (Corinne Marchand), waits for the results of a diagnostic test for cancer during the film's telescoped two-hour time period, which Varda compresses into a tight ninety minutes. The film's somewhat jarring opening sequence, in which Cléo consults a tarot card reader, is shot in rather lurid, grainy color, as the film's main titles are superimposed over the action; when this brief section is over, it's a palpable relief to return to black and white.

But Varda, whose next major work, *Le Bonheur* (1965), was photographed in absolutely vibrant, "pop art" color that fairly explodes off the screen, seemed to be employing black and white in her first two films more for economic than aesthetic reasons, despite her early work as a still photographer. Varda's career as a director extends right up to the present, with such films as the harrowing tale of life on the road, *Vagabond* (1985), *The Gleaners and I* (2000), and *The Beaches of Agnès* (2008), all photographed in color, to which Varda seems deeply attracted.

The new lightweight 16 mm sync-sound equipment engendered a new series of free-wheeling documentaries in America, such as D. A. Pennebaker's film of Bob Dylan's first British tour, *Don't Look Back* (1967), shot in grainy black and white by Howard Alk, Jones Alk, experimental filmmaker and illustrator Ed Emshwiller, and Pennebaker himself. In addition, a series of equally gritty black-and-white cinema verité films by Albert and David Maysles, such as *Salesman* (1966), *With Love from Truman* (1966), and *What's Happening! The Beatles in the U.S.A.* (1964), were all shot with a handheld camera, no rehearsal, no sets, and no script. The attempt, as with all this sort of work, was to capture real life without interfering, to see what was going on in our daily lives, often—then—unobserved. As Albert Maysles noted, "People are people. We're out to discover what is going on behind the scenes and get as close as we can to what is happening."

In Britain as elsewhere, a sharp departure from the past was taking place, with such young filmmakers as Tony Richardson, Karel Reisz, Lindsay Anderson, Basil Dearden, and Joseph Losey deeply involved in what would become a genuine revolution in the cinema, and a direct response to the cultural and social repression that defined much of the 1950s. During the Cold War, Britain became a haven for American directors under attack from the House Un-American Activities Committee for supposed communist leanings. Losey was perhaps the most famous of these cinematic refugees, and other talented writers, directors, actors, and producers followed his example, among them screenwriter Ben Barzman, while director Jules Dassin fled to France.

As Rebecca Prime notes in her book *Hollywood Exiles in Europe: The Blacklist and Cold War Film Culture*, Losey, Barzman, and Dassin were not the only Hollywood figures who decided it was better to leave America than battle it out with the openly hostile HUAC. Though some, like Losey, managed to completely reinvent themselves and create work of

David and Albert Maysles shooting their groundbreaking documentary *Salesman* (1966), using a handheld camera, available light, and a portable 16 mm camera

lasting worth and brilliance, numerous others were plowed under by the effects of the Blacklist, and never really regained their footing either in Hollywood or abroad, such as director Bernard Vorhaus, who up until the late 1940s had enjoyed a promising career. Dassin managed to get his heist thriller *Rififi* (1955, d.p. Philippe Agostini) off the ground in Europe, but afterward he fell afoul of the *Cahiers* critics, who felt that he was deserting the grittiness he had displayed in *The Naked City* (1948, d.p. William Daniels), which was shot on location in New York.

While England offered some sort of sanctuary to these cultural refugees, all too often they were still forced to work under pseudonyms, for cut-price producers like Edward and Harry Danziger, churning out

episodic television programming to stay alive, whether as screenwriters or directors. Since they couldn't even use their own names, all their previous work counted for nothing as a bargaining chip, and they worked for pathetically small salaries as virtual unknowns, really starting all over at the bottom of the ladder. As Losey said of his work for the Danzigers, who prided themselves quite publicly on making the cheapest feature films and television series in the business, "Most of the time you couldn't rehearse, and you had to film the whole episode in a half day. I have no fond memories of the experience, which was simply a means to an end. Financially, I needed the work; that's really all I can say about it" (Prime 56).

It was in this atmosphere of cultural ferment that the British New Wave took shape. The cinematographers who brought this vision to the screen were every bit as iconoclastic as the directors who took the lion's share of credit for the films. Jack Clayton's *Room at the Top* (1959), for example, was shot by the incomparably gifted Freddie Francis, whose work as a clapper boy, then clapper loader, then assistant, and finally camera operator stretched back into the 1930s, and who was the camera operator on John Huston's *Moulin Rouge* (1952) and *Beat the Devil* (1953), among many other credits, finally earning his DP stripes with Julian Amyes's *A Hill in Korea* (1956), a Korean War drama featuring Stanley Baker, Robert Shaw, and a young Michael Caine. Soon Francis would become one of the most in-demand cinematographers of the British New Wave, with such films as Jack Cardiff's *Sons and Lovers* (1960), Karel Reisz's *Saturday Night and Sunday Morning* (1960), and Clayton's superb adaptation of Henry James's ghost story *The Innocents* (1961). Working most effectively in black-and-white CinemaScope, Francis almost singlehandedly defined the deeply shadowed yet crisply defined black-and-white imagery that epitomized the British New Wave, and he would go on to even greater triumphs in the 1960s. As Roger Manvell noted in *New Cinema in Britain*, however, there was an essential "theatricality" that still needed to be overcome:

> *Saturday Night and Sunday Morning* ... presented a realistic rather than
> a theatricalized picture of its subject [working-class life in Nottingham].
> There was no neat storyline, no carefully balanced assortment of characters;
> the film dealt very directly with a crucial phase in the experience of a high-
> spirited and hard-working boy who has neither the conscious ambition nor

the education to realize that he is in a dead-end job which makes little call on his innate ability. . . . This film . . . was the nearest to true social realism that the British feature film had yet reached. (116–117)

Oswald Morris, the cinematographer on *Look Back in Anger*, for whom Francis served as camera operator on several films, was older than many of his British New Wave colleagues, with a career stretching back to being a clapper boy on Albert Parker's programmer *After Dark* (1932). Morris rose through the ranks to become a clapper/loader, then an operator on numerous "quota quickies" (low-budget British films designed to meet government import requirements), before assisting the great DP Guy Green as camera operator on David Lean's production of *Oliver Twist*

Freddie Francis, left, in raincoat, lining up a shot on Jack Clayton's *Room at the Top* (1959)

(1948), which led to his first assignment as a director of cinematography, on Ronald Neame's adventure film *Golden Salamander* (1950).

As the New Wave rolled in, Morris instantly embraced the new sensibility of freedom the movement offered, and in rapid succession photographed Carol Reed's political satire *Our Man in Havana* (1959), from a novel by Graham Greene, shot partially on location in Cuba just as Fidel Castro was seizing power; Tony Richardson's *The Entertainer* (1960), which revitalized the career of the then somewhat sclerotic Laurence Olivier; and Stanley Kubrick's *Lolita* (1962), based on Vladimir Nabokov's notoriously scandalous novel.

The critic and filmmaker Lindsay Anderson was an early force in what he dubbed the British "Free Cinema" movement, a sort of subgroup of the British New Wave along with Richardson and Karel Reisz. Anderson tapped Walter Lassally to photograph the four-minute short *The Children Upstairs* (1955), produced as a public-service spot for the National Society for the Prevention of Cruelty to Children, which led to *Momma Don't Allow* (1955), one of the groundbreaking films of both the Free Cinema and British New Wave movements, documenting one night at the Wood Green Jazz Club with intense, participatory camerawork and striking immediacy. As Lassally later commented,

> The thing that Britain and France had in common was that the Free Cinema, or the films that followed Free Cinema, and the films of Chabrol and Truffaut in France represented an escape from "papa's cinema." If you look at earlier films from the fifties, they contain all the clichés of the working-class characters—they only appeared as comic relief, if at all. Studio people in Britain, the professionals, frowned on location-shooting and natural lighting. That barrier was broken in several countries pretty much at once, particularly in Britain and France. I remember a conversation I had once with Raoul Coutard where we agreed that these things occur more or less simultaneously, without one necessarily being influenced by the other: whether it was Lionel Rogosin in America, or us in Britain, or cinematographers like Coutard in France. (Cowie, *Revolution!* 56)

But as Lassally remembered, the big breakthrough came with the availability of sync-sound recording with, at first, a modified Arriflex camera and later the Eclair NPR, an amazingly lightweight camera that allowed almost instantaneous changing of 400' film magazines, essential in the

creation of any documentary. It also allowed for the possibility of simul-taneous sync-sound with a crystal-controlled Nagra tape recorder, all of which could be handled by two people, one for camera, one for sound. One could work with even less; as Lassally remembered, "On *Momma Don't Allow* in 1955, we used only a spring-wound Bolex 16 mm camera, so the maximum length of run was twenty-two seconds, so no shot could last longer than twenty-two seconds. It was done with a sort of primitive playback system, one might say, for the dance numbers. But all the actual syncing had to be done in the cutting-room" (Cowie, *Revolution!* 57).

Lassally became indelibly identified with this new spirit of freedom in British cinema, lensing such groundbreaking films as Edmond T. Gréville's *Beat Girl* (aka *Wild for Kicks*, 1960), one of the very earliest of the "swinging London" films, featuring the young stars Adam Faith, Shirley Ann Field, Oliver Reed, and Christopher Lee, with a superb jazz sound track by composer John Barry, performing with his group the John Barry Seven (seen in the film, as well as heard extra-diegetically on the sound track). In addition, he photographed three of Tony Richardson's films: the haunting and poignant *A Taste of Honey* (1961); *The Loneliness of the Long Distance Runner* (1962), a brilliant and disquieting film about juvenile delinquency and the class system in Britain; and, in color, *Tom Jones* (1963), adapted from the Henry Fielding novel and an enormous critical and commercial success. Lassally finally won an Academy Award for his black-and-white cinematography on Michael Cacoyannis's *Zorba the Greek* (1964), and went on to a long and distinguished career in the commercial and independent cinema, working almost entirely in color by virtue of economic necessity.

One of the foremost members of the British New Wave wasn't really a New Waver at all, or even British; he was Stanley Kubrick, a native of New York who began his career in the United States making resolutely independent films, having worked as a still photographer for *Look* maga-zine early in his career. From the start, Kubrick wanted total control over his films, and his first short, *Flying Padre* (1951), was a one-reel "RKO-Pathé Screenliner" running just nine minutes, which Kubrick directed and photographed. With his next short film, *Day of the Fight* (1951), Kubrick performed the same functions (albeit with an uncredited assist from Alexander Singer on camera) before embarking on his first feature, the war-themed *Fear and Desire* (1953), which he both directed and pho-tographed but subsequently disowned.

Pressing on, Kubrick shot and directed *Killer's Kiss* (1955), about a down-and-out boxer's doomed romance, and managed to get a solid theatrical release for the project. But with his narratively complex racetrack heist drama *The Killing* (1957), Kubrick ceded the cinematographer's chair to veteran Lucien Ballard while writing and directing the film himself, with dialogue by pulp writer Jim Thompson, based on Lionel White's novel *Clean Break*. This, in turn, led to the World War I pacifist drama *Paths of Glory* (1957), photographed by Georg Krause; his first color film, *Spartacus* (1960), where, as discussed, he took over from Anthony Mann to DP Russell Metty's intense displeasure; and then *Lolita* (1962), photographed by Oswald Morris. All were successful, but Kubrick was just warming up for the major period of his career.

By the early 1960s, Kubrick had famously left the United States to work exclusively in England, and his next film, the nightmare comedy *Dr. Strangelove: or How I Learned to Stop Worrying and Love the Bomb* (1964), is perhaps his most accomplished work, and his last film in black and white. Photographed by Gilbert Taylor, *Dr. Strangelove* depicts a cold, antiseptic world with suitably fantastic set design by Ken Adam (who went on to design many of the James Bond films), in which the shadow of nuclear destruction hangs over each scene of the production, as the certifiably insane General Jack D. Ripper (Sterling Hayden) orders an all-out attack on the Soviet Union to protect the United States' "purity of essence." The film alternates metallic grays in the wide shots of the war room—a superb set by Adam—with grainy newsreel-style cinematography as U.S. soldiers attack Burpelson Air Force Base, General Ripper's domain, in a vain attempt to stop Armageddon.

The film ends with a bizarre rant by the title character, Dr. Strangelove (Peter Sellers, who plays three roles in the film), presenting various scenarios of post-apocalyptic survival, only to be cut off by the activation of a Doomsday Machine, which detonates sufficient nuclear explosives to destroy the entire planet. We see a montage of mushroom clouds as the World War II pop hit "We'll Meet Again" accompanies these final (in every sense of the word) images. In its merciless examination of mindless warrior culture and its excoriation of the cultural emptiness of American consumer society, *Dr. Strangelove*'s ominous, glittering, deathly pallor is specifically suited to monochrome, and while such subsequent Kubrick films as *2001: A Space Odyssey* (1968) and *The Shining* (1980) are equally impressive in their own fashion, they seem overstylized in a way that

Dr. Strangelove, with its compact running time and unobtrusive mise-en-scène, is not. As director of cinematography Gilbert Taylor noted, *Dr. Strangelove*

> was at the time a unique experience because the lighting was to be incorporated in the sets, with little or no other light used. Lighting that set [the war room] was sheer magic, and I don't quite know how I got away with it all. Much of it was the same formula based on the overheads as fill and blasting in the key on faces from the side. [Taylor shot most of the scene depicting U.S. Army forces storming Burpelson Air Force Base himself, working with Kubrick.] Stanley could handle a camera, so I told him, "For all this war stuff, we'll both put on battle dresses and take Arriflexes into the action. We'll film it just like combat cameramen" . . . [Taylor ordered] a lot of special film stock that was not fully panchromatic and was originally used by the military for copying documents. It was very contrasty, and I only later found out how slow it was—the specs I'd been given were completely wrong! But the scene looks great. (Williams, "Gilbert Taylor")

Working with Roman Polanski on *Repulsion* (1965), however, was a very different matter. Although Polanski wanted Taylor on the project, Taylor wasn't all that impressed with Polanski's previous work.

> Roman had only made one feature, *Knife in the Water* [1962, d.p. Jerzy Lipman], which I thought looked absolutely dreadful. It was very wishy-washy, no real blacks at all. So when he saw the kind of image I could give him, he was impressed. He said, "I never knew you could get photography like this!" [Much of the action of *Repulsion* takes place in a seedy apartment.] We had it built onstage, of course, and lit primarily through the windows—Brutes, often fully spotted, just blasting in. A few hidden lamps on the floor bouncing into the ceiling completed the lighting. It was very extreme. I shot much of the film with a handheld Arriflex with a very wide lens and a tiny tobacco tin on the front fitted with a wee bulb to add a bit of fill, just enough to see Catherine Deneuve's skin in the shadows until I moved in close. (Williams, "Gilbert Taylor")

Though the British New Wave was already becoming a thing of the past by 1964, Britain was still home to some truly original and innovative black-and-white New Wave projects, such as Karel Reisz's *Morgan—A*

Suitable Case for Treatment (1966, d.p. Larry Pizer), Silvio Narizzano's *Georgy Girl* (1966, d.p. Kenneth Higgins), and Jonathan Miller's intoxicating version of *Alice in Wonderland* (1966, d.p. Dick Bush). As Taylor remembered shooting *A Hard Day's Night* (Richard Lester, 1964),

> We basically had to make it up as we went along. The only thing set was the music; the rest we had to invent daily! . . . [For a scene in a railway station] there was very little lighting of any sort, as the authorities would not allow us to control the station in any way. We also had a very limited budget and couldn't afford generators, so any fill was coming from a small, handheld, battery-powered lamp. They wouldn't have let us bring generators or cables onto the platform anyway. We took a real train journey with little or no extra lighting, just a little 4K generator to power some lamps in the ceiling, tracking down the corridors on roller skates and such. The raw quality of the shoot was there onscreen, and [director] Dick [Lester] was amazed at our rushes. (Williams, "Gilbert Taylor")

In Germany, the cinema was still recovering from the effects of the war, but Jean-Marie Straub and Danièle Huillet's work offered an early clue to a new direction. Straub and Huillet formed one of the few husband-and-wife production teams of true equality. Together they created some of the most demanding and interesting films of the 1960s and 1970s, beginning in 1963 with their short film *Machorka-Muff*, photographed by Wendelin Sachtler. Straub ran a local cine-club in his birthplace of Metz, France, and later worked in various assistant capacities for such directors as Jean Renoir, Abel Gance, and Robert Bresson, all of whom had an enormous influence on his work.

Straub and Huillet met in 1954 in Paris and immediately became artistic partners. In 1958 Straub, fleeing conscription into the French armed forces, moved to Munich, Germany, with Huillet, where they became involved with radical theater groups. Among Straub's early collaborators was Rainer Werner Fassbinder, who appears in Straub's short film *The Bridegroom, the Comedienne, and the Pimp* (1968, d.p. Hubertus Hagen and Niklaus Schilling). The movie combines the story of the murder of a pimp (Fassbinder) with a drastically condensed theatrical piece and a lengthy tracking shot from an automobile of prostitutes plying their trade on an ill-lit German thoroughfare. Perhaps the couple's most famous early film is *The Chronicle of Anna Magdalena Bach* (1968, d.p. Ugo Piccone),

Harpsichordist Gustav Leonhardt as Johann Sebastian Bach in Jean-Marie Straub and Danièle Huillet's *The Chronicle of Anna Magdalena Bach* (1968), photographed by Ugo Piccone

which the directors shot on actual locations of Johann Sebastian Bach's life, featuring Gustav Leonhardt, the renowned harpsichordist, as Bach, and Christiane Lang, also a classical musician, as Anna.

With period instruments borrowed from various museums for a historically accurate sound, as well as costumes and props gleaned from a variety of private collections for added authenticity, the film nevertheless almost collapsed before production. Huillet and Straub insisted on recording all the sound live on location, eschewing the use of any post-dubbing, to get the most natural and authentic performances from the ensemble of excellent musicians they had assembled, as well as to re-create the original acoustics. But this horrified the original backers, who withdrew their funding a few days before shooting was to begin. At the last possible moment, Jean-Luc Godard came through with emergency funding, but the reduced budget meant that the film had to be shot in black and white rather than in color, which the directors would have preferred. Nevertheless, *The Chronicle of Anna Magdalena Bach* was a surprise hit at the 1968 New York Film Festival and remains a stunning artistic achievement.

Elsewhere in Europe, similar waves of experimentation were taking place. Michelangelo Antonioni's early black-and-white films made a considerable impact not only in his native Italy, but throughout the world, particularly his epic *L'Avventura* (1960, photographed in appropriate drab, gray tones by Aldo Scavarda), in which a group of bored, rich friends go on a day trip to a nearby island during which one of the party, Anna (Lea Massari), mysteriously disappears. In the opening third of the film, we are led to believe that Anna will be one of the central figures in the film, but when she seems to vanish on the island with no explanation, the other characters begin to question whether or not she was even with them at all, even as Anna's boyfriend, Sandro (Gabriele Ferzetti), and her best friend, Claudia (Monica Vitti), drift into a transient romance.

By the film's end, we seem to know these people even less than we did when the film began, and Anna's disappearance is never explained. The film divided critics and audiences around the world, with critic Pauline Kael famously calling it "the film that changed the language of cinema"—a tagline the film's distributors soon adopted for promotional materials, but although this was certainly Antonioni's most ambitious exploration of alienation and ennui up to that time, it was certainly not new territory for the director. As Antonioni observed of his films during the early 1960s,

> Fellini forces reality, Visconti dramatizes reality; I try to *undramatize.*
> . . . My films are in search of things that are current, specific, burning.
> . . . I wanted to analyze the sentiments as they are today; sentiments and
> emotions—loves, regrets, states of feeling—change, just as science and
> technology change. . . . I did not make the film to demonstrate a thesis. . . .
> I see my films as narratives, *romans par images.* . . . In all my films I think
> I have eventually developed the same theme—the fragility of sentiments.
> . . . We live in an age where nothing is stable any more. Even physics have
> become metaphysical. Everything is changing. Why don't we like to admit
> that the psychology of people is also changing? (Manvell, *New Cinema in
> Europe* 38–39)

Another key figure in the Italian cinema of the 1960s was Pier Paolo Pasolini, who rapidly made a name for himself with a series of caustic, iconoclastic feature films, such as *Accattone* (1961) and *The Gospel According to St. Matthew* (1964), both photographed by Tonino Delli Colli.

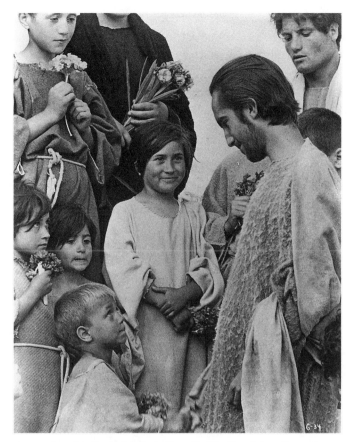

A scene from Pier Paolo Pasolini's neorealist *The Gospel According to St. Matthew* (1964), photographed by Tonino Delli Colli, with nonprofessional actor Enrique Irazoqui as Christ

Gospel is essentially a newsreel-style, handheld, "you are there" version of the life of Christ, played by nonprofessional Enrique Irazoqui. The film takes care to depict Christ not so much as a gentle redeemer, but as a force for revolutionary social change. Of working with Pasolini, Delli Colli later said,

I knew he was good, even if he didn't have a technical knowledge of cinematography at the start. When we started *Accattone*, I had to explain to him what lenses were. But after three weeks—and I do mean three weeks—he understood it all. He was happy right away with the 50mm lens because the performers could be seen clearly, even though the backgrounds were closer

and [looked] a little squashed. He said that was all right with him because everything was more concentrated. Ultimately, he came to the set in the morning with his apertures, which were fairly poorly specified but were the right ones, and he worked quickly. He had planned everything the night before; he knew whether he wanted a full shot or something else. He did that for the first two films. Then things took off from there. (qtd. in Heuring and Gallotti 39)

Pasolini's Christ is a deeply angry ambassador of heavenly tidings; for most of the film, his image is grim and uncompromising; he smiles only when surrounded by children, whose innocence inspires hope for the world. As Delli Colli said, "I really liked working with black-and-white, and I have to say that we got better results and more satisfaction from our work in comparison to color" (qtd. in Heuring and Gallotti 36).

Starting as an assistant, then a camera operator, and finally a director of cinematography at Cinecitta from 1938 onward, Delli Colli is notable not only for his superb black-and-white work, which changed to accommodate the vision of each new director he worked with, but also for his later, expansive color work with director Sergio Leone. In his black-and-white period, his major successes include the Pasolini films just cited, as well as Pasolini's *The Hawks and the Sparrows* (1966); in the same year, however, he photographed *The Good, the Bad, and the Ugly* for Sergio Leone, creating an entirely different visual style for his color work, which he continued on Leone's epic *Once Upon a Time in the West* (1968), and numerous subsequent films in color. Of all the cinematographers in this volume, Delli Colli seems to have made the shift to color with the greatest ease and satisfaction, but then again, by the mid-1960s, he really had no choice—color film had become a financial necessity, not only to lure viewers into the theater, but also to ensure resale of the film to television, which by the mid-1960s had converted almost entirely to color. Delli Colli summed up his approach by reasserting his desire for both authenticity and simplicity, to react to the material presented to him in an instinctive and natural way:

I've always tried to illuminate the stories being told using the simplicity of my feelings and the instinct that has guided me, that's a part of me, with no irritations or exasperations. A better way to put it might be that I've never used preconceived formulas to get a certain result. Instead, I've always

worked with the human and technical material that was available, and with the imagination and intuition of the moment.... I've met great professionals who have allowed me to express myself as best I can through images. If anyone asks me how I created my films technically, I always tell them to go to the theater and watch them again, because everything is right there. The magic of film can't be put into words. (Heuring and Gallotti 44–45)

Federico Fellini's directorial debut was *Variety Lights* (1950), photographed by Otello Martelli, beginning a partnership that would last for much of Fellini's black-and-white period of work. Martelli, who had worked in the Italian film industry since 1919 with Roberto Roberti's short film *La contessa Sara* as his first credit, worked steadily through the silent and early sound era on such projects as Marino Camerini's comedy *I'll Give a Million* (1935), starring a young future director Vittorio De Sica. Martelli survived the Mussolini era, conscientiously working on various genre projects until the regime collapsed, later teaming with Roberto Rossellini on the neorealist *Paisan* (1946), with Giuseppe De Santis on the equally uncompromising drama *Bitter Rice* (1949), and with Rossellini again on the brutal marital drama *Stromboli* (1950), starring Ingrid Bergman.

Martelli also served as one of three cinematographers—the others being Carlo Carlini and Luciano Trasatti—on Fellini's *I Vitelloni* (1953), about a group of layabouts in a small town who can't seem to embrace either change or the onset of adulthood; he also photographed Fellini's tragic road movie *La Strada* (1954), in collaboration with an uncredited Carlo Carlini. But these were all mere curtain raisers for Fellini's 1960 masterpiece *La Dolce Vita*, on which Martelli alone served as director of cinematography, a modern-day tale of the relentless fall from grace of Roman gossip columnist Marcello Rubini (Marcello Mastroianni), who writes for the sleaziest Italian dailies. Epic in length and scope, *La Dolce Vita* perhaps better than any other film of the early 1960s accurately predicts the rise of throwaway celebrity culture, and invented the word "paparazzi" (after the character Paparazzo [Walter Santésso], an ultra-ambitious scandal photographer who will stop at nothing to get images that will titillate Marcello's numerous readers).

Running three full hours in its original length (later cut to 174 minutes for international release) and scrupulously shot in black-and-white 2.35:1 "Totalscope" (yet another anamorphic CinemaScope knockoff), *La*

Marcello Mastroianni and companions in Federico Fellini's 1960 masterpiece *La Dolce Vita*, photographed by Otello Martelli

Dolce Vita was both a warning and a document of an era in which human tragedy would be relentlessly exploited for profit, as notoriety replaced notability in the public's mind. But *La Dolce Vita* was Fellini's penultimate black-and-white film (his last being the semi-autobiographical *8 1/2* [1963, d.p. Gianni Di Venanzo]), and the dazzling color cinematography of Fellini's *Juliet of the Spirits* (1965, d.p. Di Venanzo) was an altogether different proposition from his hard-edged monochrome universe.

One of the most kinetic and controversial monochrome films of the 1960s is Gillo Pontecorvo's *The Battle of Algiers* (1966), photographed in resolutely newsreel style by Marcello Gatti. Gatti's other works include Nanni Loy's war drama *The Four Days of Naples* (1962), Roman Polanski's bizarre comedy *What?* (1972), the frankly exploitational *Bastard, Go and Kill* (Gino Mangini, 1971), and Paolo Cavara's horror film *Black Belly of the Tarantula* (also 1971). But on *Battle of Algiers*, Gatti had a chance to create something truly remarkable and he rose to the occasion, making

a staged narrative seem so real that many viewers mistook the film for a documentary. As Peter Cowie writes,

> Marcello Gatti's hand-held camerawork persuade[s] us that we [are] watching a documentary, not a reconstruction, and the acting, in particular by Jean Martin as the French colonel and by Brahim Haggiag as the revolutionary Ali La Pointe, present[s] both sides of the conflict in tones of unprejudiced, unvarnished plausibility. The fanatical efficiency of the female bombers still shocks an audience at a time when suicide attacks are a regular occurrence in the Middle East. (*Revolution!* 171)

The film was so realistic that it was screened by the Pentagon to present officials with a textbook example of how terrorist groups act against those who would oppose them. Of all the political films of the monochrome era, the essentiality of the medium was never more effective than in *Battle of Algiers*, a film that could only have been made in black and white.

During this period, film in Eastern Europe, with a few exceptions, such as Milos Forman and his colleagues' work in Czechoslovakia, lagged far behind what was happening in the rest of the world, if only because of cultural isolation. But in Poland, the situation was markedly different. Part of this, of course, is attributable to the influence of the famed Łódź Film School, more properly known as the Leon Schiller National Higher School of Film, Television, and Theater, founded on March 8, 1948. The Łódź Film School produced two Academy Award–winning live-action directors, Roman Polanski and Andrzej Wajda, one Oscar-winning animation director, Zbigniew Rybczyński, and the noted cinematographers Paweł Edelman, Jerzy Lipman, Sławomir Idziak, Piotr Sobociński, and Dariusz Wolski, among many others.

In Wajda's films, such as the brutal World War I drama *Kanal* (1957), the "Warsaw" segment of his omnibus film *Love at Twenty* (1962), and the epic 234-minute film *The Ashes* (1965), set during the Napoleonic wars, one can easily see that the Łódź graduates were after a much more flat, "undramatic" look than the brightly suffused bounce lighting that Gilbert Taylor favored. Throughout the 1960s, the Polish cinema remained a vibrant alternative force—almost a response—to the New Wave in Britain and France, as evidenced by such films as *Mother Joan of the Angels* (1961), directed by Jerzy Kawalerowicz and photographed by

Jerzy Wójcik, which won the Special Jury Prize at the 1961 Cannes Film Festival; *The First Day of Freedom* (1964), directed by Aleksander Ford, photographed by Tadeusz Wiezan, and entered into the 1965 Cannes Film Festival; and Jerzy Skolimowski's *Barrier* (1966), which he completed while still a student at the Łódź school, with superb cinematography by Jan Laskowski.

Yet one of the most influential black-and-white cinematographers of the 1960s was, ironically enough, an untrained amateur who taught himself how to use the camera from the ground up, essentially reinventing the art of cinema in the process. Though he worked primarily in the "underground" cinema, his work came, in time, to define New York City in the 1960s. His name was Andy Warhol. While many film historians have chronicled Warhol's substantial career as a filmmaker in New York in the 1960s, the precise details of his working methods during this period are worthy of sustained examination. Warhol's film style was an individual and highly idiosyncratic affair, but at his best he created films of real intellectual interest, quickly and cheaply, using whatever materials were readily available.

In July 1963, Gerard Malanga and the poet Charles Henri Ford took Warhol to buy his first 16 mm camera, a Bolex. Warhol, who knew

Gerard Malanga and Andy Warhol, at the start of Warhol's prolific career as a filmmaker

nothing about cameras, relied on Malanga to pick out a suitable machine. They went to Peerless Camera on 47th Street, where Warhol paid $500 for a device that could hold only a 100-foot spool of film, good for about three minutes onscreen. Malanga advised Warhol to purchase an electric motor for the camera, capable of powering through an entire roll of film in one burst. As always, Warhol wanted everything to be as simple as possible. The object in all his work was mass production with minimal effort.

In November 1963, Warhol and Malanga moved into the most famous of the Warhol Factory studios, a fourth-floor loft at 231 East 47th Street, where the only way to get up there was an old and painfully slow freight elevator. All day long at the Factory, rock 'n' roll and opera blasted out of a cheap portable phonograph, as Warhol, always the first to arrive and the last to leave, continued to crank out paintings, graphics, and sculptures at an incredible pace. Malanga assisted him in turning out the silkscreen canvases that supported the Factory's decidedly chaotic lifestyle. People drifted in and out at will. Warhol welcomed nearly everyone who came, putting them to work on various projects.

Under Warhol's direction, Billy Name (Billy Linich) began covering everything in sight in the new Factory—the walls, the doors, the ceiling, even the toilet—with silver paint and aluminum foil. Warhol was lionized by Hollywood and New York pop society, and the Factory became an endless party zone. There was always time to dance or invite a visiting celebrity over for a "screen test." Dennis Hopper, Peter Fonda, Jane Fonda, Troy Donahue, and other young pop celebrities of the period would drop in unannounced. Warhol filmed each new visitor with his Bolex.

Film was cheap. A 100-foot spool of black-and-white film cost four dollars; processing was another six dollars. Color film cost roughly twice that. Warhol bought film in bulk and shot anything that seemed of interest. Fascinated with the Hollywood star system, Warhol began his major period of work as a filmmaker. For the time being, the painting supported the film work, which showed no immediate sign of making any profit. Warhol started an aggressive campaign to "reinvent" the history of the cinema, beginning with a series of 100-foot 16 mm portraits of the famous and near-famous, including Allen Ginsberg, Donovan, Lou Reed, and Bob Dylan.

This led to early films such as *Eat* (1963), forty-five minutes of artist Robert Indiana meditatively eating a mushroom; *Haircut* (1963), in which Billy Linich administers a haircut to a Factory regular; and

eventually *Sleep* (1964), documenting roughly six and a half hours of poet John Giorno peacefully slumbering. During this period of his work, Warhol also created a number of films composed of 100-foot reels strung together, including *The Thirteen Most Beautiful Boys* (1964). The first Factory "superstars" appeared: Bob Olivo (aka Ondine), Baby Jane Holzer, Bridget Berlin, and Malanga, who stepped into *Kiss* (1963) as a substitute player at the last minute, when a scheduled "actor" failed to show.

However, the Bolex camera was a problem. It was too small and didn't hold enough film. Also, it couldn't record dialogue during the shooting, and Warhol was becoming more interested in doing staged movies. After shooting *Empire*, his eight-hour homage to the Empire State Building in 1964 with a rented Auricon camera, Warhol was struck with the ease of using the machine. The Auricon could shoot thirty-five minutes of film in a single take. If one ran the film at silent speed, sixteen frames per second, that thirty-five-minute reel became fifty minutes; in addition, the Auricon was capable of recording sync-sound during filming.

The optical sound track was recorded directly on the film, eliminating the need for editing, titles, or post-production. The sound quality was terrible, but Warhol didn't care. It was fast, cheap, and, above all, easy to use. Warhol decided to buy an Auricon, and once again Malanga went around to the various rental houses with Warhol, looking for a used model for a reasonable cost. They finally found a machine at F&B Ceco on 43rd Street for $1,200, and Warhol was truly launched as an independent feature filmmaker.

Almost immediately, Warhol began turning out an enormous number of sync-sound feature films, a rarity at the time in the world of avant-garde cinema. The average cost of a Warhol production was $200 for a seventy-minute black-and-white film. Such films as *Harlot* (1964), *Poor Little Rich Girl* (1965), and *Suicide* (1965) followed one after another in rapid succession.

Other Warhol films during this period included *Camp* (1965), best described as a broken down variety show. *Camp* features "performances" by Jack Smith and transvestite Mario Montez, with Malanga as master of ceremonies. *The Life of Juanita Castro* (1965) stars Marie Menken and consists of a long series of monologues, in which, according to Warhol's press release, "Juanita criticizes her brother's regime, and condemns the infiltration of homosexuality into their lives."

Since Warhol released practically everything he shot, he was never at a loss for willing participants to appear in his films. One of the most famous of Warhol's films during this period is his production of *Vinyl*, scripted by Ron Tavel from the novel *A Clockwork Orange* by Anthony Burgess. The film was originally titled *Leather*, but Warhol changed it at the last minute, "because *Vinyl* is more plastic." Malanga played the lead role of a juvenile delinquent who goes through forced "reconditioning" after a crime spree; Tavel named Malanga's character "Victor, the Victor."

The other actors were cast very quickly from the usual crew of Factory regulars. Edie Sedgwick, who had just arrived at the Factory a few days before, was hurriedly put in the film as an extra. Edie sits on a steamer truck to the right of the frame, idly smoking a cigarette. John McDermott appears as the cop who busts Victor after a brief crime spree. The doctor who "reforms" Victor is played by Tosh Carillo, while Ondine, later famous for his portrayal of the "amphetamine Pope" in *The Chelsea Girls* (1966), appears as Victor's sidekick, Scum Baby.

Vinyl was shot in April 1965 just before Warhol's departure for Europe, where he had a show at the Sonnabend Gallery in Paris. Warhol shot the film so quickly—in less than three hours—that none of the actors had adequate time to rehearse, but this gave Warhol the rough look he was aiming for. As usual, the filming became yet another excuse for a party. A number of art world insiders were invited to witness the shoot, turning the atmosphere around the production into an astutely staged media event. Both the *Herald Tribune* and Fred McDarrah of the *Village Voice* were ready with cameras in hand.

In 1966, Warhol began the production of what was to be later known as *Chelsea Girls*, the three-and-a-half-hour split-screen feature that was his first real commercial success as a filmmaker. Warhol shot various reels of Eric Emerson doing a striptease, Nico playing with her son, Ari, and Bridget Berlin talking on the phone in various rooms of New York's Chelsea Hotel. Some reels were shot in color; most were black and white. The shooting continued through the summer of 1966, and Warhol picked up the pace of production, shooting a thirty-five-minute reel of film nearly every other day. The filmmaking process appealed to Warhol because of its ease and immediacy. As soon as a good reel of film had been shot, Warhol would screen it at the Filmmakers' Cinematheque, located in the basement of the now-demolished Wurlitzer Building on 41st Street.

Warhol was still shooting *Chelsea Girls* as late as September 9, 1966, yet the first public performance of the film took place only a few days later on September 15. Production at the Factory was still a haphazard affair. During the shooting of Ondine's sequences as the "Pope" hearing the confessions of some Factory regulars, Warhol failed to notice that the microphone wasn't plugged in properly; as a result, the initial ten minutes of the first reel are completely silent. Warhol printed the reel anyway, incorporating it near the end of the film. In addition to production difficulties, Warhol was also rather lax in preparing his films for exhibition. The day before *The Chelsea Girls* premiered, Warhol was still getting the reels printed up for the first screening.

After Warhol was shot and nearly killed by Valerie Solanas on June 3, 1968, he drastically curtailed his filmmaking and silkscreen painting. Yet his first films, made under primitive conditions and nonexistent budgets, are as resonant today as when they were first produced and deserve to be viewed, and re-viewed, as some of the finest film work created during the turbulent 1960s, an index of the social, political, and sexual concerns of the era. At the time, many observers dismissed Warhol's films as mere stunts, but since his death in 1987 it's become manifestly clear that, for all his eccentricities, Warhol was absolutely serious in his interest in cinematography, particularly black and white, the medium in which he created his best work. Bold, striking, deeply saturated, and shimmering with menace, Warhol's monochrome visions of the 1960s arguably tell us more about the reality of the decade than most commercial films.

Meanwhile, in Hollywood, the march toward an all-color world continued. John Frankenheimer, whose best films such as *All Fall Down* (1963, d.p. Lionel Lindon), *Birdman of Alcatraz* (1962, d.p. Burnett Guffey, having replaced John Alton), and *The Manchurian Candidate* (1962, d.p. Lionel Lindon) are inarguably in black and white, told the *New York Times* in 1961 that "color films should be confined, almost exclusively, to musicals and travelogues." But Frankenheimer was just getting warmed up on the subject:

> Color generally ruins good drama. It tends to convert drama into travelogues. There are exceptions, of course. There is no doubt that color will help a fine western such as *Shane*. It also improves a few spectaculars such as *Ben-Hur*. But as a rule, the director, given color, is tempted to start shooting scenery rather than scenes. I realize that my attitude toward color in movies

is considered heresy in Hollywood. But too many movies are over-produced today by American moviemakers. They ruin dramatic intent with their color and wide-screen processes. In so many of the expensive color movies made by Hollywood the [cinematography] is terribly uninteresting. (Schumach 29)

But as Frankenheimer knew, change was in the air. In the early 1960s, there was still the possibility of working in black and white in Hollywood if one could make a strong enough case, or if budget constraints were a factor, but otherwise audiences now demanded color even for the most quotidian films, as they had increasingly since 1939 with *The Wizard of Oz* and *Gone with the Wind*. Who could imagine Michael Anderson's *Around the World in 80 Days* (1956, d.p. Lionel Lindon) in monochrome? After all, as Frankenheimer so aptly put it, it was the scenery in that film that often was of more interest than any given scene.

Thus in Hollywood the die was cast. Conrad Hall, the distinguished cinematographer of such films as Richard Brooks's *In Cold Blood* (1967), one of the last major studio films in black and white, was deeply distressed by the passing of monochrome as a viable commercial medium, telling Michael Shedlin that his work on Stuart Rosenberg's *Cool Hand Luke* (1967), for one possible example, "would have been more realistic, more dramatic, in black and white. . . . I prefer black and white for telling a story. . . . Color has a tendency to be very unreal, to detract from the story. Whereas with black and white, there's no way to detract, once you accept it, which is right at the beginning" (Shedlin 6).

Haskell Wexler has the distinction of having photographed the last monochrome film to receive the Academy Award for Best Black and White Cinematography, Mike Nichols's adaptation of Edward Albee's play *Who's Afraid of Virginia Woolf?* (1966). As Wexler remembered,

We shot completely in sequence. So I would light one corner of the room, shoot the scene, then tear that down, pull a wall down and shoot in the opposite direction—knowing that three days later I had to shoot back in the same corner of the room. This meant I had to match everything precisely, so that I would have to know how many foot-candles were on the corner of the bookcase, that I had a baby with a double open end, and a stick going through—I knew all the books in the bookcase. It was complicated, and I wasn't used to complications, of that kind . . . [but] Mike has an uncanny understanding, since he understood the play so well, of when he wanted to

be how close, which is awfully important for a director. (qtd. in Callenbach and Johnson 9–10)

The elegiac, measured style of *Virginia Woolf*—especially since it is shot in black and white—assures that the film will be screened only sporadically on contemporary television, if at all, as Wexler noted in a 1994 interview:

> The pressure, particularly in television, is the commercial obligation: that is, the obligation of the television show is to keep you from switching the channel, from turning it off, talking to your wife, or going to the bathroom. Its purpose is to keep you there for the commercial, and when you have that obligation, which is the obligation of all television, including the news— you've got to jazz 'em, you've got to keep 'em—that's what runs the images of television. (Lew-Lee 11)

And in such a jazzy, rapid-cut world as commercial television, where the "wow" factor depends so much on rapid cutting and bursts of explosive color, black and white seems out of place, precisely because it requires the attention and the participation of the viewer. Color was no longer an "event"—it was the new standard of presentation, and black-and-white cinematography seemingly vanished overnight.

Epilogue

● ●

The watershed year for the end of black and white as a regularized production medium was 1965; in that year, Universal Pictures mandated that henceforth, all production of both television and theatrical features would be in color. Three-strip Technicolor's lock on film production had ended with the adoption of single-strip Eastmancolor film, and suddenly color was as easy to shoot as black and white, perhaps easier. One of Universal's last monochrome features was William Castle's macabre thriller *The Night Walker* (1964), photographed by Harold E. Stine in solid, bracing tones, before the studio abandoned black and white as a matter of policy, and all the other majors followed. At Paramount, John Frankenheimer's study of aging and the search for youth, *Seconds* (1966), shot in gritty black and white by DP James Wong Howe, was an ambitious film and a potential game-changer for star Rock Hudson, cast against type as a "reborn" corporate drone; but later that year Frankenheimer switched to color, working with Lionel Lindon on *Grand Prix* (1966), and never looked back.

In Europe the story was much the same. Jean-Luc Godard and Raoul Coutard collaborated on the brilliant, black-and-white science-fiction parable *Alphaville* in 1965, and in the same year Godard also directed his monochrome study of youth in crisis, *Masculine/Feminine*, with the German cameraman Willy Kurant, but by 1966 he was shooting two films practically simultaneously, *Two or Three Things I Know about Her* and

Director Jean-Luc Godard, who with cinematographer Raoul
Coutard changed the grammar of cinema

Made in U.S.A., both with Coutard as the cinematographer, and both in
color. François Truffaut also switched to color for his English-language
adaptation of Ray Bradbury's *Fahrenheit 451* in 1966, shot in England by
the gifted cinematographer Nicholas Roeg, and soon everyone followed
suit. Black and white was now a commercial liability.

Television programming moved to all-color around the same time,
with a concomitant increase in weekly production budgets. Often the
visual impact was reduced at the same time. The first iteration of *Drag-
net* (1951–1959), for example, was in black and white; when the series
was rebooted in color in the late 1960s, it had none of the gritty, grainy
authenticity that had defined the show's original run. Color became the

sought after medium—"in color!" screamed the posters and television promo spots for feature films and teleseries—but it was obvious that much of this fare was being ground out on an assembly-line basis.

These were, of course, exceptions. Black and white still carried a mark of distinction, of almost instantaneous quality, for those who had the power to insist upon it and use it well. Truffaut returned to black and white for *The Wild Child* (1970), photographed by Nestor Almendros, while Woody Allen employed black and white for films such as *Manhattan* (1979, d.p. Gordon Willis). Black and white was also the medium of financial necessity for many first-time auteurs. Debut films in the color era that benefitted from black and white include Darren Aronofsky's *Pi* (1998), shot in 16 mm on a microscopic budget by Matthew Libatique; Kevin Smith's "stone age" comedy *Clerks* (1994), also shot on 16 mm black and white for a reported budget of $20,000 by David Klein; and Christopher Nolan's 16 mm monochrome suspense thriller *Following* (1998), again shot for a mere pittance in 16 mm on a series of successive weekends by Nolan himself. In every case, however, these film's directors began with black-and-white "calling cards" and then abandoned monochrome as soon as they could.

But for more established filmmakers, black and white offered a sense of nostalgia, or an instant sense of artistic expressionism for more dramatic projects. Mel Brooks's *Young Frankenstein* (1974) was shot in black and white by Gerald Hirschfeld as an affectionate spoof of the Universal horror films of the 1930s and 1940s, using as props some of the original "mad lab" equipment created by Kenneth Stickfaden. Tim Burton's biopic *Ed Wood* (1994) eerily (and consciously) emulates the cheap, flat, black-and-white cinematography of Wood's own Poverty Row films such as *Plan 9 from Outer Space* (1959, d.p. William C. Thompson) with Stefan Czapsky's equally harsh, utilitarian lighting; while Martin Scorsese's brilliant *Raging Bull* (1980), superbly photographed in crisp, solid black and white by Michael Chapman, unerringly re-creates the tumultuous life of boxer Jake La Motta. There are many other examples through the 1990s, but in each case the film was shot in monochrome either out of financial necessity or as an artistic decision, usually accompanied by much nervousness from studio bosses. Since the separate black and white category was abolished, only one black-and-white film has won the Academy Award for Best Cinematography: *Schindler's List* (1993), directed by Steven Spielberg and photographed by Janusz Kaminski, and that film,

of course, concludes its 195 minutes with a final scene in color, while also twice using color effects for symbolic reasons.

Often, a director would score a resounding success with a modestly budgeted first film shot in black and white, as in Soviet Georgian filmmaker Géla Babluani's electrifying thriller about a game of compulsory Russian roulette held in an isolated country house by a group of rich, depraved gamblers, *13 Tzameti* (2005), photographed by Tariel Meliava. Everyone predicted a bright future for Babluani; the film was so assured, so absolutely perfect in every aspect of its construction, that Hollywood soon came calling. But Babluani allowed himself to be talked into a sanitized remake of the film, with a happy ending, shot in bright, hard color by Michael McDonough in 2010, which not only failed miserably at the box office but also curtailed Babluani's fledgling career. Black and white had been essential to the dark, fatalistic mood of the original film, cast with unknowns; in color and starring Mickey Rourke, however, the film was just another indifferent remake.

Black and white is no longer an everyday choice, a set of pictorial values that one can access at will. And even if you want to shoot in black and white, you have to fight for it. Black and white is now the exception in a resolutely all-color world, a world in which film itself—color or black and white—has become obsolete, replaced by digital technology from first frame to last, from shooting on the studio floor to the final theatrical screenings. Even more distressingly, many of the new black-and-white films aren't really shot in black and white at all, even digitally. *The Artist* (2011), for example, directed by Michel Hazanavicius and photographed by Guillaume Schiffman, was produced in color, which was then drained out of the images in the post-production process. Another example is Alexander Payne's *Nebraska* (2013), shot by Phedon Papamichael in color on an ALEXA digital video camera, despite all the publicity about its bleak, monochrome imagery. As Robert Hardy noted,

> *Nebraska* is a traditional character-driven road movie, and Payne had wanted it to be in black and white from the beginning. For Papamichael, the obvious choice for capture format was Kodak 5222 B&W 33mm film. However, as great as the aesthetic might be, shooting in black and white is seen as a risky proposition on the business side of filmmaking due to the fact that some audiences in various markets view it as antiquated. For that reason, Papamichael tested various color stocks and digital cameras, then had his colorist

manipulate the footage to see which format could get him the closest to the 5222 aesthetic. Papamichael ended up choosing the ALEXA and adding a 5248 film stock grain in order to emulate the 5222 stock.

Thus, even black and white isn't black and white anymore; it's just desaturated color, deemed necessary as a sort of insurance policy for producers. Perhaps twenty years or so from now all films, even the ones in black and white, will be shown in color. This time, however, they won't need to be artificially colorized as they were in the 1980s, because, quite conveniently, they have always been in color—the black-and-white images in these new "monochrome" films is a mere illusion.

Increasingly, the past of cinema is sealed off from the present. Black-and-white cinema is a foreign territory, even in domestic films, which few modern audience members investigate. For most, the excesses of IMAX, 3-D, and massive theater screens suffice. But as a number of people have recently argued—and the tide of opinion seems to be increasing—the question is this: Are these contemporary image constructs really movies, in the sense that we have been discussing them throughout this book? Just as the idea of spectacle, color, surround sound, and other technological

Fake black and white: *The Artist* (2011, directed by Michel Hazanavicius and photographed by Guillaume Schiffman)—shot in color, but screened in monochrome

advances rendered monochrome obsolete, we are now in what often seems to be the "post-plot" world, where spectacle has become all: the arresting image rules and nothing else matters. Narrative has been abandoned for sensation, and audiences, eager for eye-catching special effects, are riveted in their seats. Who cares about plot when there's an enormous explosion on display to momentarily jar one's senses? The abandonment of filmic narrative is thus the logical extension of a system of images that relies solely on sensation and nothing else.

Black-and-white cinematography is a meditation on reality, *a mediation of reality*, offering the viewer a seductive world of shadow, light, textures, and flesh tones, translated into a code system of monochrome glyphs. It has served the primary function of the cinema since its inception, to take us out of ourselves and transport us to another world. But it requires patience, and attention, and apparently that's something we no longer have. The world of black-and-white cinema thus remains an essentially insoluble mystery, a transmutational process, whose secrets have been lost to time and mortality, but whose allure remains undiminished for those who take the time to stop, look, and reflect on the shimmering images on the screen before them.

Works Cited

Alekan, Henri. "Die Magie des Lichts im Film (The Magic of Light in Film)." *Daidalos* 27 (1988): 86–93. Print.

Alland, William. "Gregg Toland on Working with Orson Welles Shooting *Citizen Kane*." *Wellesnet.com*, July 8, 2007. Web.

Allison, Deborah. "Lighting Technology and Film Style." *Film Reference.com*. Web.

Almendros, Nestor. "Lauding a Landmark." *American Cinematographer* 84.6 (2003): 94–102. Print.

Als, Hilton. "The Cameraman: Gregg Toland's Cinematographic Revolution." *New Yorker* 82.18 (2006): 46–51. Print.

Alton, John. *Painting with Light*. Berkeley: U of California P, 2013. Print.

Arnaz, Desi Sr. *A Book*. New York: Morrow, 1976. Print.

"A.S.C. on Parade." *American Cinematographer* (February 1941): 18. Print.

Beaufort, John. "Camera and Sound Effects Tell Spy Story in *Thief*." *Christian Science Monitor* December 8, 1952: 5. Print.

Behlmer, Rudy. *Inside Warner Bros. (1935–1951)*. New York: Viking, 1985. Print.

Bergery, Benjamin. "Raoul Coutard: Revolutionary of the Nouvelle Vague." *American Cinematographer* 78.3 (March 1997): 28–32. Print.

Billington, James. "Introduction." *The Survival of American Silent Feature Films: 1912–1929*. Washington, DC: Council on Library and Information Resources and the Library of Congress, 2013. vii–viii. Print.

Birchard, Robert S. "The Founding Fathers." *American Cinematographer* (August 2004). Web.

Bishop, Christopher. "An Interview with Buster Keaton." *Film Quarterly* 12.1 (1958): 15–22. Print.

Blanchard, Walter. "Aces of the Camera II: Nicholas Musuraca, A.S.C." *American Cinematographer* (February 1941): 56–57. Print.

———. "Aces of the Camera XVI: Arthur Miller, A.S.C." *American Cinematographer* 23.4 (April 1942): 158, 182–184. Print.

Bogdanovich, Peter. "An Interview with Sidney Lumet." *Film Quarterly* 14.2 (1960): 18–23. Print.

Bogdanovich, Peter. *Who the Devil Made It?* New York: Knopf, 1997. Print.

Brooks, Charles William. "Jean Renoir's *The Rules of the Game*." *French Historical Studies* 7.2 (1971): 264–283. Print.

Brownlow, Kevin. Obituary: "Charles Rosher: The Genius among Cameramen." *BKSTS Journal* 56.4 (1974): 100. Print.

Bruns, Daniel. "Shooting in Black and White." *Videomaker.com* August 7, 2013. Web.

Bush, Gregory W. "Like 'A Drop of Water in the Stream of Life': Moving Images of Mass Man from Griffith to Vidor." *Journal of American Studies* 25.2 (1991): 213–234. Print.

Callenbach, Ernest, and Albert Johnson. "The Danger Is Seduction: An Interview with Haskell Wexler." *Film Quarterly* 21.3 (1968): 3–14. Print.

Carringer, Robert L. *The Magnificent Ambersons: A Reconstruction.* Berkeley: U of California P, 1993. Print.

———. *The Making of Citizen Kane.* Revised edition. Berkeley: U of California P, 1996. Print.

Clooney, Nick. *The Movies That Changed Us: Reflections on the Screen.* New York: Atria, 2002. Print.

Cocteau, Jean. *Beauty and the Beast: Diary of a Film.* Trans. Ronald Duncan. New York: Dover, 1972. Print.

Cotter, Holland. "Behind the Camera, a Painter in Light." *New York Times* March 21, 2015: C24. Print.

Cowie, Peter. *Revolution!: The Explosion of World Cinema in the Sixties.* New York: Faber and Faber, 2004. Print.

———. *Seventy Years of Cinema.* New York: Castle, 1969. Print.

Deren, Maya. "Amateur versus Professional." *Film Culture* 39 (1965): 45–46. Print.

Dixon, Wheeler Winston, and Gwendolyn Audrey Foster. *A Short History of Film.* 2nd ed. New Brunswick, NJ: Rutgers UP, 2013. Print.

Dmytryk, Edward. *Cinema: Concept and Practice.* London: Focal Press, 1998. Print.

Dombrowski, Lisa. "Postwar Hollywood, 1947–1967." *Cinematography.* Ed. Patrick Keating. New Brunswick, NJ: Rutgers UP, 2014. 60–83. Print.

"Early Color Television: CBS Field Sequential System (US, 1940–1953)." *Early Television Museum.* Web.

Edeson, Arthur. "Wide Film Cinematography." *American Cinematographer* (September 1930): 8–9, 21. Print.

Erickson, Hal. "George J. Folsey." *All Movie Guide.* Web.

Erskine, John. "Hollywood Cameraman." *Liberty* 18.8 (February 22, 1941): 49–50. Print.

Feder, Elena. "A Reckoning: Interview with Gabriel Figueroa." *Film Quarterly* 49.3 (1996): 2–14. Print.

Fisher, Bob. "A Conversation with Raoul Coutard." *InCamera* July 1, 2011. Web.

Foster, Gwendolyn Audrey. "Fifties Hysteria Returns: Doomsday Prepping in a Culture of Fear, Death, and Automatic Weapons." *Film International* January 2, 2013. Web.

———. "Performativity and Gender in Alice Guy's *La Vie Du Christ*." *Film Criticism* 23 (1998): 6–17. Print.

French, Lawrence. "Interview with Roger Corman on Floyd Crosby." July 8, 2007. *Wellesnet. com.* Web.

Garmes, Lee. "Cinematography: Film, Tape, and Honesty." *Journal of the University Film Association* 26.4 (1974): 59–60. Print.

Gomes, P. E. Salles. *Jean Vigo.* Paris: Editions du Seuil, 1957. Print.

Goodman, Ezra. "Joseph August: Close-Up of a Camera Man." *New York Times* June 29, 1947: X3. Print.

Graham, James. "French Production Described as Being a Thoroughly Sincere and Competent Effort to Accomplish an Impossible Task." *New York Times* June 5, 1927: X5. Print.

Griffith, Richard, and Arthur Mayer. *The Movies*. Rev. ed. New York: Simon and Schuster, 1970. Print.

Guffey, Burnett. "The Photography of *King Rat*." *American Cinematographer* 46.12 (December 1965): 777–781. Print.

Hall, Hal. "Cinematographers and Directors Meet (Discuss Camera Trucking Problems)." *American Cinematographer* 13.4 (1932): 10, 47. Print.

Hardy, Robert. "*Nebraska* Cinematographer Phedon Papamichael Talks ALEXA in Black & White." *NoFilmSchool.com* January 2, 2014. Web.

Hargrave, Harry A. "Interview with Frank Capra." *Literature/Film Quarterly* 9.3 (1981): 189–204. Print.

Heuring, David, and Giosue Gallotti. "A Lifetime through the Lens." *American Cinematographer* 86.3 (March 2005): 34–45. Print.

Higham, Charles. *Hollywood Cameramen: Sources of Light*. Bloomington: Indiana UP, 1970. Print.

Higham, Charles, and Joel Greenberg. "North Light and Cigarette Bulb: Conversations with Cameramen." *Sight & Sound* 36.4 (1967): 192–197. Print.

Johnson, Tom. *Censored Screams: The British Ban on Hollywood Horror in the Thirties*. Jefferson, NC: McFarland, 2006. Print.

Jones, G. William. *Black Cinema Treasures: Lost and Found*. Denton: U of North Texas P, 1991. Print.

Kaufman, Boris. "Film Making as an Art." *Daedalus* 89.1 (Winter 1960): 138–143. Print.

Kaufman, Michael T. "What Does the Pentagon See in *Battle of Algiers*?" *New York Times*, September 7, 2003. Web.

Keating, Patrick. *Hollywood Lighting from the Silent Era to Film Noir*. New York: Columbia UP, 2009. Print.

Kemp, Peter H. "Grit 'n' Glitz: *Gold Diggers of 1933*." *Senses of Cinema* 29 (December 2003). Web.

Kennedy, Burt. "Burt Kennedy Interviews John Ford." *Directors in Action*. Ed. Bob Thomas. Indianapolis: Bobbs-Merrill, 1973. 133–137. Print.

Klein, Veronica. "Nicholas Musuraca A.S.C." *Filmographer* July 24, 2013. Web.

Knight, Arthur. "*Stagecoach* Revisited." *Directors in Action*. Ed. Bob Thomas. Indianapolis: Bobbs-Merrill, 1973. 140–143. Print.

Koszarski, Richard. "Reconstructing *Greed*." *Film Comment* 35.6 (1999): 10–15. Print.

Koszarski, Richard, and Diane Koszarski. "No Problems: They Liked What They Saw on the Screen: An Interview with Joseph Ruttenberg." *Film History* 1.1 (1987): 65–95. Print.

Lane, John Francis. "Otello Martelli Dies: Master of Cinematography behind Great Italian Movies." *Guardian* February 29, 2000. Web.

Langer, Mark J. "Flaherty's Hollywood Period: The Crosby Version." *Wide Angle: A Film Quarterly of Theory, Criticism, and Practice* 20.2 (1998): 38–57. Print.

———. "*Tabu*: The Making of a Film." *Cinema Journal* 24.3 (1985): 43–64. Print.

Lant, Antonia. "The Film Crown." *Moving Pictures: American Art and Early Films 1880–1910*. Ed. Nancy Mowll Mathews. Manchester, VT: Hudson Hills Press, 2005. 159–164. Print.

Lasky, Betty. *RKO: The Biggest Little Major of Them All.* 2nd ed. Santa Monica, CA: Round-table, 1989. Print.

Lev, Peter. *The Fifties: Transforming the Screen, 1950–1959.* Berkeley: University of California Press, 2006.

Lew-Lee, Lee. "Talking Heads: Cinematographers Reveal Lessons Learned from Docs." *International Documentary* 13 (1994): 8–11. Print.

Lightman, Herbert. "Uninhibited Camera." *American Cinematographer* (October 1951): 400, 424–428. Print.

Lipke, Katherine. "The Magic of the Cameraman." *Los Angeles Times* January 21, 1925: C7. Print.

Losada, Matt. "Great Directors: Jean Rouch." *Senses of Cinema* 57 (December 2010). Web.

Mank, Gregory William. *Hollywood Cauldron: Thirteen Horror Films from the Genre's Golden Age.* Jefferson, NC: McFarland, 2001. Print.

Manvell, Roger. *New Cinema in Britain.* London: Studio Vista / Dutton, 1969. Print.

———. *New Cinema in Europe.* London: Studio Vista / Dutton, 1966. Print.

Marcus, Alan. "Uncovering an Auteur: Fred Zinnemann." *Film History* 12.1 (2000): 49–56. Print.

Marie, Michel. *The French New Wave: An Artistic School.* Trans. Richard Neupert. Boston: Wiley-Blackwell, 2002. Print.

Mathews, Nancy Mowll. "Art and Film: Interactions." *Moving Pictures: American Art and Early Film 1880–1910.* Ed. Nancy Mowll Mathews. Manchester, VT: Hudson Hills Press, 2005. 145–158. Print.

———. "The City in Motion." *Moving Pictures: American Art and Early Film 1880–1910.* Ed. Nancy Mowll Mathews. Manchester, VT: Hudson Hills Press, 2005. 117–129. Print.

McBride, Joseph. *Frank Capra: The Catastrophe of Success.* New York: Simon and Schuster, 1992. Print.

McCarthy, Todd. "Through a Lens Darkly: The Life and Films of John Alton." John Alton, *Painting with Light.* Berkeley: U of California P, 2013. xix–xlix. Print.

McGeer, Celia. *René Clair.* Boston: Twayne, 1980. Print.

McGilligan, Patrick. *Oscar Micheaux: The Great and Only.* New York: HarperCollins, 2007. Print.

Mekas, Jonas. "The Film-Makers' Cooperative: A Brief History." *Film-Makers' Cooperative Website.* Web.

Milner, Victor. "Riddle Me This." *American Cinematographer* 13.8 (1932): 12. Print.

Mitchell, George J. "Making *All Quiet on the Western Front.*" *American Cinematographer* 66.9 (September 1985): 34–43. Print.

Mordden, Ethan. *The Hollywood Studios: House-Style in the Golden Age of the Movies.* New York: Knopf, 1988. Print.

Neve, Brian. "A Past Master of His Craft: An Interview with Fred Zinnemann." *Cineaste* 23.1 (1997): 15–20. Print.

Palma, Wayne. "Aces of the Camera." *Saturday Evening Post* 206.4 (1933): 16–17, 46. Print.

Pedullà, Gabriele. *In Broad Daylight: Movies and Spectators after the Cinema.* Trans. Patricia Gaborik. London: Verso, 2012. Print.

Pierce, David. *The Survival of American Silent Feature Films: 1912–1929.* Washington, DC: Council on Library and Information Resources and the Library of Congress, 2013. Print.

Pipolo, Tony. "Joan of Arc: The Cinema's Immortal Maid." *Cineaste* 25.4 (2000): 16–21. Print.

Pizzello, Stephen. "Sven Nykvist, A.S.C. and Ingmar Bergman." *American Cinematographer* 79.11 (1998): 74–76. Print.

Prime, Rebecca. *Hollywood Exiles in Europe: The Blacklist and Cold War Film Culture.* New Brunswick, NJ: Rutgers UP, 2013. Print.

Purtell, Tim. "1946: The Year for Movie Going." *Entertainment Weekly* April 29, 1994. Web.

Raskin, Richard. "If There Is Such a Thing as Real Angels: An Interview with Henri Alekan, Director of Photography." *P.O.V.: A Danish Journal of Film Studies* 8 (1999): 21–37. Print.

Reitan, Ed. "RCA-NBC Firsts in Color Television." *Novia.net* March 8, 2004. Web.

Richie, Donald. *Ozu.* Berkeley: U of California P, 1977. Print.

Rittau, Günther. "Camera Art." *International Photographer* 1.5 (June 1929): 29. Print.

Rivette, Jacques, and François Truffaut. "Interview with Jean Renoir." Trans. C. G. Marsac. *Jean Renoir: Interviews.* Ed. Bert Cardullo. Jackson: UP of Mississippi, 2005. 3–48. Print.

Rowland, Richard. "Carl Dreyer's World." *Hollywood Quarterly* 5.1 (1950): 53–60. Print.

Salt, Barry. "Film Style and Technology in the Thirties." *Film Quarterly* 30.1 (Autumn 1976): 19–32. Print.

Schaefer, Eric. "Nicholas Musuraca." *Film Reference.com.* Web.

Schumach, Murray. "Director Decries Color Film Glut." *New York Times* October 6, 1961: 29. Print.

Scorsese, Martin. *The Film Foundation Website: Film Preservation.* Web.

Shamroy, Leon. "The Future of Cinematography." *American Cinematographer* 80.3 (1999): 128. Print.

Shedlin, Michael. "Conrad Hall: An Interview." *Film Quarterly* 24.3 (1971): 2–11. Print.

"Shooting with Ingmar Bergman: A Conversation with Sven Nykvist: Interview at the American Film Institute, 1984." *EuroScreenwriters.* Web.

Siegel, Joel E. *Val Lewton: The Reality of Terror.* New York: Viking, 1973. Print.

Siomopoulos, Anna. "The Birth of a Black Cinema: Race, Deception, and Oscar Micheaux's *Within Our Gates.*" *Moving Image* 6.2 (2006): 111–118. Print.

Smith, Susan. "Bri Murphy: Eye of the Camera." *Los Angeles Times* May 27, 1979: M34–35, M36. Print.

Stafford, Jeff. "*Crossfire.*" *TCM.com.* Web.

"Stanley Cortez." *Great Cinematographers.* Web.

Sternbergh, Adam. "Harrison Ford on Fanboys and Fatsuits." *New York Times* August 9, 2013. Web.

Sweeney, Kenneth. "*The Adventures of Antoine Doinel:* DVD Playback." *ASC.com* (September 2003). Web.

Thomas, Bob. *King Cohn: The Life and Times of Harry Cohn.* New York: G. P. Putnam's, 1967. Print.

Thomas, Kevin. "Shamroy—Virtuoso of the All-Seeing Eye." *Los Angeles Times* May 8, 1966: M6. Print.

Thompson, Frank. "Joseph B. Walker." *Film Reference.com.* Web.

Toland, Gregg. "The Motion Picture Cameraman." *Theatre Arts Magazine* (September 1941). Rpt. in *WellesNet.com.* Web.

Trainor, Richard. "Henri Alekan: Black and White Light." *Sight and Sound* June 1, 1993: 14–17. Print.

Turan, Kenneth. "A Life's Worth of Paces and Places." *Washington Post* July 11, 1977: B1, B9. Print.

Turner, George. "*Casablanca.*" *American Cinematographer* 80.3 (1999): 112. Print.

——. "Cinemasters: Milton Krasner, A.S.C." *American Cinematographer* 67.9 (September 1986): 38–47. Print.

——. "The Innovators 1940–1950." *Sight & Sound* 9.7 (1999): 24–26. Print.

Turner, George. "*Out of the Past.*" *American Cinematographer* 65.3 (March 1984): 32–36. Print.

———. "*Touch of Evil.*" *American Cinematographer* 80.3 (March 1999): 146. Print.

Uroskie, Andrew V. "Beyond the Black Box: The Lettrist Cinema of Disjunction." *October* 135 (Winter 2011): 21–48. Print.

Usai, Paolo Cherchi. *The Death of Cinema: History, Culture Memory, and the Digital Dark Age.* London: BFI, 2001. Print.

Valentine, Joseph. "Make-Up and Set Painting Aid New Film." *American Cinematographer* (February 1939): 54–56, 85. Print.

Walker, Joseph, and Juanita Walker. *The Light on Her Face.* Hollywood, CA: ASC Press, 1993. Print.

Wanamaker, Marc. "Cinemasters: George Folsey, ASC." *American Cinematographer* 66 (1985): 40–48. Print.

Williams, David. "Clubhouse News: ASC International Award Honoree Freddie Francis, BSC, 1917–2007." *American Cinematographer* 88.6 (June 2007): 122. Print.

———. "Gilbert Taylor, BSC, Is Given the Spotlight in the ASC's International Achievement Award." *American Cinematographer* 87.2 (February 2006). Web.

Winokur, Mark, and Bruce Holsinger. "Movies and Film: The Aesthetics of Black and White and Color." *Infoplease.* Web.

Zeitchek, Steven. "*Guardians of the Galaxy* and the Rise of Post-Plot Cinema." *Los Angeles Times* August 4, 2014. Web.

Index

Page numbers in italics refer to illustrations.

About the Author

Wheeler Winston Dixon is the James Ryan Professor of Film Studies, coordinator of the Film Studies Program, and professor of English at the University of Nebraska, Lincoln, and, with Gwendolyn Audrey Foster, editor of the new book series *Quick Takes: Movies and Popular Culture* for Rutgers University Press. As a filmmaker, his collected works are part of the permanent collection of the Museum of Modern Art, New York. His newest books are *Cinema at the Margins* (2013); *Streaming: Movies, Media, and Instant Access* (2013); *Death of the Moguls: The End of Classical Hollywood* (2012); *21st Century Hollywood: Movies in the Era of Transformation* (2011, coauthored with Gwendolyn Audrey Foster); *A History of Horror* (2010), and *Film Noir and the Cinema of Paranoia* (2009). Dixon's book *A Short History of Film* (2008, coauthored with Gwendolyn Audrey Foster) was reprinted six times through 2012. A second, revised edition was published in 2013; the book is a required text in universities throughout the world.